Selected Lectures of
Rudolf Wittkower

Selected Lectures of Rudolf Wittkower

THE IMPACT OF NON-EUROPEAN CIVILIZATIONS ON THE ART OF THE WEST

compiled and edited by
Donald Martin Reynolds

foreword by
Margot Wittkower

The right of the
University of Cambridge
to print and sell
all manner of books
was granted by
Henry VIII in 1534.
The University has printed
and published continuously
since 1584.

CAMBRIDGE UNIVERSITY PRESS

Cambridge

New York New Rochelle Melbourne Sydney

Grateful acknowledgment is made for permission to reproduce works from the following:
 The Groeninge Museum, Bruges; Museum of Modern Art, New York; British Museum, London; Baghdad Museum, Baghdad; State Museum, East Berlin; Archaeological Museum, Istanbul; Louvre, Paris; National Gallery, London; Archaeological Museum, Olympia; Museo Municipale, Tarquinia; Hermitage, Leningrad; National Museum, Damascus; Capitoline Museum, Rome; National Museum, Copenhagen; R. Accad. de la Historia, Madrid; University of Pennsylvania Museum, Philadelphia; Metropolitan Museum of Art, New York; Poitiers Museum, Poitiers; Musée Lapidaire, Arles; Bibliothèque Nationale, Paris; Museum of Fine Arts, Boston; John Rylands Library, Manchester; Museo Civico, Viterbo; Trinity College, Cambridge; Uffizi Gallery, Florence; Vatican Library, Rome; Royal Library, Windsor Castle; All Souls College, Oxford; Chatsworth Settlement, London; Museum Narodowe w Krckowie, Cracow; Ashmoleum Museum of Art and Archaeology, Oxford; Wadsworth Athenaeum, Hartford; National Museum, Stockholm; Brass Collection, Vienna; National Gallery, Washington, D. C.; Museum of Art, Raleigh; Admiralty, London.

Photographic credits appear in each caption, except for illustrations taken from the Rudolf Wittkower archive of photographs and slides at Columbia University. Locations of works and published sources of the illustrations are included in the captions to provide the reader with easy access to the material discussed.

Published by the Press Syndicate of the University of Cambridge
The Pitt Building, Trumpington Street, Cambridge CB2 1RP
32 East 57th Street, New York, NY 10022, USA
10 Stamford Road, Oakleigh, Melbourne 3166, Australia

First published 1989

Printed in the United States of America

Library of Congress Cataloging-in-Publication Data
Wittkower, Rudolf.
 Selected lectures of Rudolf Wittkower.
 Bibliography: p.
 Includes index.
 1. Art, European – Oriental influences. 2. Art,
European – Foreign influences. I. Reynolds, Donald M.
II. Title.
N6750.W56 1989 709'.4 88–34218
ISBN 0-521-30508-X

British Library Cataloguing in Publication Data
Wittkower, Rudolf
 Selected lectures of Rudolf Wittkower: the impact of non–European civilizations on the art of the West
 1. Western visual arts. Influence of non–European visual arts to 1970
 I. Title II. Reynolds, Donald Martin 709
 ISBN 0-521-30508-X

Contents

List of illustrations *page* vii
Foreword by Margot Wittkower xxiii
Preface xxvii

ONE Europe and the Near East I: Migrations
 and Waves of Penetration 1
TWO Europe and the Near East II: Waves of
 Penetration 18
THREE Egypt and Europe 36
FOUR The Obelisk I: Its Role in Architectural
 Decoration and Urban Organization 60
FIVE The Obelisk II: Its Significance in the
 Seventeenth and Eighteenth Centuries 75
SIX Hieroglyphics I: The Conceptual Impact of
 Egypt from the Fifteenth Century Onward 94
SEVEN Hieroglyphics II: Seventeenth and
 Eighteenth Century Philological Concerns 113
EIGHT Piranesi's Contribution to European
 Egyptomania 127

v

NINE China and Europe I: Early Connections 145
TEN China and Europe II: Chinoiserie and the
 Anglo-Chinese Garden 161
ELEVEN Europe, India, and the Turks 193

 *Bibliography: Rudolf Wittkower's Reading
 List, 1969* 221
 Index 229

Illustrations

1–1 Capital with griffins. Puy-le-Dôme, Mozac.
Twelfth century A.D. 3

1–2 Jan van Eyck. *Madonna with Canon van der Paele*. A.D. 1436. 3

1–3 Picasso. *Les demoiselles d'Avignon*. 1907. 5

1–4 Cast gold ornamental plates from girdle clasps, Scythian. Seventh and sixth century B.C. Borovka. 5

1–5 Mirror, Hiberno-Saxon. Eighth century A.D. 8

1–6 Cylinder seal of Nur-Adad with names of Hittite kings from Hattushash (modern Bogatzköy, Turkey), Assyrian. Hero taming winged bulls. Eighth to seventh century B.C. 8

1–7 Cylinder seal and impression, Akkadian. Nude bull man holding two lions and bearded hero holding two bulls. ca. 2500 B.C. 9

1–8 Alabaster vase, from Uruk. Scenes of temple offerings. 3000 B.C. 9

1–9 Detail of 1–8. 9

1–10 Ishtar Gate, from Babylon. 604–562 B.C. 10

1–11 Alexander sarcophagus frieze. Battle, north side. 330–325 B.C. 12

1–12 Bronze griffin head, from Susa. Sixth century B.C. 12

1–13 Bronze griffin head decorating a cauldron, Etruscan. ca. 650 B.C. 12

1–14 Bronze vessel support with sphinxes and Bellerophon riding Pegasus, Etruscan. Mid-sixth century B.C. 13

1–15 Silver vase, Sassanian. Eagle killing faun. Sixth to eighth century A.D. 13

1–16 Priests, tribune ceremonial fresco. Temple of Baal. Second century A.D. 13

1–17 Arch of Constantine. Relief, north side. Rome. A.D. 312–5. 15

1–18 Arch of Constantine Relief, north side. Rome. A.D. 312–5. 15

1–19 Colossal head of Constantine. ca. A.D. 330. 15

1–20 Mosaic, north wall. S. Apollinare, Nuovo, Ravenna. Sixth century A.D. 16

1–21 Celtic silver cauldron, from Gundestrup, Denmark. 80–50 B.C. 16

2–1 Shroud of St. Victor, detail. 21

2–2 Shroud of St. Victor, detail. 21

2–3 Daniel and Nebuchadnezzar. 1073–1109. From *Beatus Apocalypse.* 22

2–4 Initial "A." Crossed gazelles, plant, dogs. From *Expositio Psalmorum* (Commentary to Psalms), Madrid. 22

2–5 Soundbox of harp with shell inlay, from Ur. Hero protecting bulls. ca. 2600 B.C. 24

2–6 Detail of 2–5. 24

2–7 Capital with devil between winged lions with bulls' feet. San Michele, Pavia. ca. 1120. 24

2–8 Trumeau with interlaced animals. S. Pierre, Moissac. 1120–5. 25

2–9 Ornamental slab. Cathedral of Sorrento. Tenth century. 25

2–10 Capital with griffins. Puy-le-Dôme, Mozac. Twelfth century. 25

2–11 Silk with griffin pattern, Hispano-Islamic. Twelfth century. 26

2–12	Barisanus of Trani. Bronze door, detail. ca. 1179.	26
2–13	Capital with griffins. S. Martin, *Fuentidueña*. Twelfth century.	27
2–14	Griffin capital, Romanesque. S. Cugat del Vallès, Barcelona.	27
2–15	Papal stockings of Clement II (d. 1047), from Constantinople. Before 1047.	28
2–16	Silk and linen antependium, Islamo-Hispanic. Mid-thirteenth century.	28
2–17	Choir capital, probably from St. Hilaire in Poitou. 1044–9.	29
2–18	Capital, Romanesque. Sphinxes with bovine bodies.	29
2–19	Capital, Romanesque. One head crowning two bodies. Chateauneuf-sur-Charente.	30
2–20	Andalo di Negro. *Introductio ad Judicia Astrologiae*. Jupiter (Zeus). Fourteenth century.	31
2–21	Albumasar. *Introductio in Astrologiam*. Saturn rising and setting. Fourteenth century.	31
2–22	Palazzo Schifanoia. Scheme of arrangement of fresco cycle painted for Borso d'Este. 1467–70.	32
2–23	Fresco cycle, Palazzo Schifanoia. March. The Triumph of Minerva. Aries and figuration for the second decade.	33
2–24	Fresco cycle, Palazzo Schifanoia. April. The Triumph of Venus. Taurus and figuration for the second decade.	34
3–1	Kouros, Greek. ca. 600 B.C.	37
3–2	Mycerinus and his queen, Egyptian. ca. 2470 B.C.	37
3–3	Pyramid of Cestius. Gate of Ostiensis. Rome. Erected 12 B.C.	39
3–4	Obelisk, Egyptian. Erected 1588 in Piazza di S. Giovanni in Laterano, Rome. Transported by Emperor Constantius A.D. 357.	39
3–5	Fresco, Pompeii. Zeus-Io-Argos legend.	40
3–6	Bird killing a snake (Christ overcoming Satan). Eleventh century.	42

3–7 Obelisk, from St. Peter's, Rome. View from
 the southeast. 1530s. Drawing by Marten van
 Heemskerck. 44
3–8 Atrium mosaic. Granaries of Joseph, detail
 with pyramids. ca. 1270. 45
3–9 Petrus Vassalettus. Sphinx. 1215–32. 46
3–10 Petrus Vassalettus. Pascal candelabrum.
 Thirteenth century. 46
3–11 Petrus Vassalettus. Sphinx. Pascal
 candelabrum, detail. ca. 1170. 47
3–12a Fra. Pasquale. Sphinx, from S. Maria in Gradi.
 1286. 48
3–12b Detail of 3–12a. 48
3–13 The Heavenly Jerusalem, Spanish. Eleventh
 century. 49
3–14 Celestial Jerusalem, French. ca. 1230–50. 49
3–15 Raphael. Chigi Chapel (altered 1652). Plan and
 section. 1513. 50
3–16 Raphael. Chigi Chapel. 1513–6. S. Maria del
 Popolo, Rome. 51
3–17 Michele Sanmicheli. Tomb of Lavinia Thiene.
 1542. 52
3–18 Michele Sanmicheli. Vittoria Contarini tomb.
 1544–8. 53
3–19 Francesco Colonna. Mausoleum of
 Halicarnassus. Woodcut. 1499. 53
3–20 Vincenzo de'Rossi. Tomb sculpture, Cesi
 Chapel. ca. 1550–63. 54
3–21 Companion view to 3–20. 54
3–22 Prospero Sogari (called il Clemente).
 Tomb of Humanist Ludovico Parisetti. ca.
 1555. 55
3–23 Georg Franz Ebenhech. Marble sphinx with
 putti. ca. 1755. 55
3–24 Marble sphinxes on Adam wooden stands.
 Mid-eighteenth century. 56
3–25 F. Carcani. Tomb of Monsignore Agostino
 Favoriti. 1682–6. 56
3–26 Antonio Canova. Bozzetto for monument to
 Titian. 1794. 57
3–27 Antonio Canova. Tomb of Maria Christina,
 Archduchess of Austria. 1805. 57

3–28	Michelangelo's Catafalque in San Lorenzo. Sketch, pen and ink. 1564. Probably artist in Cellini's circle after design by Vasari.	58
3–29	Michelangelo's Catafalque. Reconstructed elevation.	58
3–30	Jacques Callot. Obsequies of Emperor Matthias in Florence. Engraving and etching. 1619.	58
4–1	Aristotile da Sangallo for Antonio da Sangallo (the elder). S. Maria di Loreto, Rome. Elevation drawing. 1520–5(?).	61
4–2	Antonio da Sangallo (the elder). Church of the Madonna di S. Biagio. 1518–34.	62
4–3	Jacopo Sansovino. Library of St. Mark (Libreria Vecchia), Venice. 1536–60. Completed by Scamozzi, 1591.	63
4–4	Church design. From Sebastiano Serlio, *L'Architettura*, Book Four. Venice, 1537.	65
4–5	Obelisk designs. From Sebastiano Serlio, *L'Architettura*, Book Three, Venice, 1540.	65
4–6	Obelisk. Piazza del Popolo, Rome. Erected 1589. Transported by Augustus from Heliopolis to Circus Maximus in 10 B.C.	66
4–7	Obelisk. Vatican, Rome. Erected 1586. From Circus of Nero.	66
4–8	Obelisk. S. Maria Maggiore, Rome. Erected 1582. From tomb of Augustus. Found 1527 near San Rocco.	67
4–9	Giacomo da Vignola. S. Maria dell'Orto, Rome. 1566–7.	69
4–10	Juan de Herrera. Facade of the Escorial. 1563–84. Near Madrid.	69
4–11	Pietro Antonio Barca (?). Church of S. Maria degli Angeli, Milan. ca. 1600.	70
4–12	Tomb of Cardinal Francesco Sfondrato. Designed by Francesco Dattaro and executed by Giovanni Battista Cambi. 1561.	71
4–13	Obelisk. Piazza del Quirinale, Rome. Erected 1786.	73
5–1	Marten van Heemskerck. *Roman Sketchbook*. View of Capitol. 1530s.	76
5–2	Obelisk. Piazza Navona, Rome. Erected 1649–50.	77

5–3 Francesco Borromini. Piazza Navona project.
 1647. 78
5–4 Gianlorenzo Bernini. Four Rivers Fountain
 studies. 1648–51. 79
5–5 Gianlorenzo Bernini. Elephant and obelisk,
 drawing. 1666–7. 79
5–6 Gianlorenzo Bernini. Elephant obelisk. Piazza
 S. Maria Sopra Minerva, Rome. 1667. 81
5–7 Gianlorenzo Bernini workshop. Giant
 (Hercules) carrying obelisk. Drawing. 1665.
 Vatican Library, Rome. 82
5–8 Gianlorenzo Bernini. Obelisk carried by two
 men. Drawing. 1665(?) 82
5–9 Carlo Fontana. Trevi Fountain project.
 Drawing, no. 534 (*left*), no. 535 (*right*). 1706. 84
5–10 Carlo Fontana. Trevi Fountain project.
 Drawing, no. 526 (*left*), no. 528 (*right*). 1706. 84
5–11 Carlo Fontana. Trevi Fountain project.
 Drawing, no. 532 (*left*), no. 531 (*right*). 1706. 85
5–12 Obelisk. View in front of Pantheon, Rome.
 Erected 1711. 85
5–13 Trinità dei Monti obelisk, Rome. Erected
 1789. 86
5–14 Vincenzo Scamozzi. Villa Pisani, Lonigo. 1576. 86
5–15 Vincenzo Scamozzi. Villa Badoeri, Peraga near
 Padua. 1588. 88
5–16 Villa Foscarini. Vincenza. 88
5–17 Nicholas Hawksmoor. Pyramid in Pretty
 Wood. Castle Howard, Yorkshire. 1720s. 89
5–18 Nicholas Hawksmoor. Pyramid with
 monument. Castle Howard, Yorkshire. 89
5–19 Nicholas Hawksmoor. Design for St. Anne
 Limehouse, London. 1714. 90
5–20 Nicholas Hawksmoor. Design for a church
 based on Mausoleum of Halicarnassus (*left*).
 All Souls College, Oxford. Design for church
 based on Mausoleum of Halicarnassus (*center*).
 Design for St. George's of Bloomsbury, London
 (*right*). 1720s. 90
5–21 Detail of 5–20: steeple. 91
5–22 Nicholas Hawksmoor. St. Luke's, London.
 1730. 91

5–23 Sphinx. Gardens of Lord Burlington's Villa,
 Chiswick. 1720s. 91
5–24 William Kent. Drawing of gardens. Chiswick
 House, London. Chatsworth Settlement. 92
5–25 Obelisk, pond, and classical temple. Gardens
 of Lord Burlington's villa. Chiswick House,
 London. 92
6–1 Pavement depicting Hermes Trismegistus
 Handing over the Tablets of the Law to the
 Egyptians. Siena Cathedral. 1482–3. 96
6–2 Pierio Valeriano. Obelisk with hieroglyph
 depicting a child, and old man, and a bird,
 fish, and rhinoceros: the process of life. From
 Hieroglyphica, 1556. 96
6–3 Albrecht Dürer. Illustration depicting a dog,
 two men, and a bucket with flame. From
 Horapollo Hieroglyphica (Latin translation by
 Willibald Pirckheimer, ca. 1514). 98
6–4 Roman temple frieze, from San Lorenzo fuori
 le mura. Capitoline Museum, Rome. 98
6–5 Fragment of temple of Vespasian, Rome.
 Temple begun by Vespasian's son Titus at
 death of Vespasian A.D. 79, and completed by
 Domitian (Vespasian's second son) on Titus's
 death A.D. 81. 99
6–6 Hieroglyph. From Fra Francesco Colonna,
 Hypnerotomachia Poliphili. Venice, 1499. 101
6–7 Matteo de Pasti. Medal with portrait of Alberti
 (obverse). ca. 1450. Reverse: eye surrounded by
 laurel wreath. 101
6–8 Pisanello. Medal with portrait of Alfonso V,
 King of Aragon and Sicily (obverse). 1449.
 Reverse: eagle, flanked by birds of prey.
 National Gallery, Kress Collection,
 Washington, D.C. 102
6–9 Pisanello. Medal with portrait of Belloto
 Cumano (obverse). 1447. Reverse: ermine. 102
6–10 Leonardo da Vinci. *Portrait of a Woman with
 Ermine* (Cecilia Gallerani). ca. 1483. 104
6–11 Francesco di Giorgio(?). Medal with portrait of
 Antonio d'Ambrogio Spannocchi (obverse).
 1494(?) Reverse: salamander in flames. 104

6–12 Battista Elia da Genoa(?) Medal with portrait
 of Doge Battista II di Pietro di Campofregoso
 (obverse). 1478–83. Reverse: bird and
 crocodile. 104
6–13 Bernardino. Pinturicchio. Isis and Osiris fresco
 cycle. Borgia Apartments, Vatican. 105
6–14 Dürer et al. Triumphal Arch of Maximilian I.
 Design completed, 1515. Woodcut. 108
6–15 Detail of 6–14. 109
6–16 Hieroglyph. From Francesco Colonna,
 Hypnerotomachia Poliphili. Venice, 1499. 109
6–17 Andreae Alciati. *Emblemata cum
 Commentariis.* 1531 and 1551. A posthumous
 edition of 1621. 111
6–18 Hieroglyphs. From Pierio Valeriano (Giovanni
 Pietro della Fossa), *Hieroglyphica.* 1556. 111
7–1 Achillis Bocchi. *Symbolicarum Questionum
 . . . Libri.* Bologna, 1555, 1574. 115
7–2 Jean Goujon. Reproduction of rhinoceros and
 obelisk. Erected for entry of Henry II to Paris,
 1549. 116
7–3 Elephant and obelisk. From Francesco
 Colonna, *Hypnerotomachia Poliphili.* Venice,
 1499. 116
7–4 Jules Hardouin Mansart. Invalides Chapel,
 Paris. 1679–91. Engraving by Jacques Lepautre.
 1687. 119
7–5 Nicholas Poussin. *Adoration of the Golden
 Calf.* 1636. 119
7–6 Nicholas Poussin. *Moses Taken from the
 Water.* 1651. 120
7–7 Nicholas Poussin. *Rest on the Flight into
 Egypt.* 1655. 120
7–8 Egyptian columns. Plate LXVI of Richard
 Pococke, *A Description of the East.* 1743–5. 122
7–9 Egyptian columns and capitals. Plate LVI of
 Frederik Ludvig Norden, *Voyage d'Egypte et
 de Nubie.* Copenhague: Imprimerie de la
 maison royale des orphelino, 1755. In English:
 *The Antiquities, Natural History, Ruins, and
 Other Curiosities of Egypt, Nubia, and
 Thebes.* London: Jeffery, 1792. 123

7–10	Portal of Luxor. Plate CVI of Norden, *Voyage*....	123
7–11	Isis. From Dom. Bernard de Montfaucon, *L'Antiquité Expliquée et Représentée en figures*..., 1719.	124
7–12	Anubis, a god with a dog's head, and sphinxes. From Montfaucon, *L'Antiquité, Expliquée et Représentée en figures*..., 1719.	124
7–13	Table of Isis. From Montfaucon, *L'Antiquité, Expliquée et Représentée en figures*..., 1719.	125
8–1	Tomb of Sothis with hieroglyphics from the *Hypnerotomachia*. From Johann Bernhard Fischer von Erlach, *Entwurf einer historischen architectur*..., 2nd ed. Vienna, 1721.	128
8–2	Pyramids of Memphis. From Fischer von Erlach, *Entwurf einer historischen architectur*, 2nd ed. Vienna, 1721.	128
8–3	Pyramids. From Fischer von Erlach, *Entwurf einer historischen architectur*, 2nd ed. Vienna, 1721.	129
8–4	Prison view. Giovanni Battista Piranesi, *Carceri d'Invenzione* (1745, 1760–1).	130
8–5	Piranesi, *Carceri d'Invenzione*.	130
8–6	Views of Antiquity from Piranesi, *Antichità Romane*. 1748, 1756.	132
8–7	Piranesi, *Parere su l'Architettura*. 1765.	133
8–8	Piranesi, *Parere su l'Architettura*. 1765.	133
8–9	Piranesi, *The Diverse Manners of Decorating Chimney Pieces*. Rome, 1769.	134
8–10	Piranesi, *The Diverse Manners of Decorating Chimney Pieces*. Rome, 1769.	134
8–11	Piranesi, *The Diverse Manners of Decorating Chimney Pieces*. Rome, 1769.	135
8–12	Piranesi, *The Diverse Manners of Decorating Chimney Pieces*. Rome, 1769.	135
8–13	Piranesi. Wall painting in Egyptian style. English Coffee House. Piazza di Spagna, Rome. ca. 1765.	136
8–14	Emblems from Egyptian Temples. From Vivant Denon, *Voyage dans la basse et la haute Egypte*. Paris, 1802.	136

8–15 Tempio di Latopoli. From Denon, *Voyage dans la basse et la haute Egypte*. Paris, 1802. 139

8–16 Etienne-Louis Boullée. Design for Palais d'Assemblée Nationale. 139

8–17 Design for Bookcase. From Charles Percier and Pierre Fontaine, *Recueil de decorations interieures...*, 1812. 140

8–18 Design for Clock. From Percier and Fontaine, *Recueil de decorations interieures*, 1812. 140

8–19 Hotel Beauharnais, Paris, 1805. 141

8–20 Hotel Beauharnais, Paris, 1805. 141

8–21 Peter Frederick Robinson. Egyptian Hall. Engraving. Piccadilly, London. 1812. 142

8–22 Carl Haller von Hallerstein. Design for Munich Glyptothek and Hall of Temple of Denderah. 1814. 142

8–23 Elihu Vedder. *Questioner of the Sphinx*. 1863. 143

9–1 Ivory casket, Byzantine. Tenth century. 147

9–2 Bronze mirror with phoenix. T'ang Dynasty (618–906). 147

9–3 Serpents haunting Chinese province of Caragian. Early fifteenth century. 149

9–4 Cynocephali (dog-headed) people of Andaman Islands. Marco Polo ms. codex 2810, folio 76. 149

9–5 Monsters seen in Siberia. Marco Polo ms. codex 2810, folio 29. 151

9–6 Ambrogio Lorenzetti. *Martyrdom of Franciscan Friars*. Details of Tartar and Mongol spectators. ca. 1326. 151

9–7 Ambrogio Lorenzetti. *Martyrdom of Franciscan Friars*. Details of Tartar and Mongol spectators. ca. 1326. 151

9–8 Ambrogio Lorenzetti. *Martyrdom of Franciscan Friars*. Details of Tartar and Mongol spectators. ca. 1326. 151

9–9 Pisanello. Kalmuck in fresco of the legend of St. George. Before 1440. 152

9–10 Pisanello. Study of Kalmuck for 9–9. 153

9–11 Textile, Italian. Fourteenth century. 153

9–12	Textile, Italian (Luccan). Fourteenth century.	154
9–13	Textile, Italian (Venetian). Fifteenth century.	154
9–14	Textile, Chinese. Fourteenth century.	155
9–15	Antonio Vivarini. *Adoration of the Magi* (detail). 1444.	155
9–16	Monster. From Spanish Bible. 1197.	157
9–17	Chinese chimera. Han Dynasty (202 B.C.–A.D. 220).	157
9–18	Fantastic animals. Bayeux Cathedral.	158
9–19	Rohan Hours (*Grande Heures de la famille Rohan*). Demon fighting archangel (*right*). 1430. Tcheou Ki-tch'ang and Lin T'ing-kouei. Demon carrying the bones of Buddha, Chinese (*left*). ca. 1163–80.	159
10–1	Faience plate, Chinoiserie, French (Rouen). Eighteenth century.	163
10–2	Porcelain figures, Chinoiserie, German. Eighteenth century.	163
10–3	Terra cotta figures, Venetian. Eighteenth century.	164
10–4	Lacquered commode, Chinoiserie, French. Eighteenth century.	164
10–5	Secretary, Chinoiserie, French. Eighteenth century.	165
10–6	Needlepoint panel, French. Eighteenth century.	166
10–7	Printed cotton textile, Chinoiserie, Spanish. Eighteenth century.	166
10–8	Gabinetto di Toeletta della Regina (Chinese Room). Palazzo Reale, Turin. 1733–7.	167
10–9	Chinese Room. Palazzo Reale. Detail of 10–8.	168
10–10	Beauvais tapestry. *The Audience*. Woven after design by J. B. Fontenay and J. J. Dumas. ca. 1725–30.	168
10–11	Beauvais tapestry. *La toilette*. Woven after design by Boucher. ca. 1743.	169
10–12	Watteau. *Chinese Dance*. ca. 1718.	169
10–13	Boucher. *La danse Chinoise*. Engraving. ca. 1740.	170

10–14 Watteau (after). *Goddess Ki Mao Sao.*
Engraving by Aubert. 1719. 170

10–15 Watteau (after). *Chinese Emperor.* Engraving.
ca. 1729–30. 171

10–16 Pillement, *Panneaux* [de Chinoiserie style]
"d'Après les Originaux (Pillement-Boucher)."
Invented and engraved by Pillement. Paris:
Calavas, 1880. 171

10–17 Pillement, *Panneaux* [de Chinoiserie style]
"d'Après les Originaux (Pillement-Boucher)." 172

10–18 Pillement, *Panneaux* [de Chinoiserie style]
"d'Après les Originaux (Pillement-Boucher)." 172

10–19 Pillement, *Panneaux* [de Chinoiserie style]
"d'Après les Originaux (Pillement-Boucher)." 173

10–20 Pagoda. From Jan Nieuhoff, *An Embassy from
the East-India Company to the Grand Tartar.*
1665; English edition, 1699. 173

10–21 Court of the Emperors, Palace at Peking. From
Nieuhoff, *An Embassy from the East-India
Company to the Grand Tartar.* 1665; English
edition, 1699. 174

10–22 Nine-story porcelain Pagoda, Nanking
(destroyed 1853). From Erlach, *Entwurf.*
Copied from Nieuhoff. 174

10–23 Garden at Wang School, Suchou. A perfect
T'ai-Hu stone. 175

10–24 A T'ai-Hu stone. Attributed to Hui Tsung
(1082–1135) but later. 175

10–25 Doors, Salon and Chinese Room Hall, Claydon
House. Sir. T. Robinson. Buckinghamshire.
1768–71. 177

10–26 Carved wood relief. Chinese Room, Claydon
House. 1768–71. 177

10–27 Chinese Room, Claydon House. Chimneypiece
(detail). 178

10–28 Chinese Room, Claydon House (detail). 178

10–29 Chinese Temple. From Charles Over,
*Ornamental Architecture in the Gothic,
Chinese, and Modern Taste.* London: Sayer,
1758. 179

10–30 Gothic temple. From Over, *Ornamental
Architecture.* 179

10–31 A Gothic structure. From Paul Decker, the younger. *Gothic Architecture Decorated.* London, 1759. 180

10–32 Kew Gardens, Aquatint. Sir William Chambers. *Plans, Elevations, Sections, and Perspective Views of the Gardens and Buildings at Kew in Surrey.* London, 1763. 180

10–33 William Kent. Merlin's Cave. 1735. 181

10–34 William Halfpenny. New Designs for Chinese Gates. 1752. The elevation of a temple partly in the Chinese taste. From *New Designs for Chinese Temples, Triumphal Arches, Garden Seats, etc.* London, 1750–2. 181

10–35 Thomas Lightoler. Farmhouse in Chinese Taste. From *The Gentleman and Farmer's Architect.* London: Sayer, 1764. 182

10–36 Pavilion for Contemplation of Moon in Ching Yen Yüan, the garden of Lin Ch'ing, in Ch'ing Chiang P'u. Early nineteenth century. 182

10–37 J. G. Buering. Tea House. Sanssouci, Potsdam. 1754–7. 183

10–38 Part of private garden, Peking. 183

10–39 François-Joseph Belanger. Pavilion du Philosophe Chinois, Bagatelle. 1782. Plans, 1775 by Belanger from Comte d'Artois, brother of Louis XVI. Published in Johann Karl Krafft, *Plans des plus beaux jardins pittoresques de France, d'Angleterre et d'Allemagne* ... Paris: Levrault, 1809. 184

10–40 William Kent. Garden cascade, Chiswick House, Chatsworth Settlement. 184

10–41 Layout of garden, Chiswick House. 185

10–42 Villa d'Este Gardens, Tivoli. Engraving. Sixteenth century. 185

10–43a Palace layout. Versailles. Seventeenth century. Engraving by (Adam and Nicolas[?]) Pérelle. Plan with Le Notre's garden design, 1661–8. 187

10–43b Plan of Chinese gardens outside Peking. 1810. Published in Krafft, *Plans des plus.* 187

10–43c Batty Langley. Plan for Garden in New Style. From *New Principles of Gardening.* London, 1728. 187

10–44	Perelle. Bosquet du Marais. Versailles. Engraving. 1674. From *Les delices*.	188
10–45	Charles Hamilton. Painshill Park, Surrey. Artificial lake, Turkish tent, Roman mausoleum, temple dedicated to Bacchus, Gothic pavilion, grotto, Chinese type rockery and bridge. 1740s.	188
10–46	Imperial Gardens of Jehol. From Father Matteo Ripa, *Thirty-six Views of Jehol*. 1713. British Museum, London.	190
10–47	View of Jehol. From Father Matteo Ripa, *Thirty-Six Views of Jehol*. British Museum, London.	190
11–1	John Nash. The Royal Pavilion, Brighton. 1815–23. Two exterior views.	195
11–2	Royal Pavilion, Brighton. Front. Design by Humphry Repton (published by him 1808).	197
11–3	Samuel Pepys Cockerell. Sezincote House, near Moreton-in-the Marsh, Gloucestershire. ca. 1805.	197
11–4	Samuel Pepys Cockerell. Sezincote House. Aquatint by John Martin.	198
11–5	Samuel Pepys Cockerell. Sezincote House. Doorway, detail.	198
11–6	Jean-Jacques Lequeu. *Indian Pagoda Dedicated to Intelligence*. 1792. Collection of Gothic-, Hindu-, Chinese-, Moslem-, and Egyptian-style drawings.	199
11–7	Mihrab. Lustre-painted glazed ceramic, Persian. 1226.	199
11–8	Duccio. *Rucellai Madonna*. 1285.	201
11–9	Masaccio. *Madonna and Child*. Pisa Altarpiece. 1426.	202
11–10	Detail of 11–9.	202
11–11	Arco del Sabat. Mosque. Cordova. Ninth or tenth century.	202
11–12	Gentile Bellini. *Turkish Man*. Drawing. 1479–81.	203
11–13	Gentile Bellini. *Turkish Woman*. Drawing. 1479–81.	203
11–14	Pisanello. *John VIII, Palaeologus. Emperor of Constantinople*. Made at Council of Ferrara, 1438.	204

11–15 Costanzo da Ferrara. *Sultan Mohamed II.*
1481. 204

11–16 Titian (once attributed). *Portrait of Sultan
Abdul Hamid I.* 1774–89. 205

11–17 Carpaccio. *St. George Killing the Dragon.*
1505. 205

11–18 Master of the Bruges Passion. *Ecce Homo.*
1500–10. 208

11–19 Detail of 11–18. 208

11–20 Jacques Callot. *Scenic Design for Il Solimano.*
Engraving. 1620. 208

11–21 Jacques Bellànge. *Oriental rider (left), Magus
(right).* Etching. ca. 1600. 209

11–22 Rembrandt van Rijn. *Oriental on Horseback.*
Drawing. 1625–6. 209

11–23 Rembrandt van Rijn. *Orientals in Turbans.*
Drawing. ca. 1637. 210

11–24 Nicoletto. *Turkish Family.* Engraving. ca.
1500. London Collection. 210

11–25 Vrancke van der Stoct. Unexplained subject.
ca. 1470. Docs. 1471, 1473. 212

11–26 Jan Lievens (attributed to Rembrandt). *Esther
Accusing Haman.* ca. 1620–30. 212

11–27 Moghul miniature. Schoenbrunn. 213

11–28 Moghul miniature. *Pious Conclave.* Shah
Jahan. Seventeenth century. 213

11–29 Rembrandt van Rijn. *Emperor Timur.*
Drawing. ca. 1655. 214

11–30 Rembrandt van Rijn. *Abraham Entertaining
Angels.* Etching. 1656. 214

11–31 Rembrandt van Rijn. *Indian Horseman.*
Drawing. 214

11–32 Jan van Eyck. *Man in Red Turban.* 1433. 216

11–33 Tiepolo. *Scherzo di Fantasia.* Etching. 216

11–34 William Hodges. *Cape Stephens, New
Zealand, with waterspout.* ca. 1776. 218

11–35 William Hodges. *Bay of Oaitepeha, Society
Islands.* ca. 1776. 218

11–36 Richard Wilson. *Ceyx and Alcyone.* 1768. 219

Foreword

Rudolf Wittkower's last lecture course before his retirement from the Department of Art History and Archaeology at Columbia University was devoted to a topic that had intrigued him since student days: the influence of Eastern art on the art and arts of the West. Over the years he collected a vast amount of material, parts of which he used for publications such as " 'Roc': An Eastern Prodigy in a Dutch Engraving" (1937); "Eagle and Serpent" (1938–9); "Marvels of the East: A Study in the History of Monsters" (1942); "Marco Polo and the Pictorial Tradition of the East" (1955); "East and West: The Problem of Cultural Exchange" (1966); "Neo-Classicism, Chinoiserie, and the Landscape Garden" (1969); "Piranesi and Eighteenth-Century Egyptomania" (1970); and "Hieroglyphics in the Early Renaissance" (1972, printed posthumously).

The first version of a comprehensive account of the links between Western and Eastern art was given in 1964 as a course of three public lectures at the University of California at Berkeley. This was so well received that the Department of Art proposed to publish it as a special volume in their series of *University of California Studies in the History of Art,* but my husband regretfully declined because he felt that much more

work had to be done before publication – work he hoped to do abroad during his sabbatical leave in 1968. But he fell ill and in June 1969 he wrote to a friend: "Five months of my sabbatical leave went to the dogs.... the summer of 1969 was my last semester 'on active service' and consequently immensely full. I gave a course... entitled 'Non-European Influences on European Art.' I had done this before, but wanted to give an immensely improved edition preliminary to writing it up in book form. Now, owing to the illness, I am still very far from this goal."

The Berkeley lectures have survived in his own words because it was my husband's habit to read public lectures from fully prepared typescripts. These and the accompanying slide lists are still on file. For the less official lectures to the graduate students at Columbia he used only notes. Knowing this, an attempt was made to record the talks on tapes, but this attempt had soon to be given up. The transcriptions were rather useless – partly because my husband liked to walk to and fro while talking so that many words were lost, partly because foreign names of persons and places were too often mistranscribed beyond recognition. Fortunately, however, four enthusiastic students had taken copious notes and these were of great value to Dr. Donald Reynolds, whose idea it was to compile and edit the present volume.

It is, of course, impossible to say how much and in which direction Rudolf Wittkower would have extended his research, nor is it possible to know which of the many sketched-out ideas he would have incorporated in the text and which he would have relegated to footnotes. The editor therefore decided not to annotate any references or statements but to preserve the character and, as far as possible, the flavor of these freely delivered lectures.

When Donald Reynolds first approached me with his plan, I welcomed the prospect that the work of so many years would not remain dispersed in often rather inaccessible journals or buried in unpublished lectures but be gathered in one comprehensive volume. When I saw his first draft I was greatly impressed by his assiduity, courage, and devotion in undertaking this intricate task. Professors Alfred Frazer and the late H. W. Janson who kindly read the typescript were unreservedly in favor of publishing it. I am grateful for their advice, but especially grateful to Donald Reynolds for producing a book that,

I hope and trust, will prove readable to an interested general public and stimulate scholars to take up the trend and elaborate the research where my husband had to leave it.

Margot Wittkower
New York

Preface

Rudolf Wittkower decried specialization, a conviction to which these lectures bear witness. His relentless investigation of the cultural interrelationships of East and West reveals, at once, the diversity and the universality of humanity's artistic expression from ancient to modern times.

Whereas disparate levels of artistic sophistication reflect different societies' cultural development at given times, the compatibility of Eastern and Western motifs, styles, and iconography, over time, demonstrates a creative faculty that is common to human expression.

As new links are being forged between East and West, these lectures, characteristic of so many of Rudolf Wittkower's studies, continue today to have far-reaching implications for scholars of various disciplines. Philosophers, for example, are now raising anew such questions as whether the human mind is indeed unique or whether there is a Western mind and an Eastern mind.

Professor Wittkower's remarks at the McEnerney Lectures in Berkeley on 2 March 1964 not only provide useful insight into his enchantment with the subject but also underscore his hope that through his lectures others would be con-

vinced of the value of the search for the artistic links between Eastern and Western civilizations:

> The theme of these lectures is immense. Some of you may have regarded and may regard my boldness as foolhardy – and I have no quarrel with them. I must confess that I have chosen my topic mainly because I have long been puzzled by it and I hope you will not think me ungracious and ungrateful if I seized the kind invitation extended to me by your great University as a splendid opportunity of verbalizing ideas which will still need a long period of gestation.
>
> Seen as a whole, the history of European art has been and still is insular or rather pen-insular (if we look upon Europe as a peninsula of the Asiatic landmass). It is true that in the last 60 or 70 years an ever growing number of scholarly investigations into the links between the arts of Europe and of non-European civilizations has appeared, but I would claim that rarely, if ever, has this problem been approached and discussed in its entirety. Nor can I do this satisfactorily in this series of lectures, although I hope to be able to convince you of the value of such an attempt.

The McEnerney Lectures were established with an endowment left to the University of California by Garrett William McEnerney, an attorney of international distinction and chairman of the University of California Board of Regents from 1937 to 1942. The lectures were begun in 1958 with Alistair Cooke's "The Pains and Pleasures of Anglo-American Understanding." Other lecturers included Dean Acheson, Gunnar Myrdal, and C. P. Snow.

It is timely that this volume is appearing now. Nineteen eighty-nine marks the twenty-fifth anniversary of Rudolf Wittkower's McEnerney Lectures and the twentieth anniversary of his more fully developed course on the same subject at Columbia University just before he retired. Last year was the sixty-fifth anniversary of Rudolf Wittkower's defense of his Ph.D. thesis, "The Painters of Verona (1480–1530)," at the University of Berlin, and of his marriage to Margot Holzmann, who became not only his wife but also his constant helpmate throughout his career and his coauthor of *Born under Saturn* (1963) and *The Divine Michelangelo* (1964).

But for the genius of Rudolf Wittkower, this publication would never have been possible. And without the faith, wisdom, and dedication of others, it would never have been produced. I am grateful to George Collins, Professor of Art History (retired) at Columbia University, who introduced me to Margot

Wittkower; to Rosemary Davidson, Editorial Director, Education, Cambridge University Press, whose interest in the manuscript led to its publication; and to editor Liz Maguire, Cambridge University Press, for her skillful and sensitive treatment of the manuscript at every step.

I am indebted to William Fouks, Frederick Hill, and Karen Rubinson, whose class notes were helpful to me in reconstructing Professor Wittkower's Columbia lectures. Theodore Feder and his staff at Art Resource and Columbia graduate students Rachel Bessent and Robert Carlucci assisted in the arduous task of locating and securing the illustrations.

An adequate acknowledgment of Margot Wittkower's role in this publication is impossible. But George Riches, chairman of Phaidon Press, allowed me to borrow an appropriate one from Rudolf Wittkower's 1955 Preface to *Gianlorenzo Bernini:*

> The book is the result of a lifetime's study of the subject and I do not wish to conclude the preface without mentioning that it is impossible for me to estimate how much I owe to the many clarifying discussions with my wife and to her constant vigilance.

<div style="text-align: right">

Donald Martin Reynolds
New York

</div>

ONE

Europe and the Near East I
MIGRATIONS AND
WAVES OF PENETRATION

In the course of these lectures, such terms as influences, migration, assimilation, translation, and convergence take on specific meaning, and it may be useful here, at the beginning, to point out the theoretical considerations behind their use. In discussing the impact of non-European civilizations on European art, there are primarily three different sets of problems that require analysis and solution.

The first, and perhaps most important, category concerns the migration of forms, designs, and styles. Of course, forms, designs, and styles do not migrate. People migrate and works of art, like other ware, may be transported across wide spaces. What I have loosely called "migration of forms" may in actual fact have resulted from the activity of foreign (that is, non-European) artisans on European soil or from the commercial trading of objects. Both are familiar occurrences, as the documented presence of great numbers of Syrians in Rome or of Persian and Arab craftsmen in Spain and Sicily demonstrates. Similarly, art objects from Asia Minor, for example, have been found in English hoards, and Persian and even Chinese objects were among the offerings in early Swedish tombs.

In the present context, it is more interesting to follow the

1

assimilation and adaptation of non-European import ware in Europe; this process went on throughout the entire history of Western art. The historian's task consists in trying to find the starting point and in analyzing, if possible, the steps by which such adaptation took place. At the end of this process there may be complete transformation, so much so that only modern methods of art historical research may reveal a non-European origin.

Thus, the study of the migration of forms, designs, and styles contains a triple challenge of ascending complexity: from the importation of non-European material, to its assimilation and adaptation, to its complete transformation. Although the broad view taken in this study prevents the presentation of coherent chains of test cases, the problems indicated here are constantly present. It should also be pointed out that the precisely defined schema employed to categorize these phenomena hardly does justice to the infinite possibilities that are encountered in reality. Three different cases of transformation may successfully illustrate this complexity.

Many Near Eastern designs were incorporated into Romanesque art, particularly Romanesque capitals (1–1), but they do not intrude upon the style as a foreign element. The use of a foreign element such as the oriental carpet in Jan van Eyck's *Madonna with Canon van der Paele* of 1436 (Bruges, 1–2) does not strike the viewer as strange. The cogency of the style overrules the strangeness of the foreign intruder. A work by Picasso of his African period (1–3) appears patently non-European in style, but the sophistication of the design turns the picture unmistakably into a European work.

In the first case (the Romanesque capital), the artist worked with an assimilated repertory of oriental types; in the second case (van Eyck's madonna), the artist prominently rendered a meticulous copy of a specific foreign object; in the third case (Picasso's painting), foreign principles of form and style constituted the basis for a highly personal interpretation. The three works, each in its own way, contribute to a vigorous, characteristically European tradition.

In my second category, which comprises the wide field of the migration of concepts and motifs, I combine religious, literary, and scientific currents with individual symbolic or iconological imagery, because in all such cases the problems are similar. Basically, these offer three possibilities of classifica-

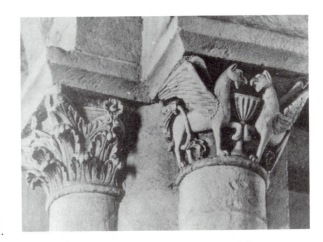

Figure 1-1. Capital with griffins. Puy-le-Dôme, Mozac. Twelfth century A.D. Austin/Art Resource.

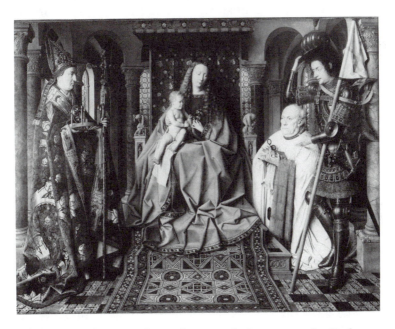

Figure 1-2. Jan van Eyck. *Madonna with Canon van der Paele.* A.D. 1436. Groeninge Museum, Bruges. Marburg/Art Resource.

tion. First, the content may survive or be revived while the visual expression undergoes a complete change. Babylonian astrology, for instance, was revived in Europe even though European astrological imagery hardly revealed the source from which it was ultimately derived. Similarly, a symbolic image such as the eagle and snake, which originated in the Near East, may retain its basic meaning (the fight of good and evil, 1–4), whereas its style may become completely divorced from its original source. Second, the visual formula may survive but its meaning may change: Examples include many themes of Christian iconography, whose original prototype has often passed through a phase of classical antique adaptation. Finally, concepts may survive or be revived, emptied of their original meaning. Thus my second category, the migration of concepts and motifs, may lead to three different results: The content may survive and the visual expression change; the visual formula may survive and the content change; and the visual formula may survive without any specific meaning.

My third category takes us away from style, form, design, and content. Non-European objects, plants, animals, and humans may be rendered in order to show life in faraway countries. The reasons for such renderings may be manifold. In any case, herbals, bestiaries, and romances, or encyclopedias and travelers' reports may offer a type of imagery that sets out to acquaint the beholder with the visual appearance of the non-European world. The focus here is on the unfamiliar, unknown, and strange. It is needless to emphasize that before the age of explorations the ideas formed of distant countries were based on a medley of colorful legends and traditions; weird notions that came from these sources prevailed even down to the eighteenth century. This category may be aptly called "the European image of non-European civilizations" and is uniquely important because it offers insight into the nature of European receptivity to this material.

Despite the complexity of non-European influences on European art, one point should be made quite clear: The impact of foreign civilizations never had the power to deprive Europe, after its consolidation, of its typically occidental mode of expression, a mode of expression that the Greeks created about twenty-five centuries ago. It is one of the miracles of the Western mind that so many and often discordant non-European influences were assimilated, and that in the long run they spurred

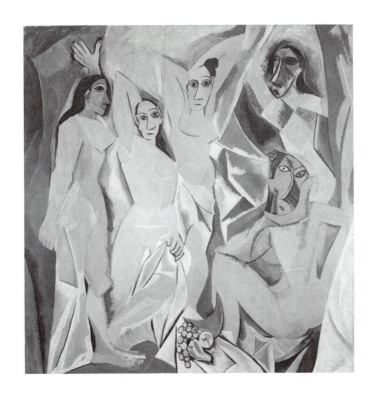

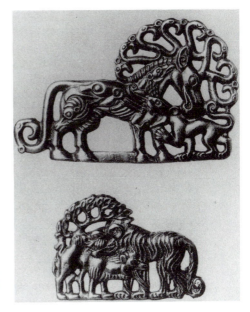

Figure 1-3. Picasso. *Les demoiselles d'Avignon*. 1907. Collection, Museum of Modern Art, New York. Acquired through the Lillie P. Bliss Bequest.

Figure 1-4. Cast gold ornamental plates from girdle clasps, Scythian. Seventh and sixth century B.C. Borovka.

original, typically Western creation rather than impeded it. In fact, the uninterrupted contact of Europe with non-European civilization helped to intensify the unbelievable variety of European art.

At least a word must be said here at the outset about two antagonistic theories – namely, that of the diffusion of ideas, concepts, techniques, and forms of art and that of independent, autonomous creation (independent invention). These diverse concepts have been hotly debated ever since Adolf Bastian* propounded the evolutionary thesis that similar cultural characteristics arise at a parallel phase in the development of different societies. Diffusionists and antidiffusionists are still at each other's throats over this question. In the heat of the discussion they are inclined to forget that for the high civilizations with literary traditions diffusionism has been developed into a universally accepted technique of research; in art historical controversies the degree and character of diffusion may be disputed but not the principle of diffusionism. Everything I say in these lectures is based on this premise. Nevertheless, a word of caution must be voiced. The test of diffusionism lies, of course, in the proof of the existence of historical roads of migration, transmission, and dissemination. But alert, critical judgment must be exercised at all times, even when ample historical material is available. Although Europe had lively contacts with China in the thirteenth and fourteenth centuries, it does not follow that everything vaguely Chinese in the European art of that period is the result of Chinese influence. Moreover, despite a wealth of historical information, the gaps in our knowledge are enormous and often, particularly in the early periods of the European history of art, hypothesis and probability have to serve in lieu of proof.

In these lectures, I am concerned only with part of the phenomenon of non-European influences on European art. My selection of the Near East, Egypt, China, and India as test cases, however, is not arbitrary. A map of Europe and Asia shows that large mountain ranges, going from east to west, divide these areas into a southern half with its rich geological formation and its direct access to the open sea, and a northern half with

*For a discussion of Bastian's ideas see R. H. Lowie. *The History of Ethnological Theory*. New York. 1937.

its wide, intercontinental, almost featureless plains that stretch from Siberia to northern Europe.

All the high civilizations of antiquity – China, India, Persia, Babylonia, Egypt, Greece, and Rome – lie in the southern belt. In contrast to the clearly marked character of each of these great urban civilizations, nomad or seminomad civilizations of comparative uniformity are found to inhabit the wide steppes of the northern belt. The fascinating history of what happened in these vast areas and how the art created there influenced the European heartland can only be hinted at in this survey. Nomad art was almost entirely confined to portable objects such as weapons, implements of daily use, and personal ornaments. The tribal cultures of the semibarbaric nations along – and later partly within – the northern and eastern borders of the Roman Empire (the Germanic tribes, the Celts, and the Scythians) showed a high degree of artistic ability, but their art was to a large extent, though not entirely, abstract and non-representational (1–4, 5). On the other hand, the art of all the old civilizations of the southern belt was representational and monumental and its focus was on humans and animals.

The ancient Near East, with which we will be mainly concerned in these first lectures, contributed at least three major and very specific features to the art of the high civilizations. The first is the near-realistic or near-organic representation of animals, composite beings, and monsters. To this "fantastic fauna" (to use Henri Frankfort's expression) belong the bulls with human heads, quadrupeds with enormous necks, winged men and winged bulls, horses, and lions, bird-footed and bird-headed monsters, and monsters with two bodies and one head (or vice-versa) (1–6, 7). Second, in spite of the realistic treatment of the surface, these animals had a skeletal structure that was rigidly ornamentalized, and their compositional arrangement, too, was subordinated to ornamental principles: Heraldic symmetry and the antithetical group are the rule rather than the exception. This is true for monumental Near Eastern art as well as for the cylinder seals in which the continuity of the style was preserved over thousands of years. Third, frieze compositions of animals and humans are arranged as endless sequences – precise repetitions that might be extended uninterrupted in both directions (1–8–10).

Frequently encountered also is the principle of expressing

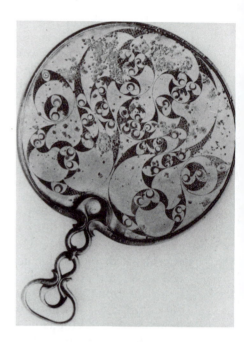

Figure 1-5. Mirror, Hiberno-Saxon. Eighth century A.D. British Museum, London.

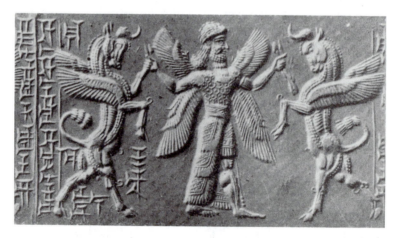

Figure 1-6. Cylinder seal of Nur-Adad with names of Hittite kings from Hattushash (modern Bogatzköy, Turkey), Assyrian. Hero taming winged bulls. Eighth to seventh century B.C. British Museum, London. Reproduced in Henri Frankfort, *Art and Architecture of the Ancient Orient,* 2nd rev. ed. Harmondsworth, 1958.

Figure 1-7. Cylinder seal (*left*) and impression, Akkadian. Nude bull man holding two lions and bearded hero holding two bulls. ca. 2500 B.C. British Museum, London. Reproduced in Eva Strommenger, *5,000 Years of the Art of Mesopotamia*. New York, 1964. See also Henri Frankfort, *Cylinder Seals*. London, 1939. Reprint, London, 1965.

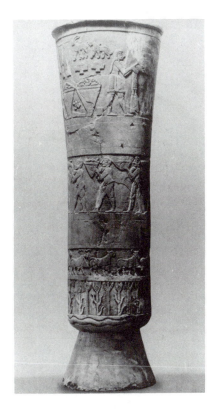

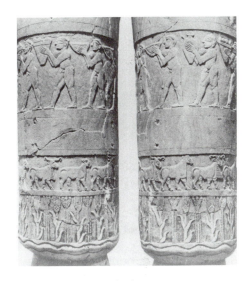

Figure 1-9. Detail of 1-8.

Figure 1-8. Alabaster vase, from Uruk. Scenes of temple offerings. 3000 B.C. Baghdad Museum. Reproduced in Strommenger, *5,000 Years of the Art of Mesopotamia*.

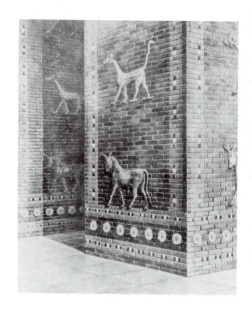

Figure 1-10. Ishtar Gate, from Babylon.
604–562 B.C. State Museum, Berlin (East).
Art Resource

importance by extravagant size, a principle also used by the
Egyptians: By giving god, hero, or king giant physical stature
and a permanency of expression, the individual's divine nature
was emphasized to every beholder. This device was generally
foreign to the Greeks. Their Olympian gods never exceed the
mortals in size. To represent spiritual greatness by physical
enlargement was incompatible with their humane conception
of life. Nor did the Greeks of the classical period accept the
representational formulas of the endless sequence and the an-
tithetical group. Classical Greek reliefs show a clearly defined
field and a harmoniously balanced composition (1–11). This
interpretation of enclosed space as well as the rhythmic equi-
librium of the figures became basic factors in all classical pe-
riods of Western art.

With such differentiations in mind, we may approach the
problem of Near Eastern influences on the West. As I see it
now, we can distinguish six major waves of penetration in the
course of two thousand years, intrusions upon the West that
grew in complexity and varied considerably in character.

The first wave of oriental art inundated the young Greek
art of the seventh century B.C. Oriental monsters and oriental
compositional principles made their entry then, reaching the

Greek mainland, as archaeologists have shown, from Assyria to Phoenicia and on by way of Cyprus and Crete. This wave swept past Greece to the Italian mainland and had a formative influence on the still mysterious Etruscan art. In contrast to Greece, it was Etruria where the Near Eastern repertory had a long lease on life (1–12–14).

During the many centuries of Greek and Roman ascendancy, the East was on the defensive. Despite the power of the Achaemenid Empire, which under Cyrus (559–530 B.C.) stretched from India to the Mediterranean, it was the West rather that gave to the East. And after Alexander's conquest of Persia in 330 B.C. the Hellenization of the East progressed rapidly. But when the Graeco-Roman veneer began to crack, ancient oriental habits of mind reasserted themselves. In the beginning of the third century A.D., there arose on the highland of Iran (in succession to the old Persian Empire) a great civilization with an enormous expansive power: the kingdom of the Sassanids. They broke the resistance of the Roman legions and at times their empire included (apart from their homeland, Iran) Armenia, Mesopotamia, parts of Asia Minor, Syria, and even Egypt. For more than three hundred years the Sassanians were the greatest power in the East. Sassanian art contains, of course, realistic Hellenic elements, but basically its roots lie far back in the ancient Near East (1–15).

The second period of oriental penetration resulted from Sassanian power and Roman weakness. The Roman Empire was wide open to the influence of Eastern mystery religions and in the third century Mithraism had spread far and wide and seemed to emerge as the victorious religion. Roman institutions became increasingly orientalized and Constantine's predecessor Diocletian, who ruled the eastern part of the divided Empire, remodeled it into a centralized bureaucracy along oriental lines. He even introduced the ceremonial Persian dress at his court.

Not unexpectedly, Roman art became receptive to oriental representational principles. Characteristics of the hieratic Eastern style appeared as early as the beginning of the second century A.D. in the Roman frontier town Dura-Europos on the Euphrates (1–16). They penetrated even to the center of the western empire and cannot be overlooked in such works as the Constantinian reliefs from the Arch of Constantine in Rome (1–17, 18).

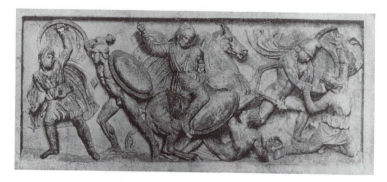

Figure 1-11. Alexander sarcophagus frieze. Battle, north side. 330–325 B.C. Archaeological Museum, Istanbul.

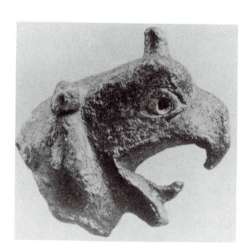

Figure 1-12. Bronze griffin head, from Susa. Sixth century B.C. Louvre, Paris. Reproduced in Ulf Jantzen, *Griechische Greifenkessel*. Berlin, 1955.

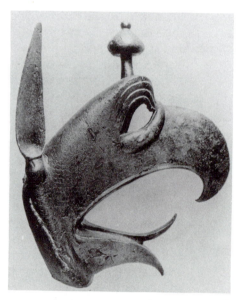

Figure 1-13. Bronze griffin head decorating a cauldron, Etruscan. ca. 650 B.C. Archaeological Museum, Olympia. Reproduced in Jantzen, *Griechische Greifenkessel*.

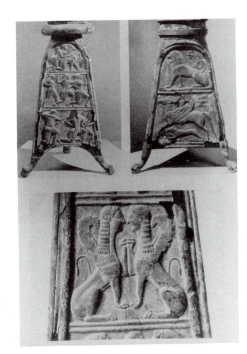

Figure 1-14. Bronze vessel support with sphinxes and Bellerophon riding Pegasus, Etruscan. Mid-sixth century B.C. Museo Municipale, Tarquinia.

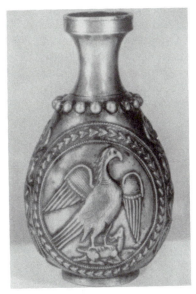

Figure 1-15. Silver vase, Sassanian. Eagle killing faun. Sixth to eighth century A.D. Hermitage, Leningrad.

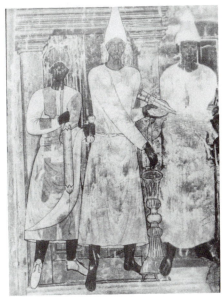

Figure 1-16. Priests, tribune ceremonial fresco, Temple of Baal. Second century A.D. From Dura-Europos. National Museum, Damascus.

The oriental contrast of scale between the divine ruler and his people made its entry into Roman art, as well. The famous colossal head of Constantine (1–19), the most important surviving part of a giant figure, also shows the stereotyped features and the remoteness of expression of oriental royal images. But although in such works the concept and, to a certain extent, even the style may be called oriental, the language of forms – the vocabulary – remains Roman and occidental.

During the centuries of the barbarian invasions, the Latin West sank into chaos and monumental art was entirely wiped out. Stability and tradition were vested in the Greek East. But though Byzantium remained the custodian of Hellenistic culture, the character of the rising empire was largely formed by its contact with the East. Runciman has rightly said that the history of the "Byzantine Empire is the history of the infiltration of Oriental ideas to tinge the Graeco-Roman traditions." The new synthesis was immensely effective in the arts. Oriental concepts and formal devices embodied in Byzantine art filtered through to the West along many roads of transmission, and we may therefore regard Orientalism in Byzantine transformation as the third wave of penetration. From the mid-sixth century on it left its imprint on the Byzantine dominions in Italy, as the procession of female saints in S. Apollinare Nuovo at Ravenna so effectively illustrates (1–20). Here is the unlimited sequence, the stylized uniformity of gesture, the ghostlike gaze – all elements that belong to the repertory of Near Eastern art.

I have reasons to separate from this early Byzantine penetration a later and perhaps even more important one. But before turning to it, I would like to pay fleeting attention to another wave of Orientalism – the fourth – that reached the West also during these early centuries of our era by a roundabout route of migration, and in a form that hardly reveals its origin. Scythian tribes, living in the southern Russian steppes and along the borders of the Black Sea, had penetrated into Iran from the north and carried away from there a distinct animal style in which fighting animals play a dominant part. The Scyths transformed the semirealistic heraldic oriental animal style into one of extreme decorative ornamentation, a style that maintained its expressive energy for no less than fifteen hundred years in spite of many important modifications and that can be found over the whole north of Asia and Europe

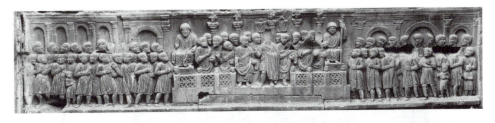

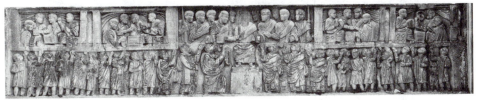

Figures 1-17. (top), 1-18 (bottom) Arch of Constantine. Reliefs, north side. Rome. A.D. 312–5. Anderson/Art Resource.

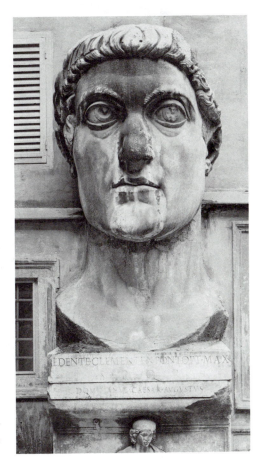

Figure 1-19. Colossal head of Constantine. ca. A.D. 330 Capitoline Museum, Rome. Alinari/Art Resource.

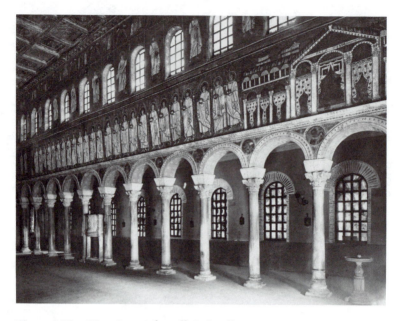

Figure 1-20. Mosaic, north wall. S. Apollinare Nuovo, Ravenna. Sixth century A.D. Alinari/Art Resource.

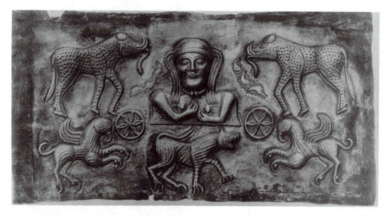

Figure 1-21. Celtic silver cauldron, from Gundestrup, Denmark. 80–50 B.C. National Museum, Copenhagen.

from the Pacific to Ireland. At a relatively early date – between the sixth and the fourth centuries B.C. – Scythian nomad civilization spread along the Danube upward to eastern Germany and influenced Celtic production, as the silver cauldron found at Gundestrup (Denmark) but produced in the middle Danube region shows (1–21). This dynamic animal style was particularly effective in Ireland in the seventh and eighth centuries and spread from there across the Continent.

To the uninitiate, it would seem almost inconceivable that both the row of figures in S. Apollinare and the decorative animal design of the Book of Durrow should ultimately have a similar Near Eastern pedigree. The secret is the substantial transformation to which Near Eastern material was subjected on the roads of transmission: In Byzantium the transforming agent was Hellenism; with the nomads the transforming agent was their innate gift for abstract patterning.

TWO

Europe and the Near East II

WAVES OF PENETRATION

What I would like to call the fifth wave of eastern penetration cannot be easily separated from the third; for about seven hundred years (between the fifth and the twelfth centuries) the West lay wide open to influences from the East along the southern trade route. Yet there is good reason for suggesting a caesura within this fluid situation, because the maps of Europe and the East changed beyond recognition in the course of the eighth century. On the one hand Charlemagne united Western Christendom in a great imperial state, thereby consolidating a development inaugurated by his Frankish predecessors; on the other hand, Islam swiftly rose to the position of a world power that had the potential to engulf the entire Western world.

Regarded as the divinely appointed successor to the Roman emperors, Charlemagne was oriented toward Rome and aspired to the resurrection of its fallen greatness. And so he inaugurated the first of succeeding waves of classical Renascences (to use Panofsky's term), and for the next centuries we have to see the history of art as an alternating dialectic of classical revivals and nonclassical trends (which do not necessarily coincide with non-European penetrations).

Charlemagne's impressive experiment in national con-

solidation eventually led to the establishment of the European nations as we know them today, but despite this development the Western world remained for centuries an open society, ready to absorb what the Arabs had to offer. After the Prophet's death in 632 the Arab tribes burst forth from the interior of their peninsula with irresistible force and in a very short time overran not only all the large territories from Persia and India to Egypt, but also drove on through North Africa to Spain, the greater part of which came under Islamic domination as early as the middle of the eighth century. During the following centuries, particularly in the tenth, the Caliphate of Cordova was the most flourishing cultural center in the whole of Europe.

Now, Islam created an art of its own, based on a mixture of folk elements with those of the high civilizations across which the Arab conquest had swept. But it is important to realize that the Islamic world was soon dominated by Persian culture, and Persian literature and art experienced an extraordinary expansion. This development came into its own after the Eastern Caliphate had been transferred from Damascus in Syria to Baghdad on the Tigris in Mesopotamia, a city founded in 752. Persian artisans and craftsmen were called upon to work for Islamic rulers from Samarkand to Gibraltar and by the tenth century great numbers of Persians were settling in Spain.

This, then, is clearly a direct road of transmission. Similarly, Sicily was mostly in Arab hands from the ninth century, and even after the Norman conquest it remained a center of Saracen culture from which oriental influences reached the mainland. Moreover, the Mediterranean always was an inland waterway that pulled peoples together rather than kept them apart. Although its shores were held by three deeply divided parties – Catholic, Orthodox, and Islamic – trade along ancient and new routes flourished. At an early period the old ports of Amalfi, Salerno, and Naples were wide open to oriental commerce, and so was Marseilles. Venice's oriental trade began in the tenth century and Genoa's in the eleventh. These great seafaring city-states followed a most liberal commercial policy and preferred fighting each other for eastern markets to combining forces against their common enemy. Genoa, for instance, concluded a treaty with Sultan Saladin of Egypt in 1177, and in the thirteenth century Venetian interests were entirely cosmopolitan: They extended by way of Constantinople to the shores of the Black Sea, to Armenia, and beyond. Finally, the

Crusaders became an important link between East and West; in the eleventh and twelfth centuries they returned home, laden with the spoils of the Orient.

The wares that reached the West in this way were often small objects: ivories, silver, jewels, ornaments, intaglios, and, above all, textiles. Silk has always had an enormous attraction in the West and the silk trade with China had been a flourishing one since the days of Alexander's empire. The Chinese who had discovered the usefulness of the silkworm in the immemorial past treated their knowledge as a closely guarded secret. But Iran, which had acted as a transit country for the trade in raw and woven silks from Roman times, started a rival production. After the great Sassanian kings developed the industry, the silk fabrics that reached Byzantium and the West in the sixth century and still in the seventh were probably of Sassanian origin. But in the sixth century, Byzantium managed to import silkworms and thereby to break the Sassanian monopoly. It took a few more centuries for silk weaving to become established further west; in the eleventh century it was introduced into Greece and Sicily, and in the twelfth century silk fabrics were locally produced in Spain. Oriental and Byzantine silk fabrics were immensely popular in the West. By the eighth century Rome had become an important distribution center for silk fabrics, which even reached the north of England from there.

It is a remarkable fact that many of the Sassanian and post-Sassanian designs migrated with the silk industry to the newly established centers and survived stubbornly for hundreds of years. Behind these Sassanian designs there are, of course, often types and motifs of Mesopotamian origin (2–1, 2). The imperial manufacturing operation at Constantinople was the most important center from which these designs were disseminated throughout the West.

The part played by Christian Syria, a province of the Byzantine Empire, as a link between East and West should also be mentioned. Syrian merchants and monks appeared in large numbers at an early date in Italy, France, and Germany. Of the ten popes between 685 and 741 no less than five were Syrians, and it has long been recognized that Syrian Christianity made an extensive contribution to the Christian pictorial cycles that reached the West. Of course, much of this material stemmed from the Hellenistic tradition. But there seem to have been

Figure 2-1. Shroud of St. Victor, detail, Byzantine. Eighth century. Cathedral, Sens. Reproduced in F. Volbach and G. Duthuit, *Art Byzantin.* Paris, 1934.

Figure 2-2. Shroud of St. Victor. Detail.

schools of miniature painters, particularly between the seventh and tenth centuries (after Syria had become predominantly Islamic), in which oriental traditions reasserted themselves. Some of the orientalizing imagery of Mozarabic manuscripts – that is, of Christian manuscripts produced in Moslem Spain – may have been derived from those Syrian schools. This would explain such Persian-style figures as the giant Nebuchadnezzar with little Daniel beside him (2–3) in a late eleventh-century Beatus manuscript, as well as such an initial in a tenth-century Madrid commentary to the Psalms in which an antithetical group of gazelles with bodies crossed and heads turned to each other, forming the letter *A*, appears to nibble at a stylized Tree of Life (2–4), a motif well known to us from Babylonian cylinder seals.

Textiles and miniatures, and possibly other small objects, furnished the models for the most interesting and most puz-

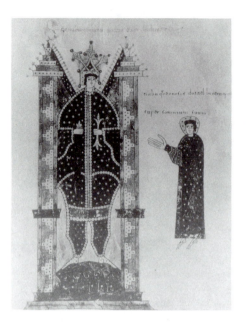

Figure 2-3. Daniel and Nebuchadnezzar. 1073–1109. From *Beatus Apocalypse* (Spain, ca. 775). British Museum, London (ms. 11695, fol. 232v).

Figure 2-4. Initial "A." Crossed gazelles, plant, dogs. 980. From *Expositio Psalmorum* (Commentary to Psalms). R. Accad. de la Historia, Madrid (8 fol. 124v).

zling oriental invasion of this period. From the ninth century onward and increasingly in the tenth, eleventh, and twelfth centuries, the whole animal kingdom – real and imaginary – was let loose in the churches of western Europe. Sculptured animals cover facades, tympanums, portals and capitals, rood screens and pulpits. Examples appear early in the heel of Italy and in Spain, but the center of this fashion lies in the west and south of France and in Lombardy, and to a lesser extent in Germany and England.

A considerable part (though by no means all) of this repertory of Romanesque animals shows, as far as motifs and designs go, close points of contact with Babylonian and even Sumerian art. The art of the Euphrates valley of the fourth and third millennium B.C. – the antithetical group, the heraldic animals, addorsed griffins, fighting and interlaced animals, the animal-taming hero, oriental monsters of various kinds, and

much more – reappears in the Romanesque animal style (2–5–7). This phenomenon has, of course, aroused the curiosity of scholars in the past and all further research is particularly indebted to the works by E. Mâle, Bernheimer, and Baltrušaitis. The roads of transmission have already been indicated: Sassanian and post-Sassanian art revived the ancient Near Eastern repertory and the old motifs traveled either with Mohammedan Persians directly to Sicily and Spain or wandered west from Byzantium and Syria as well as from Egypt, where they had found a new home.

The fact cannot but be accepted that the Romanesque animal style translated flat textiles and illuminations into sculptural form and unknowingly returned to the sculptured fauna of old, the existence of which was, of course, completely unknown to the Romanesque masons. It remains to show how Romanesque sculptors overcame the handicap of the flat models that they used before their repertory was established, and how a style sui generis emerged in the course of the twelfth century, a style that, though tied to heraldic and antithetical schemata, is marked by a sculptural forcefulness and a directness of characterization that belong to the enduring elements of the Graeco-Roman tradition (2–8).

A few South Italian slabs from Sorrento with heraldic oriental griffins, dating from between the tenth and the late eleventh centuries (2–9), show how the animals progressively lose their flat and decorative quality. The same motif has acquired a three-dimensional compactness in a twelfth-century capital from Mozac (Puy le Dome, 2–10). These griffins hardly reveal their derivation from oriental prototypes, for their bodies have no longer the characteristic ornamentation on legs and joints.

Rampant antithetical griffins of oriental derivation are common in silk fabrics: for example, a Hispanic-Islamic work of the twelfth century (2–11); a twelfth-century piece from the bronze door of the cathedral at Ravello in southern Italy (2–12); and a Spanish capital from S. Martin at Fuentidueña (2–13), also of the twelfth century. A capital from Barcelona shows how intelligently the motif has been adjusted to the requirement of the capital form (2–14). By carrying the motif over the corner, a new richness of design was introduced, for here are two interrelated but contrasting antithetical groups. Because this arrangement is unknown in the Near East, it reveals the

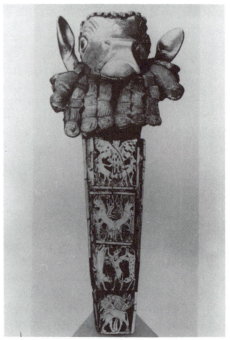

Figure 2-5. Soundbox of harp with shell inlay, from Ur. Hero protecting bulls. ca. 2600 B.C. University of Pennsylvania Museum, Philadelphia. Reproduced in Frankfort, *Art and Architecture of the Ancient Orient*.

Figure 2-6. Detail of 2-5.

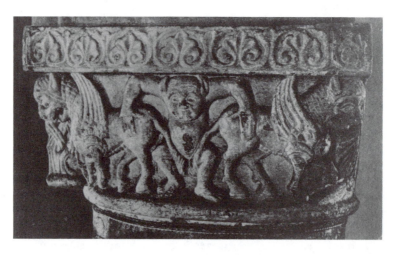

Figure 2-7. Capital with devil between winged lions with bulls' feet. San Michele, Pavia. ca. 1120. Reproduced in Richard Bernheimer, *Romanische Tierplastik und die Urspruenge ihrer Motive*. Munich, 1931.

Figure 2-8 (left). Trumeau with inter-laced animals. S. Pierre, Moissac. 1120–5. Austin/Art Resource.

Figure 2-9 (right). Ornamental slab. Cathedral of Sorrento. Tenth century.

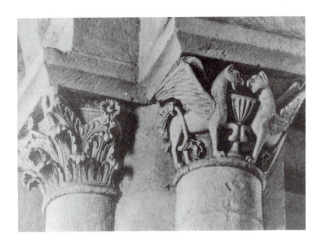

Figure 2-10. Capital with griffins. Puy-le-Dôme, Mo-zac. Twelfth century. Aus-tin/Art Resource.

specific Romanesque sense for the intricate ornamentalization of the entire design.

Rampant griffins and panthers appear on the stockings that were part of the funeral attire of Pope Clement II who was

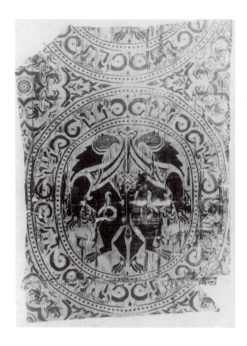

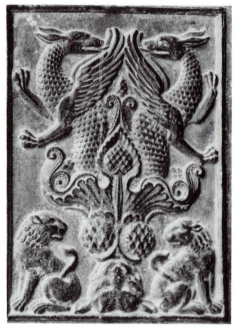

Figure 2-11. Silk with griffin pattern, Hispano-Islamic. Twelfth century. Metropolitan Museum of Art, New York.

Figure 2-12. Barisanus of Trani. Bronze door, detail. ca. 1179. Cathedral at Ravello. Alinari/Art Resource.

buried in 1047 in the cathedral of Bamberg (2–15). The stockings and the other pontifical robes were woven in Constantinople. A mid-thirteenth-century Hispano-Islamic antependium in Hamburg (until recently believed to have been woven in Regensburg) shows the same motif (2–16). This motif was also adapted to the form of a capital in the church of Notre Dame at Poitiers (2–17), where the lions across the corner have one head and two bodies, an old oriental device.

Where the means of illustrating the links in the chain of transmission no longer exist, they may be postulated by analogy to examples with more complete documentation. Thus, the two sphinxes of a capital in Arles (2–18) have a Near Eastern rather than an Egyptian pedigree, for they have bovine bodies just as the custodians of the gates of Assyrian and Persian palaces. To the same tradition belongs a capital from Chateauneuf-sur-Charente where once again one head crowns two bodies (2–19). But the heads have now acquired, as it were, a

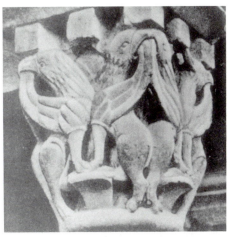

Figure 2-13. Capital with griffins. S. Martin, *Fuentidueña.* Twelfth century. Cloisters, New York.

Figure 2-14. Griffin capital, Romanesque. S. Cugat del Vallès, Barcelona. Reproduced in Bernheimer, *Romanische Tierplastik.* See also Jurgis Baltrušaitis, *Les Chapiteaux de Sant Cugat del Vallès* ... Paris, 1931.

speaking likeness. The spectator now senses the freshness of individual observation that opened the way to the Gothic style. With its rise, the Romanesque love for patterned heraldic designs had seen its day.

These few examples are meant to prove a point, not to give an idea of the richness of the Romanesque animal style. If it must be agreed that this style received vital impulses from the Near East, it must also be admitted that there is no link between the meaning of the oriental and the Romanesque fauna, a point that will be touched upon in my next lecture.

I must forgo discussing the controversial question as to what extent salient features of Romanesque architecture were derived from the East and especially from Persia, such as the barrel-vaulted nave, the horseshoe arch, the vertical division into bays by means of pilaster strips, blind arcades and blind arches, and the sculptured tympanum. Whatever the answer may be, all these elements were subjected by the Western architects to a new, mathematically lucid conception of space and mass – in fact, to a coherent architectural system, the first

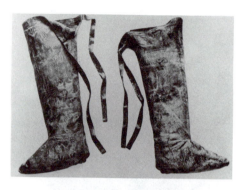

Figure 2-15. Papal stockings of Clement II (d. 1047), from Constantinople. Before 1047. Cathedral of Bamburg, Germany. Reproduced in *Sakrale Gewaender des Mittelalters: Ausstellung im Bayerischen National Museum, München. 8 Juli bis 25 Sept. 1955.* Munich, 1955.

Figure 2-16. Silk and linen antependium, Islamo-Hispanic. Mid-thirteenth century. Hamburg. Reproduced in *Sakrale Gewaender des Mittelalters.*

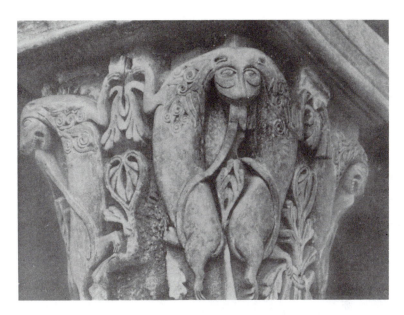

Figure 2-17. Choir capital, probably from St. Hilaire in Poitou. 1044–9. Poitiers Museum.

Figure 2-18. Capital, Romanesque. Sphinxes with bovine bodies. Musée Lapidaire, Arles.

Figure 2-19. Capital, Romanesque. One head crowning two bodies.
Chateauneuf-sur-Charente. Reproduced in Bernheimer, *Romanische
Tierplastik*. Austin/Art Resource.

Western architectural system with a unified and consistent
treatment of wall and vault.

And yet, the interior of Romanesque churches was much
more oriental in appearance than is realized today. Roman-
esque churches did not present the large, bare spaces to which
spectators are accustomed. On the contrary, many separate
units were created by the use of textiles that were hung be-
tween the columns, around the altar, and along the clerestory.
About 1150 the great Abbot Suger, – under whom St. Denis,
the first Gothic church, was built – described that the earlier
church had "treasures of purest gold and silver and hung on its
walls, columns, and arches, tapestries woven of gold and richly
adorned with a variety of pearls." It has already been demon-
strated that the trade with Byzantium and the Orient and later
orientalizing home production catered to these needs.

I have stressed in this discussion the inspiration coming
from the Iranian highland, the heir to the civilization of the
Euphrates valley. Much more might be said about Persia's re-
generating influence on Europe. It may be useful to mention,

Figure 2-20. Andalo di Negro. *Introductio ad Judicia Astrologiae.*
Jupiter (Zeus). Fourteenth century. British Museum, London (ms.
23770 fol. 31v).

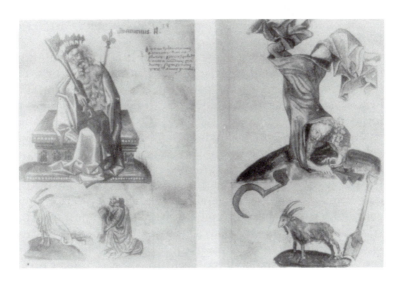

Figure 2-21. Albumasar. *Introductio in Astrologiam.* Saturn rising
and setting. Fourteenth century. Bibliothèque Nationale, Paris (ms.
7331, fol 6v).

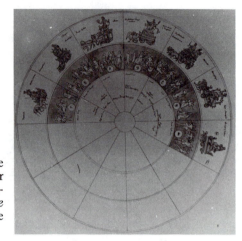

Figure 2-22. Palazzo Schifanoia. Scheme of arrangement of fresco cycle painted for Borso d'Este. 1467–70. Ferrara. Reproductions published in Paolo d'Ancona, *The Schifanoia Months at Ferrara.* Edizione del Milione, 1954 or 1955.

at least, that through its new lustre technique Persia revitalized the southern European ceramic industry. Moreover, the popular lustre faience produced in Spain from the tenth century onward was made by Persians or imitated from their models. From Spain the technique traveled to Italy where it found a home, as late as the sixteenth century, in the celebrated potteries of Deruta and Gubbio.

Nevertheless, by the end of the twelfth or the beginning of the thirteenth century, the massive intrusion of the Near East upon European art had come more or less to an end. But just when the Near East had ceased to be a formative power for the artistic language of the West, it made a conquest of an entirely different kind, which I would call the sixth and last penetration. Babylonian astrology entered the European consciousness. Astrology had gained a firm foothold in the Hellenistic world and in imperial Rome, but its fatalism and determinism were not acceptable to Christianity. Islam, however, fully embraced the fatalistic belief in the power of the stars and at the time of Islam's cultural predominance, astrological theory and practice were accepted by the West. From the thirteenth to the sixteenth centuries the astrological tide grew rapidly, and astrology acquired the status of an all-embracing science. It was taught at the universities of Padua, Bologna, and Paris, and the great Renaissance pope, Leo X, instituted a chair for astrology at the university of Rome.

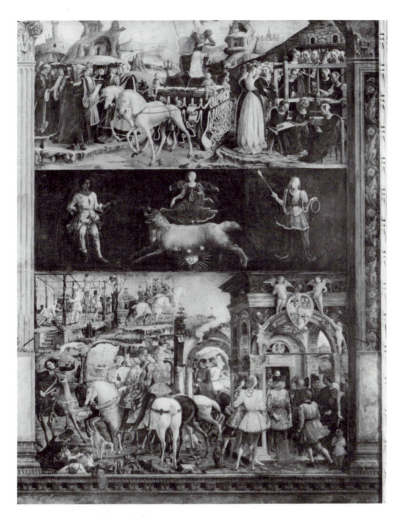

Figure 2-23. Fresco cycle, Palazzo Schifanoia. March. The Triumph of Minerva. Aries and figuration for the second decade. Reproduced in d'Ancona, *The Schifanoia Months at Ferrara*. Alinari/Art Resource.

While astronomical manuscripts down to the eleventh century are firmly rooted in the Western, Graeco-Roman tradition, the imagery of astrological manuscripts after this period shows that the Greek celestial sphere was orientalized under Arab influence (2–20, 21). But in the astrological cycles of the Renaissance, no formal trace remains of the East. Though in a

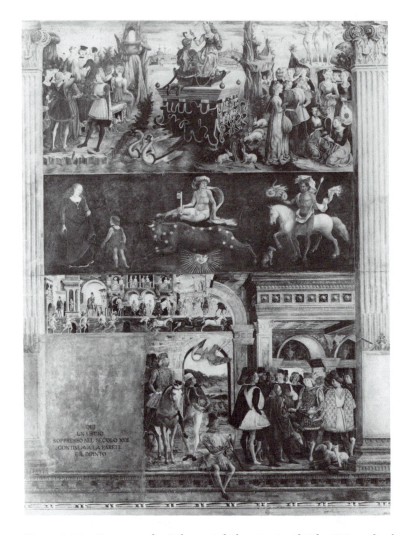

Figure 2-24. Fresco cycle, Palazzo Schifanoia. April. The Triumph of
Venus. Taurus and figuration for the second decade. Reproduced in
d'Ancona, *The Schifanoia Months at Ferrara.* Alinari/Art Resource.

fresco cycle like that painted for Borso d'Este in the Palazzo
Schifanoia at Ferrara between 1467 and 1470, the formal lan-
guage is entirely that of the Italian Renaissance, the astrological
conception that gave rise to these frescoes is of Persian-Egyp-
tian derivation (2–22–24). In a brilliant and revolutionary paper,
Aby Warburg showed, more than sixty years ago, how this

ancient astrological material reached Renaissance Italy by way of Arab sources that were translated in Spain into Hebrew and from Hebrew into Latin.

Man only responds to precedent when the world in which he lives is ripe for it. This statement is neither revealing nor particularly helpful; and yet, in investigating historical situations a positivistic analysis of cause and effect is more often misleading than explanatory. I would be prepared to heap argument upon argument in order to prove that there is historical necessity in the events here under review – namely, that the early Middle Ages could catch up with the formal typology of the Near East but not with its meaning, whereas the later Middle Ages and the Renaissance had to submit to the letter and the spirit of Near Eastern determinism but had hardly any use for oriental expressive formulas. But when all is said and done, would we have solved the ultimate riddles embedded in historical processes?

THREE

Egypt and Europe

Whether the Near East or Egypt had a greater effect on Europe is difficult to decide. Yet one thing is certain: The Egyptian influence was more sustained than the Near Eastern, lasting well into the nineteenth century. Historians underestimate that influence on European thought, whereas in many respects the Egyptian impact is as important as the classical tradition in its formative influence.

The impact of Egypt starts very early with many Greeks traveling to Egypt and bringing back various philosophic and scientific ideas that were formative to Greek thought. Herodotus, for example, went to Egypt, apparently as a tourist. Greeks used to go into that strange country of wonders and marvels and admire the great pyramids, obelisks, and sphinxes, and some Greek tourists, as uneducated as modern tourists, scribbled their names on monuments and thereby left a record of their visits.

The earliest phase of Egyptian influence can be summarized briefly. Like the Near East, Egypt had a formative influence on early Greek art, but while the Near East may be regarded as the godparent of Greek representational fauna, Egypt helped to create the conception of the Greek human

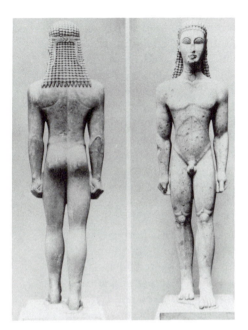

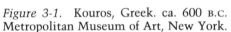

Figure 3-1. Kouros, Greek. ca. 600 B.C. Metropolitan Museum of Art, New York.

Figure 3-2. Mycerinus and his queen, Egyptian. ca. 2470 B.C. Museum of Fine Arts, Boston.

figure. This is fundamental and a comparison of Mycerinus and his queen (ca. 2470 B.C.) in Boston's Museum of Fine Arts with the Metropolitan Museum of Art's kouros of about 600 B.C. (3–1, 2) underscores this considerable influence. After the sixth century B.C., however, Greek art developed independently of Egypt for centuries, even though the connection with Egypt remained constant.

The renewed contact that came about after Alexander the Great had conquered Egypt resulted in the Hellenization of Egypt's upper social strata, which populated mainly the big cities – in particular, Alexandria. These societies were somewhat divorced from the indigenous population and therefore the Hellenization of Egypt was confined, for the most part, to the larger centers of population.

Nonetheless, the consequences of this Hellenization for

the history of the Western world were immeasurable. As early as the third century B.C., the intellectual center of the Hellenic world shifted from Athens to Alexandria. Alexandria became the guardian of Greek civilization and remained so for centuries, until the fall of the Roman Empire. Alexandria had the best stocked library in antiquity, and the tabulation of knowledge and the development of science flourished there to a degree never known before in human history. However, next to Greek rationalism there existed another trend: Alexandria was the most international city of antiquity and the meeting place of East and West. This was the soil on which Eastern mystery religions, mystical philosophical thought, and esoteric syncretism thrived and where allegory, alchemy, and astrology prospered. Some of these aspects will be considered more fully in subsequent lectures.

Rome's interest in matters Egyptian dates largely from the late first century B.C. After the Battle of Actium in 31 B.C., Egypt became part of the empire. Among the marvels that the Romans found in that ancient country of mysterious wisdom were three that aroused their immediate interest and admiration: sphinxes, obelisks, and pyramids. Sphinxes and obelisks were removable, but pyramids defeated even the engineering skill of the Romans. Still, they could be copied, and pyramids soon became a fashionable form for Roman tombs. That of Cestius (3–3) erected in 12 B.C. survives to this day. A second, similar pyramid near the Vatican was destroyed in the early sixteenth century.

Original sphinxes and obelisks, however, were shipped to Rome – an almost unbelievable feat when it is remembered that the largest of these granite shafts weighed many hundred tons. These spoils must have meant more to the Romans than victors' trophies. Augustus himself, the conqueror of Egypt, had at least six obelisks brought to Rome. Two of them were placed at his mausoleum. This alone underscores the funerary connotations the Egyptian needle had for the Romans. Eventually, Rome had more than forty-two obelisks, twelve of which survive; the last and the tallest of all was shipped over by Emperor Constantius in 357. It now stands in the Piazza of S. Giovanni in Laterano (3–4). This enormous obelisk itself (without the top, which was put on when it was placed there) was about one hundred feet tall.

When the first obelisks reached Rome, the cult of Isis and

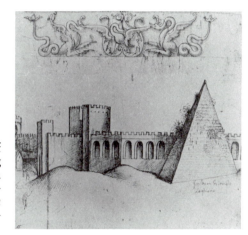

Figure 3-3. Pyramid of Cestius. Gate of Ostiensis. Rome. Erected 12 B.C. Drawing from the School of Ghirlandaoi. From *Codex Escurialensis.* Reproduced in Hermann Egger, *Codex Escurialensis: Ein Skizzzenbuch aus der Werkstatt Domenico Ghirlandaios.* 2 vols. Vienna, 1906.

Figure 3-4. Obelisk, Egyptian. Erected 1588 in Piazza di S. Giovanni in Laterano, Rome. Transported by Emperor Constantius A.D. 357. Art Resource.

Figure 3-5. Fresco, Pompeii. Zeus-Io-Argos legend.

Serapis had long gained a firm foothold in Italy. Numerous references to the Isis cult are found in painting of the period, especially in the frescoes at Pompeii. Of special interest in this respect are the panels that portray the Zeus–Io–Argos legend in which Io, loved by Zeus, is changed into a cow by Argos, Zeus's jealous wife (3–5). The cult of Isis spread in the beginning of the Empire and a large Isis temple was built in the very center of Rome by Caligula in A.D. 38 and an even larger one by Caracalla in A.D. 215 on the Quirinale. Remains of Caracalla's temple to Isis are still standing.

The Romans' rising interest in the Egyptian mystery religion was accompanied by their heightened taste for Egyptian art. Under Hadrian, a particular devotee of Isis, hieratic Egyptian-style products were especially fashionable. Hadrian's villa built near Tivoli is an extraordinary expression of his interest. The mural paintings have disappeared, but the structure is still standing. In front of the villa there is a canal, which is fashioned after a canal that existed in the city of Canopus, a place not far from Alexandria that held great appeal to pilgrims as well as vacationers. A temple there, much honored and famed for its healing powers, attracted great multitudes of pilgrims who went there from Alexandria by means of the canal (which came from a branch of the Nile).

Several famous murals demonstrate the Romans' interest in the local atmosphere of the Nile and the penetrating influence that the Nile had on the Romans' view of landscape – for example, the familiar Nile landscape from Pompeii in the Museo Nazionale at Naples and the equally well-known Nile landscape from Palestrina. The great temple area in Palestrina was reconstructed in the sixteenth century. A revised layout of the entire area has been developed based on excavations since World War II. This will be discussed further in a subsequent lecture. The temple architecture and animal forms are reminiscent of Egyptian work, and the mural figures portray people of Egypt at work and at leisure. There is also a kind of caricature of the Nile landscape. For example, in one panel an enormous crocodile threatens a man, and in another pygmies catch a crocodile in amusing fashion. This shows, among other things, that in the atmosphere of Pompeii, Egypt was not only the land of mystery but the subject for amusement and caricature.

The Egyptian vogue in Rome came to an end in the third century. Of course, it is possible to find some material later, and in fact an obelisk was transported to Rome in the middle of the fourth century, but by the third century the popularity of the Persian Mithras cult had eclipsed the appeal of Egyptian religion.

The next phase of Egyptian penetration would require a lengthy exposition, but here it will be sufficient simply to mention that after the Christianization of Egypt the Coptic Church in Upper Egypt started the monastic movement and consequently the relations between Egypt and the West became very close. To what extent Coptic art must be regarded as disembodied Hellenistic art or as a resurgence of the native oriental tradition has to remain undecided; the debate on the extent that Coptic art may have migrated with the monastic movement to the West and thus have influenced Merovingian art must also continue. But a few observations are in order concerning the *Physiologus*, that strange collection of moralized and allegorized animal stories that was probably compiled in Egypt in the second century A.D.

Many traditions – Greek, oriental, Egyptian – were here united and those unfamiliar with this kind of literary production may find the work weird and abstruse. Fifteen hundred years ago people thought otherwise. E. P. Evans, the author of a work on animal symbolism, rightly says that "perhaps no

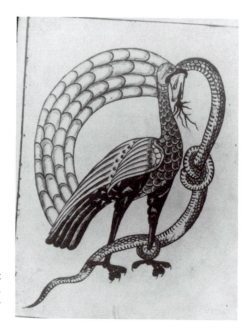

Figure 3-6. Bird killing a snake (Christ overcoming Satan). Eleventh century. From *Beatus Apocalypse.* John Rylands Library, Manchester.

book except the Bible, has ever been so widely diffused among so many people and for so many centuries as the *Physiologus.*" It was translated into every conceivable language, including Icelandic, and from the twelfth century onward it got a new lease on life through the bestiaries, the repositories of medieval zoological knowledge.

It is useful to consider at least one example of the intrusion of *Physiologus* material into Western imagery. In some of the tenth- and eleventh-century illustrations of Beatus's commentary on the Apocalypse, written in Spain in about 775, there is a picture of a large bird killing a snake (3–6). To deceive the enemy, so the text relates, the bird covers himself with dirt, which he throws off at the moment of attack. The dirt is indicated in the picture by an arched design in blue color above the bird. The whole is a pictorial adumbration of Christ who (according to the text) girded himself with human weakness and enveloped himself with the dirt of our flesh to fight Satan whom he extinguished, as if with a strong beak, through the word of his mouth. This same story with precisely the same allegorical meaning is told in the *Physiologus* of the catlike

Ichneumon, an Egyptian animal. In the Beatus miniature, an unintelligible symbol, the Ichneumon, was replaced by an intelligible one, the eagle, a familiar symbol of Christ from earliest Christian times. But the bird here is not recognizably an eagle: It is rather a glamorous bird of prey without a true zoological pedigree. I suggest that its ancestry is Sassanian. If this is correct, the picture results from a dual oriental tradition: its allegorization from (Hellenized) Egypt and its formal appearance from the Near East. To what extent the *Physiologus* and its successors, the bestiaries, influenced the symbolism of the Romanesque and Gothic fauna can only be decided by assembling such case histories as this.

To return to the tangible testimonies of Egyptian art — sphinxes, obelisks, and pyramids — it is a remarkable fact that soon after the last obelisk had been shipped to Rome in the middle of the fourth century all this Egyptian material dropped from what may be called the collective memory. It is true that eventually most of the obelisks shared the fate of the ancient city and her treasures, and were buried deep in Roman soil. But the two pyramids already mentioned remained standing and well known, although one was destroyed in the early sixteenth century; the Vatican obelisk survived and enjoyed fame all during the Middle Ages as Julius Caesar's tomb (3–7). The explanation that the Church looked askance at these archpagan remains will not do, for nobody interfered with this obelisk next to the old Basilica of St. Peter's, the center of Christianity. (A drawing that must date from the late 1560s, judging from the condition of the drums of the dome, shows parts of the nave of the old Basilica and the obelisk almost disappearing in the tangle of new buildings going up.) Moreover, suddenly, in the thirteenth century, the most characteristic Egyptian conceptions reenter visual consciousness. Pyramids appear after a lapse of more than a thousand years in the mosaics of S. Marco in Venice (for example, a mosaic in the atrium of S. Marco dating from ca. 1270, 3–8), but, in accordance with a medieval cosmographical tradition, not as the tombs of the Pharaohs, but as Joseph's granaries and therefore in a proper Biblical context.

During the same period Rome had a genuine Egyptian Renaissance. Egyptian sphinxes appeared in stylistically correct adaptations in and near Rome: in the cloister of the Lateran (3–9, a work of the Vassaletto family of artists), in the cathe-

Figure 3-7. Obelisk, from St. Peter's, Rome. View from the southeast. 1530s. Drawing by Marten van Heemskerck. State Museum, Berlin. Reproduced in Egger, *Codex Escurialensis.*

drals of Ferentino and Anagni (3–10, also by the Vassalettos), in St. Paul's Outside the Wall (3–11; in these latter two, carrying the Easter candlestick), and in a fully signed and dated specimen with a female head and long tresses (a typical Western interpretation of Egyptian style) by Fra. Pasquale in 1286 from S. Maria in Gradi and now in the museum at Viterbo (3–12). Moreover, around 1300, pyramids were for the first time incorporated into Christian tomb monuments in Bologna.

Another strange occurrence may be noted, within this context. In Spanish and French manuscripts of the thirteenth century, pictures are occasionally found showing a central area framed by walls each of which is given in orthogonal projection. The method is well known from Egyptian paintings. To my knowledge, such representations appear first in the West in eleventh-century Beatus manuscripts (for example, the eleventh-century *Beatus Apocalypse* in the Bibliothèque Nationale in Paris, 3–13) – that is, on Spanish soil – and this may suggest Egyptian influence rather than accidental convergence. The thirteenth-century illuminators had, of course, as their models Beatus manuscripts rather than original Egyptian material. A

Figure 3-8. Atrium mosaic. Granaries of Joseph, detail with pyramids. ca. 1270. S. Marco, Venice. Alinari/Art Resource.

particularly rich example is the *Apocalypse* manuscript in French, now in Trinity College, Cambridge, dating from ca. 1250 (3–14).

The thirteenth-century Egyptian revival was of comparatively brief duration. When the Egyptian paraphernalia reappeared once again in the fifteenth century, they had come to stay. They formed part of an Egyptian renascence, the nature

Figure 3-9. Petrus Vassalettus. Sphinx. 1215–32. S. Giovanni in Lateran Cloister, Rome. Reproduced in Edward Hutton, *The Cosmati.* London, 1950.

Figure 3-10. Petrus Vassalettus. Pascal candelabrum. Thirteenth century. Cathedral, Anagni.

Figure 3-11. Petrus Vassalettus. Sphinx. Pascal candelabrum, detail. ca. 1170. St. Paul's Outside the Wall, Rome. Anderson/Art Resource.

of which is well known and which requires consideration here. An early sixteenth-century work by Raphael will serve as an instructive example with which to begin.

Raphael created a new type of funerary monument by incorporating a pyramid into his design of the Chigi Chapel in S. Maria del Popolo in Rome, erected between 1513 and 1516 (3–15, 16). The point was made by John Shearman in his article

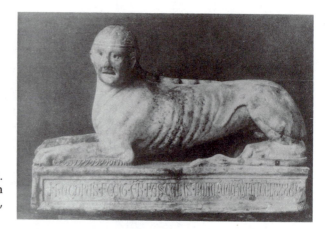

Figure 3-12a. Fra. Pasquale. Sphinx, from S. Maria in Gradi. 1286. Museo Civico, Viterbo.

Figure 3-12b. Detail of 3-12a.

on the Chigi Chapel in the *Journal of the Warburg and Courtauld Institutes* in 1961 that this pyramid is really something halfway between a pyramid and an obelisk. He called it a well-motivated hybrid, for both pyramid and obelisk carried funerary associations. To be sure, Raphael's hybrid structure appears as a foreign element within the classical Renaissance vocabulary,

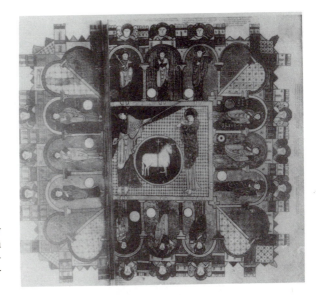

Figure 3-13. The Heavenly Jerusalem, Spanish. Eleventh century. From *Beatus Apocalypse*. Bibliothèque Nationale, Paris (ms. 8878).

Figure 3-14. Celestial Jerusalem, French. ca. 1230–50. From *Apocalypse*. Trinity College, Cambridge (R. 16.2). Reproduced in Jurgis Baltrušaitis, *Reveils et Prodiges*. Paris, 1960.

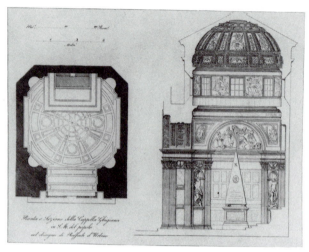

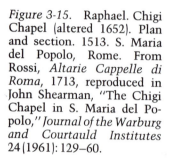

Figure 3-15. Raphael. Chigi Chapel (altered 1652). Plan and section. 1513. S. Maria del Popolo, Rome. From Rossi, *Altarie Cappelle di Roma,* 1713, reproduced in John Shearman, "The Chigi Chapel in S. Maria del Popolo," *Journal of the Warburg and Courtauld Institutes* 24 (1961): 129–60.

for the triangular shape of the pyramid would seem to be at variance with the horizontals, verticals, and circles, the basic shapes of Renaissance architecture. On the other hand, the clear definition and severity of the pyramidal shape made this intruder acceptable, and as a symbol of eternity and immortality the pyramid was soon given a firm place in funerary monuments.

How "Egyptian" is this funerary element in its new setting? Even where the tomb is entirely unadorned and consists of such simple geometrical shapes – as in the tomb of Lavinia Thiene in the cathedral of Vicenza, designed by Sanmicheli in 1542 (3–17) – the pyramid is worlds apart from its Egyptian ancestor. It is not only the transformation of the monolithic mass into flat relief that separates the one from the other; more important still, the Italian funerary pyramid, instead of being firmly planted on the ground (as all Egyptian pyramids are), always crowns a tomb structure and, true to the prevailing feeling for style, is invariably set off from its substructure by (what we may call) joints. In the present case it is even lifted into the air on short legs: No more radical reinterpretation (or misinterpretation) of the prototype could be imagined. The pyramid here has been turned into a mere funerary emblem.

When sculpture is used on the monument, the emblematic character of the pyramid is even more pronounced. This

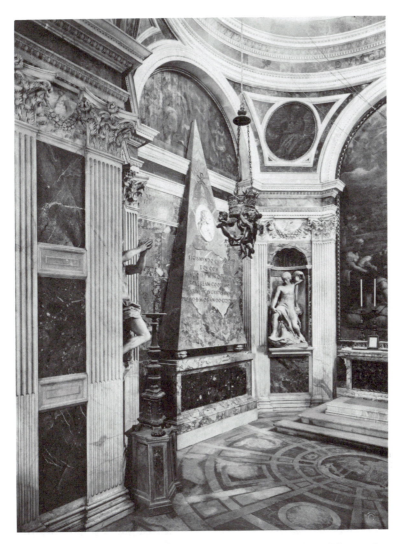

Figure 3-16. Raphael. Chigi Chapel. 1513–6. S. Maria del Popolo, Rome. Reproduced in Shearman, "The Chigi Chapel." Alinari/Art Resource.

is the case in the Contarini tomb in the Santo in Padua, also designed by Sanmicheli and executed between 1544 and 1548 (3–18). Here the pyramid is opened up and gives room to a niche with the bust of the deceased. This type, anticipated by Raphael, became extremely common, because it combined

Figure 3-17. Michele Sanmicheli. Tomb of Lavinia Thiene. 1542. Cathedral of Vicenza.

commemoration (bust) and the symbol of immortality in one image. In addition, instead of the simple pyramid with unbroken walls, Sanmicheli used here the step pyramid, a type rare in Egypt but well known at the time from one of the strangest and, at the same time, most influential Renaissance productions, the *Hypnerotomachia Polifili*, an antiquarian romance published in Venice in 1499. A picturesque woodcut in the *Hypnerotomachia*, apparently an attempt to reconstruct the Mausoleum of Halicarnassus, shows an obelisk perched on top of a step pyramid – thus joining two funerary symbols into a weird design (3–19).

Compared with the frequent appearance of the pyramid on funerary monuments about the mid-sixteenth century, the sphinx is a rare form; it appears on tombs mainly after the middle of the sixteenth century. Near 1550, Vincenzo de'Rossi rested the sarcophagi of the Capella Cesi tombs in S. Maria

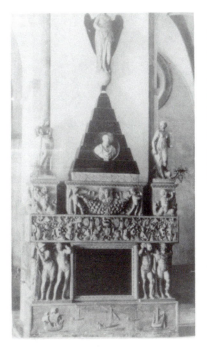

Figure 3-18. Michele Sanmicheli. Vittoria Contarini tomb. 1544–8. Santo, Padua.

Figure 3-19. Francesco Colonna. Mausoleum of Halicarnassus. Woodcut. 1499. *Hypnerotomachia Poliphili* (Venice, 1499). Reproduced in J. Appel, *The Dream of Poliphilus: Fac-similes of one hundred and sixty-eight woodcuts in "Hypnerotomachia Poliphili."* London, 1893.

della Pace in Rome on sphinxes (3–20, 21), and Prospero Sogari (called il Clemente) employed sphinxes similarly in the tomb of the humanist Ludovico Parisetti, which he designed about 1555 for S. Prospero at Reggio Emilia (3–22). The motif migrated with Primaticcio to Fontainebleau, and sphinxes, in completely different settings, began to appear far away from the important centers (3–23, 24).

These later sphinxes have female breasts and heads, whereas the common type of the Egyptian sphinx has the body of a lion and the head of the reigning monarch with the stylized wig-cover. This type is extremely rare in Europe before the late eighteenth century. In Assyria, the Egyptian sphinx had been changed into a winged female monster. This Assyrian type was

 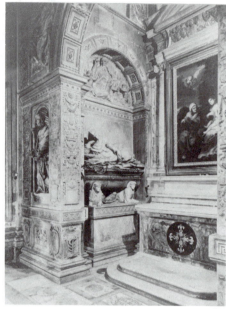

Figure 3-20. Vincenzo de'Rossi. Tomb *Figure 3-21.* Companion view to 3-20.
sculpture, Cesi Chapel. ca. 1550–63. S.
Maria della Pace, Rome. Alinari/Art
Resource.

taken over by the Greeks, who in classical times represented
their sphinxes as squatting on the hind-hams only. European
sphinxes, wingless and lying on all fours like the Egyptian
sphinxes, but female like the Greek ones, are strange crossings
between the Egyptian and Greek creations. In this hybrid form
they invaded designs between the sixteenth and the eighteenth
centuries, and as rather jolly, engaging, and even alluring mon-
sters they supply an exotic touch hardly ever missing from
eighteenth-century gardens.

To return to the pyramids, from about 1600 onward they
appear in ever increasing numbers on tombs in Rome and else-
where in Italy, and soon also in the rest of Europe. They are
extremely common in typical Baroque settings and were as-
similated to such an extent that nobody had any qualms about
this union of discordant elements (3–25). In fact, while Raphael
for one adopted an "Egyptian" motif in the full knowledge of
what he was doing, most later tomb designers followed icon-
ographical precedent without much ado. A change of approach

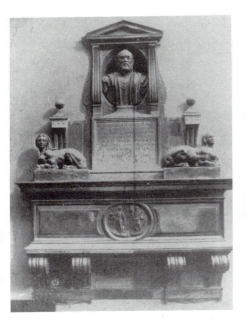

Figure 3-22. Prospero Sogari (called il Clemente). Tomb of Humanist Ludovico Parisetti. ca. 1555. S. Prospero at Reggio Emilia.

Figure 3-23. Georg Franz Ebenhech. Marble sphinx with putti. ca. 1755. Sanssouci, Potsdam. Published in Willy Kurth, *Sanssouci ein Beitrag zur Kunst des Deutschen Rokoko*. Berlin, 1962.

dates from the age of Neoclassicism. In 1794, Canova made models for a tomb of Titian (3–26), which he never executed; he used the design for the tomb of the Archduchess Christina of Austria in Vienna (3–27). Perhaps for the first time since the Renaissance he gave the pyramid a broader, more correct shape and planted it firmly on the ground. This archaeologizing spirit, however, does not make such tomb designs more Egyptian (or, for that matter, more antique) than were Renaissance or Baroque creations. However, the Neoclassical pyramid revives an Egyptian element in that it is a tomb chamber: Figures are walking into the chamber where the sarcophagus is.

This argument may be concluded with the observation that the pyramid became a standard feature of catafalques. This happened for the first time at the obsequies of Michelangelo (3–28, 29), celebrated in S. Lorenzo in Florence on 14 July 1564. (Scores of prints preserve temporary structures of this sort and

Figure 3-24. Carved marble sphinxes on Adam wooden stands. Mid-eighteenth century. Formerly collection of Earl of Jersey. Published Sotheby Parke Bernet catalog, 21 February 1962 (London).

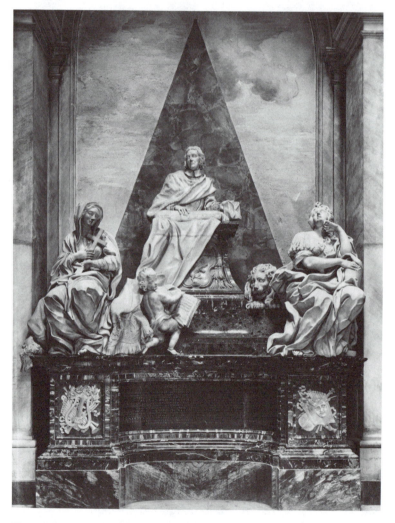

Figure 3-25. F. Carcani. Tomb of Monsignore Agostino Favoriti. 1682–6. S. Maria Maggiore, Rome. Anderson/Art Resource.

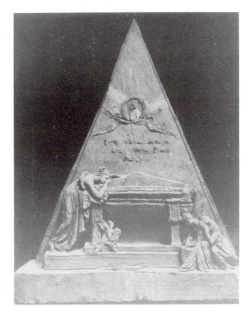

Figure 3-26. Antonio Canova. Bozzetto
for monument to Titian. 1794. Possagno.

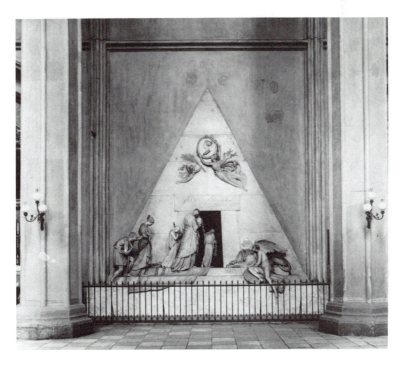

Figure 3-27. Antonio Canova. Tomb of Maria Christina, Archdu-
chess of Austria. 1805. Augustinerkirche, Vienna. Marburg/Art
Resource.

Figure 3-28. Michelangelo's Catafalque in San Lorenzo. Sketch, pen and ink. 1564. Probably artist in Cellini's circle after design by Vasari. Graphische Sammlung, Munich. Reproduced in R. Wittkower and M. Wittkower, *The Divine Michelangelo: The Florentine Academy's Homage on His Death in 1564.* London, 1964.

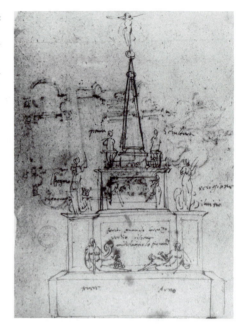

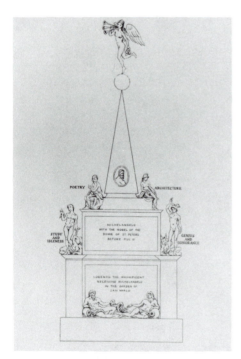

Figure 3-29. Michelangelo's Catafalque. Reconstructed elevation from Wittkower, *The Divine Michelangelo.*

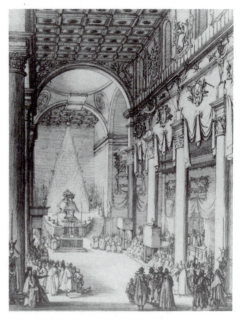

Figure 3-30. Jacques Callot. Obsequies of Emperor Matthias in Florence. Engraving and etching. 1619. San Lorenzo, Rome. Reproduced in Wittkower, *The Divine Michelangelo.*

demonstrate the extent to which the pyramid was regarded as a symbol associated with the idea of victory over Death; see 3–30.) It will be noticed that this type of freestanding catafalque was derived from such tombs as the Contarini monument in the Santo. After Michelangelo's obsequies, pyramids remained the most essential part of catafalques for two hundred years.

The story of the obelisk appears to be far more complex, for in contrast to the unadorned pyramids, obelisks were incised with enigmatic designs, the hieroglyphs. For this reason obelisks were objects of endless curiosity and of the most involved speculations. Once they had become objects of general attention, they made their appearance as crowning elements on tombs and churches, on portals, palaces, and country houses, and were even used on fountains and squares.

FOUR

The Obelisk I
ITS ROLE IN ARCHITECTURAL DECORATION
AND URBAN ORGANIZATION

Obelisks surely pose the principal problem in understanding the Egyptian revival or the revival of interest in Egyptian manners in Europe from the sixteenth to the nineteenth centuries. With the enigmatic writing inscribed on their surfaces, obelisks became objects of infinite curiosity to the European public, and it even appears that it was the obelisks with their hieroglyphics, especially in their role as decorative objects, that brought about the passion for Egyptian manners that took place in Europe in the sixteenth and seventeenth centuries.

Obelisks enter into the compositions of European artists as early as the sixteenth century, and they appear even before that in architectural designs in the West. An instructive example of the obelisk's early use, as a decorative element, is found in the design for S. Maria di Loreto in Rome, by Antonio da Sangallo (the elder) where obelisk–pyramid forms appear as crowning features above cornices (4–1). The hybrid crossing of obelisks and pyramids appears here as a decorative feature and it is impossible to attach any emblematic significance to these obelisks or obelisk–pyramids.

The usual dating of this church is 1507, which is especially interesting with regard to the appearance of obelisks;

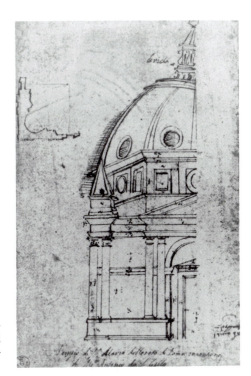

Figure 4-1. Aristotile da Sangallo for Antonio da Sangallo (the elder). S. Maria di Loreto, Rome. Elevation drawing. 1520–5(?). Uffizi Gallery, Florence.

however, it has not been determined exactly when the church was designed. Based on a chronology of Sangallo drawings, James Ackerman dates the design of the church between 1520 and 1525. As discussed previously, it was Raphael who actually started the rage for Egyptian elements in Italy with his tomb in the Chigi Chapel, and that was executed in the second decade of the century. Ackerman's dating, therefore, is plausible.

There was a considerable amount of investigation into the decorative possibilities of Egyptian forms among artists and architects at this time in Italy, as a perusal of contemporary drawings reveals. Members of the Sangallo family, for example, were extremely active in Rome in the first half of the sixteenth century, and one finds in their drawings, particularly those of Antonio da Sangallo (the younger, nephew of the elder), much Egyptian material.

Another monument by Antonio da Sangallo (the elder) serves as an informative example of the period in the use of

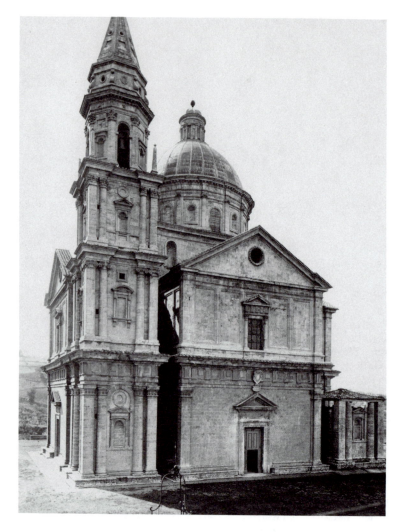

Figure 4-2. Antonio da Sangallo (the elder). Church of the Madonna di S. Biagio. 1518–34. Montepulciano. Alinari/Art Resource.

the obelisk–pyramid form – the church of the Madonna di S. Biagio begun in 1518 but not finished until about 1545 (4–2). This is an impressive Renaissance central-plan design in which the architect has, in rather subdued fashion, put obelisks on the third tier of the church tower. They are not very evident; indeed, nobody seems to have ever remarked on them. In a

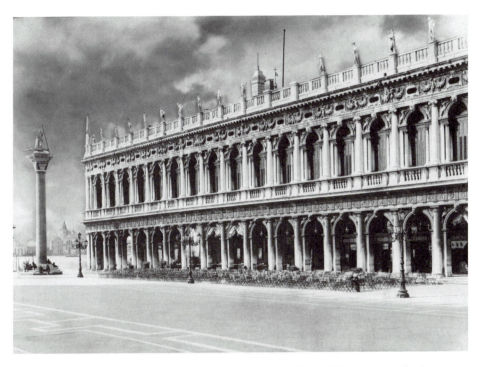

Figure 4-3. Jacopo Sansovino. Library of St. Mark (Libreria Vecchia), Venice. 1536–60. Completed by Scamozzi, 1591. Anderson/Art Resource.

way, they appear somewhat out of place on this church, yet Sangallo has employed the obelisks to continue the vertical lines of the tower, which rise from the lower registers. Again, however, the architect imparts no symbolic or emblematic significance to these Egyptian forms. They serve only as formal and decorative elements.

In spite of the Sangallos' interest in obelisks and the curiosity about them among contemporary artists, they are rare at this time in Rome; however, they are encountered rather frequently in the north of Italy. In fact, they are found in a building in which one would hardly expect to see them – Jacopo Sansovino's Libreria Vecchia (1536) in Venice (4–3). Sansovino had been in the Bramante orbit in Rome and he, as so many other artists and architects, left the papal city in 1527 after the sack of Rome, when it was apparent that there would be very little work for artists there. He then went to Venice where he

became that city's most important practitioner by the 1530s; in 1537, his plans accepted, the foundation of the Libreria was laid. In this design, obelisks appear at strategic points as decorative and architectonic elements. As in the buildings of Sangallo mentioned previously, the Egyptian elements in Sansovino's Libreria carry no particular symbolic meaning. The building was completed by Vincenzo Scamozzi (1591), whose contributions to the Egyptian revival will be discussed.

The most interesting phenomenon of the age in this matter of obelisks and things Egyptian is surely Sebastiano Serlio, author of the great architectural treatise, *L'Architettura*. Serlio, who relied in his treatise to a large extent on material of his great teacher Baldassare Peruzzi, succeeded in recapturing the climate of Rome of the first two decades of the sixteenth century. Serlio also went to Venice after the sack of Rome, and there he condensed his collection of material into his architectural treatise. The work appeared in five volumes over a number of years, but the books were not published in logical sequence. Thus, the first books that appeared were Books IV and III published in Venice in 1537 and 1540, respectively. Serlio left Venice in 1540 at the age of sixty-five and made his home in Paris, where he worked on various architectural projects and continued to write his treatise. Consequently, Books I, II, and V were published in Paris in 1545 and 1547.

It is difficult to determine to what degree, if at all, Serlio was aware of what was going on in the Bramante and Raphael circles in Rome concerning the subject of obelisks and Egyptian forms in general. It seems that apparently he had little, if any, interest in Egyptian elements beyond their formal and decorative characteristics, an attitude that would have been very much in line with Serlio's character and mentality. He was more of a practitioner than an intellectual, and his greatest strength was a keen sense for summarizing what others had done. This is in no way meant to minimize his achievement. Serlio's treatise was the handbook most widely used in the sixteenth century. His importance to the history of architecture at this period cannot be overestimated, and his contribution is at once distinct and enormous. His work is of particular interest in any discussion of obelisks.

In Serlio's Book IV, he published a design of a central-plan church that featured large obelisks at all four corners to be the exact height of the pediment (4–4). In his text he refers to the

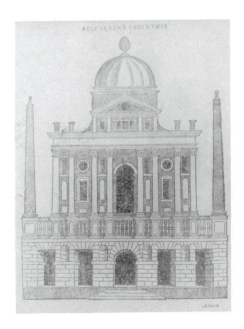

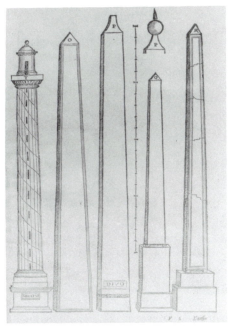

Figure 4-4. Church design. From Sebastiano Serlio, *L'Architettura*, Book Four. Venice, 1537.

Figure 4-5. Obelisk designs. From Sebastiano Serlio, *L'Architettura*, Book Three. Venice, 1540.

obelisks as affording excellent ornament (4–5), reiterating the keynote for the use of obelisks at the time – for ornamental and not for emblematical purposes.

Some of the obelisks in Rome that Serlio describes are not immediately identifiable. However, a careful reading of his text and a close scrutiny of the obelisks of Rome leads to certain convincing identifications. It seems that his first obelisk is the one that stands now in the Piazza del Popolo (4–6); the second must be the Vatican obelisk (4–7); and the third is unquestionably the one that was erected in front of the apse of Santa Maria Maggiore (4–8). (Serlio states that the obelisk was found near the church San Rocco in three pieces). The last one Serlio represents consists of five pieces and must be the obelisk that now stands in the Piazza Navona, which will be discussed.

Another of Serlio's Egyptian illustrations of considerable interest is composed of a curious design of pyramids in which a strange female head is placed next to one of the pyramids. In

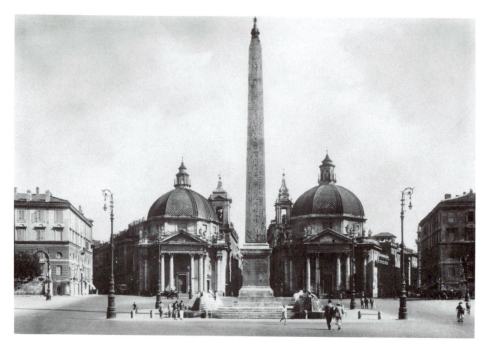

Figure 4-6. Obelisk. Piazza del Popolo, Rome. Erected 1589. Transported by Augustus from Heliopolis to Circus Maximus in 10 B.C. Alinari/Art Resource.

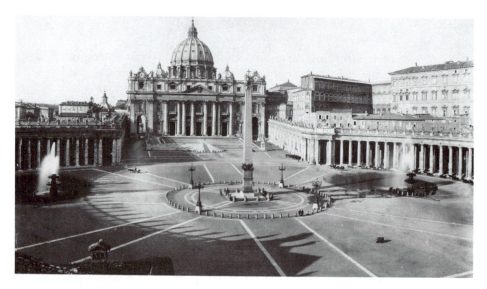

Figure 4-7. Obelisk. Vatican, Rome. Erected 1586. From Circus of Nero. Alinari/Art Resource.

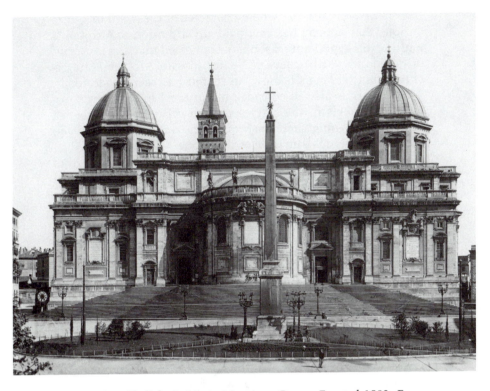

Figure 4-8. Obelisk. S. Maria Maggiore, Rome. Erected 1582. From tomb of Augustus. Found 1527 near San Rocco. Anderson/Art Resource.

the accompanying text, Serlio emphasizes that he received all the measurements and the description of these pyramids from Marco Grimani, a member of a leading Venetian family and the Patriarch of Acropolia. Serlio tells us that Grimani had been in Egypt where he had investigated and measured the pyramids. He insists that the rendering of the figure (which is extremely awkward) next to the pyramid derives directly from Grimani's description. There can be no doubt in view of the further description of how one enters the pyramid and gains access to the chamber that this is the famous Cheops pyramid at Giza, not far from Cairo. Pococke's famous description of Egypt from 1743 is almost identical to that which Serlio quotes. It is not clear to what extent Grimani, traveling to Egypt in the early sixteenth century, was aware of the significance of what he was seeing.

If we consider the whole character of these studies, it is curious that nobody has ever paid any attention to Grimani's journey to Egypt. I am reasonably convinced that a manuscript of his journey still exists in Venice (possibly in the state archives) but as far as I know no search has been made for it. This matter is also of considerable interest in the context of Egyptian travels in the early sixteenth century. A number of people were going there inspecting the antiquities and even measuring them; Grimani was not alone.

Travelers to Egypt went not only from Italy but also from France and Germany, and they returned with accounts that were not confined to Egypt alone, but that extended to Greece, Asia, and India. The number of travelers continued to increase. By the eighteenth century the complexion of world travel had become quite different from that of the fifteenth and sixteenth centuries, but that topic will be considered on another occasion.

It is evident that Serlio's influence in propagating things Egyptian was particularly far reaching in the sixteenth century; it is true also that the growing interest in Egyptian forms extended beyond church decoration to all sorts of monuments, secular buildings, villas, gates, and fountains. It is impossible to survey the full richness of the revival of Egyptian elements, but a few examples – some of which may seem strange, and some of which may seem inconsistent – may prove instructive.

I said before that Rome is very poor in the use of Egyptian elements, but it may be well to mention here that there is one great church, Giacomo da Vignola's S. Maria dell'Orto erected between 1566 and 1567, in which an ample use of obelisks is found (4–9). Compared with the church facade of the Madonna di Loreto, S. Maria dell'Orto's facade may be seen as an expansion of Sangallo's earlier design. The obelisk has become a more important feature and, indeed, it makes a considerable impact on the character of the design. I would like to mention here that in discussing mid-sixteenth-century architecture, it is hardly ever mentioned, though in this respect the facade is almost unique in Rome.

Soon, this type of church design with obelisks as a crowning feature spread (probably radiating from Vignola's S. Maria dell'Orto) to the north and also beyond the frontiers of Italy. A particularly striking example (4–10) of this influence that breaks through Italian boundaries is the monumental entrance

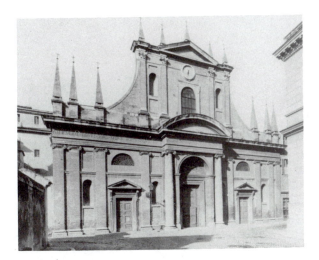

Figure 4-9. Giacomo da Vignola. S. Maria dell'Orto, Rome. 1566–7. Published in Fasolo Furio, *La Fabbrica Cincuescentesca di Santa Maria dell'Orto.* Rome, 1944.

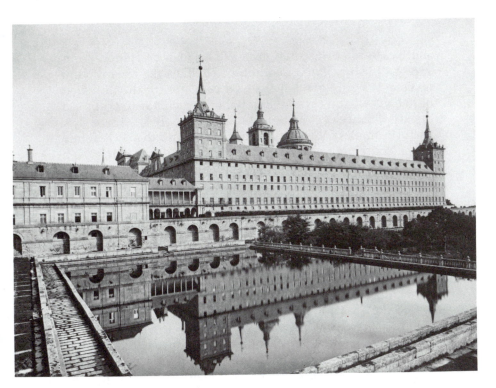

Figure 4-10. Juan de Herrera. Facade of the Escorial. 1563–84. Near Madrid. Anderson / Art Resource.

Figure 4-11. Pietro Antonio
Barca (?). Church of S. Maria
degli Angeli, Milan. ca. 1600.

and facade of the Escorial executed by Juan de Herrera from
1563 to 1584, a period that almost parallels the construction
of Vignola's S. Maria dell'Orto. Of course, with the intrusion
of Italians working on the Escorial over such a span of time, a
direct influence of Roman material could only be expected. A
useful example of Vignola's influence in the north may be found
in the church of S. Maria degli Angeli in Milan (4–11), which
was formerly attributed to Vincenzo Seregni (and too early at
that – 1552); it is now believed to be the work of Pietro Antonio
Barca and dated about 1600.

At this point, it would be useful to consider an especially
important, as well as interesting, monument in the north of
Italy. It is the tomb of Cardinal Francesco Sfondrato in the
cathedral of Cremona (4–12). Sfondrato was an intellectual who
came from a great Milanese family. He had studied law in Pavia,
then entered the service of Francesco Sforza in Milan and later
served the emperor Charles V. Sfondrato and his wife (a vis-
countess) were both highly connected and led socially active
lives together. However, Sfondrato's wife died early, in 1535,
and he then took Holy Orders. He made his way rapidly in
the hierarchy of the church and became a cardinal in 1544
(Gregory XIV, who was to reign but a short time in 1590, was
his son). Sfondrato died in 1550 and a monument was erected

Figure 4-12. Tomb of Cardinal Francesco Sfondrato. Designed by Francesco Dattaro and executed by Giovanni Battista Cambi. 1561. Cathedral of Cremona. Alinari/Art Resource.

to him that marks an important shift in the use of Egyptian forms. It was designed by a minor artist, Francesco Dattaro, and executed by Giovanni Battista Cambi, an able craftsman, who completed it in 1561. Even though the monument is not especially noteworthy artistically, an unusual use of Egyptian forms distinguishes it at this time. The monument features an

obelisk covered with emblematic designs that have specific and hidden meaning.

This strange mixture of Egyptian elements and Renaissance features assigns to these forms a symbolic role that departs from the traditional use of Egyptian elements for decorative or architectonic purposes alone. Sfondrato was apparently very close to the intellectual circles in Rome and no doubt had requested this design, which marks an innovative move right into Egyptology. It is significant also, in this monument, that the intellectual patron himself is probably responsible for the design of the tomb.

In spite of the relative scarcity of the use of Egyptian motifs in Rome at this time, there was nonetheless a complex of ideas that reflected its influence there. One of the most spectacular expressions of this general attitude is found in the enormous urban accomplishments of Pope Sixtus V, who, when Rome was lacking in artists, managed to lay the foundations for most of what happened in Rome in the seventeenth and eighteenth centuries. The execution of his visionary ideas in Rome in the sixteenth century gave a preview of what would happen elsewhere in the world in ages to come. (The idea that prevailed for so long that every self-respecting city had to have at least one obelisk stems directly from him.) Sixtus, whose papacy lasted only five years (from 1585 to 1590), with his court architect, Domenico Fontana, was extremely effective in recasting the face of Rome.

The principal device employed in Sixtus V's reorganization of Rome was an ingenious union of a network of long, wide avenues and strategically placed obelisks. Rome's entire cityscape was reorganized by means of great obelisks dramatically positioned at crucial points in the city plan. Like enormous exclamation points, their magnetic forms attracted the spectator's eye, which came to rest on the ancient form.

This idea of using the Roman obelisks did not originate with the particularly fruitful collaboration of Pope Sixtus V and Domenico Fontana. Even though it did serve to further the long interest in Egyptian things, there had been for some time an active antiquarian interest in the Roman obelisks, an interest that went back to the fifteenth century. For instance, when Pope Nicholas V consulted Alberti with regard to the replanning of St. Peter's, Alberti proposed to transfer the obelisk standing at the side of the old Basilica (3–7) to the front

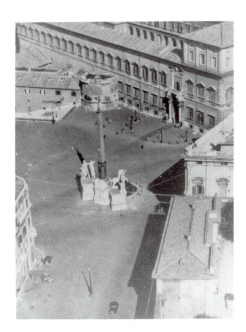

Figure 4-13. Obelisk. Piazza del Quirinale, Rome. Erected 1786. From tomb of Augustus found 1527 near S. Rocco. (See 4-8 for second obelisk found at tomb of Augustus.) Anderson/Art Resource.

of the new building. In the beginning of the sixteenth century, there was considerable interest in obelisks. In fact, the documents show that most of the obelisks that were discovered in Roman soil were excavated early in the sixteenth century. So this matter was very much in the air then; it simply awaited an energetic personality, a man of immense imagination – and, of course, a man who had the power and the resources of the papacy at his disposal – to exploit its possibilities. It all began with the obelisk of St. Peter's, which was placed in its present position in 1586.

The operation was an enormously complex one in many ways, and we are therefore extremely fortunate in having a full account of the event by the architect himself, Domenico Fontana. From extant drawings, the obelisk can be seen in its position next to Old St. Peter's (3–7) before that building was pulled down in the early years of the seventeenth century. Transporting the obelisk to its new location in the piazza of New St. Peter's was not only an immensely difficult mechanical feat but it posed an extremely complex set of problems involved in determining the precise axis of the new basilica,

because the obelisk was intended to rest in the axis of the yet unfinished new Basilica.

When Carlo Maderna built the nave and facade of New St. Peter's in the early years of the seventeenth century, he discovered that the axial direction of the nave was slightly out of line with the obelisk. To get the central door into the axis of the obelisk, he had to break the nave by a degree or two. This is not perceptible in plans because there is a tendency to regularize such things, but the discrepancy can be observed. I have personally spent many hours measuring this on the square of St. Peter's, which one can do only between four and five in the morning.

The obelisks, being pagan monuments, presented another problem, though not an insurmountable one. In the case of the Vatican obelisk (4–7), just discussed, Pope Sixtus V himself exorcised the great needle and then erected the cross over the obelisk, which symbolized the supersession of paganism by Christianity (all of the Roman obelisks are surmounted by the cross). It should be noted, however, that the pagan character of the obelisks was not taken too seriously by the intellectuals at the time because they regarded the obelisks as embodiments of some mysterious wisdom that was not far removed from Christianity.

The placement of other obelisks followed shortly. The obelisk in S. Giovanni in Laterano (3–4), the largest in Rome, had reached the city in A.D. 357 and was excavated in the sixteenth century. Sixtus had it placed in the Lateran piazza in 1588, and it was illustrated in 1593 in Tempesta's plan of Rome.

The obelisk in the Piazza del Popolo (4–6), erected in 1589, was also illustrated in the Tempesta plan. This obelisk was transported from Heliopolis to Rome by Augustus and placed in the Circus Maximus. Sixtus placed it at the focus of three streets that radiate from it, and Rainaldi's churches that face it impart an urban structure to the space.

The obelisk of S. Maria Maggiore (4–8) came from the tomb of Augustus, who brought over two obelisks to Rome for the decoration of his tomb. These obelisks were found in 1527 near the church of San Rocco, but at that time they could not be moved. Sixtus had one of them placed at S. Maria Maggiore in 1587, and the second remained in situ until the late eighteenth century, when it was placed in the Piazza del Quirinale (4–13), where it still stands.

FIVE

The Obelisk II
ITS SIGNIFICANCE IN THE SEVENTEENTH
AND EIGHTEENTH CENTURIES

After the fantastic activity between 1585 and 1590, there was, of course, a period of lesser activity but the interest in obelisks persisted. Before proceeding into the next phase, let us consider a small obelisk that is usually forgotten. Its origins are obscure. All that is known is that it was standing on the Capitol near the church of S. Maria in Aracoeli (5–1) as early as the first years of the fifteenth century and that it was removed in 1582. A few years before Sixtus V became pope it was given by the senate to Ciriaco Mattei, who transported it to his villa Mattei on Monte Celio, where the obelisk is still standing. This underscores the observation already made that the technology of moving obelisks employed under Sixtus V had been developed with smaller obelisks earlier in the century.

A second obelisk of considerable interest, also a small one, was found in the seventeenth century outside the Porta Maggiore and transported to the Barberini Palace. Gianlorenzo Bernini made plans to erect it there in front of the palace in 1632, but because the project was never executed, the obelisk remained lying in the vicinity of the palace until the late eighteenth century. It was then given in 1773 to Pope Clement XIV, who tried to place it somewhere in the Vatican, but to no avail.

Figure 5-1. Marten van Heemskerck. *Roman Sketchbook.* View of Capitol. 1530s. State Museum, Berlin (II Fol. 16r).

Finally, it was placed on the Pincio in 1822, where it still stands today.

Another obelisk was transported at about the same time (or a little later) that this small obelisk was discovered outside the Porta Maggiore; it is now standing in the Piazza Navona (5–2), where it was erected by Bernini. The obelisk was originally part of the complex of the Temple of Isis from which it was taken in the fourth century, and it was found in the seventeenth century lying in pieces in the Campagna near the monument of Cecilia Metella. The Pamphili pope, Innocent X, undertook to have it erected in the Piazza Navona, which was the reigning Pamphili family's property.

At this time (1647), Bernini was out of favor with the ruling power in the Vatican, and Francesco Borromini was selected to make designs for the installation of the obelisk (5–3). Nonetheless, Bernini somehow succeeded in supplanting Borromini, and by the summer of 1648 work on the foundations for the installation was begun according to his design. From then on the progress of the monument and fountain is carefully documented. By July 1648 the obelisk had been transported to

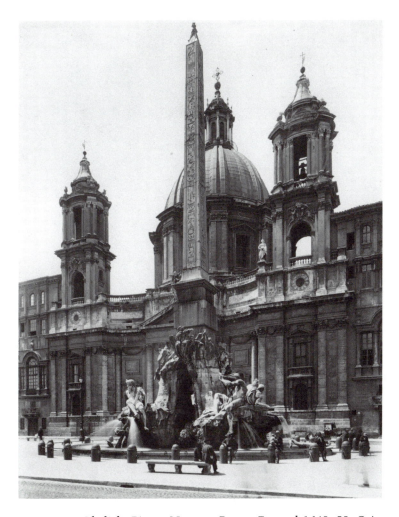

Figure 5-2. Obelisk. Piazza Navona, Rome. Erected 1649–50. Originally in Temple of Isis, Campo Marzio; hieroglyphs cut in Rome under Domitian. Under Maxentius (fourth century A.D.) placed in Circus, Via Appia. Marburg/Art Resource.

the Piazza Navona and was erected in August of the following year (1649). The fountain was unveiled on 14 June 1651.

The idea of placing the obelisk over an open rock was indeed spectacular. Early sketches are useful in following the development of Bernini's conception (5–4). At first, the entire design is completely symmetrical. A large *bozzetto* exists in

Figure 5-3. Francesco Borromini. Piazza Navona project. 1647. Vatican Library, Rome (Cod. Vat. lat. 11258, II, 200). Reproduced in Eberhard Hempel, *Francesco Borromini*, Vienna, 1924.

the Giocondi collection in Rome in which the rock still has a kind of structural quality but the design is still quite symmetrical. The decisive moment came in early 1649 when Bernini began to develop the character of the rock formation in a kind of diagonal direction, which offered a dramatic contrast with the precise vertical thrust of the obelisk. Thus, in addition to the breathtaking effect of placing the obelisk over a rocky cavity, the lively movement of the rock on which the figures sit reinforces and enhances the plastic quality of the mass, which departs remarkably from the static tradition of fountain composition and construction.

At that point Bernini decided to do something completely irrational, namely, to break into the pedestal by means of an inserted transverse block (carrying the inscriptions), which further denied the feeling of static structure and emphasized the weight of the obelisk pressing down on its support. This illu-

Figure 5-4. Gianlorenzo Bernini. Four Rivers Fountain studies. 1648–51. Leipzig. Reproduced in *Drawings by Gianlorenzo Bernini from the Museum der Bilden Kunst*. Princeton, 1981. See also Franco Borsi, *Bernini*. New York, 1984.

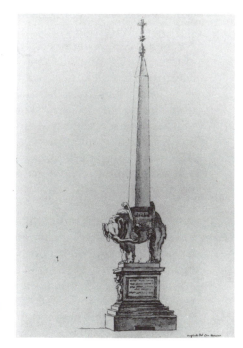

Figure 5-5. Gianlorenzo Bernini. Elephant and obelisk, drawing. 1666–7. Vatican Library, Rome (Cod. Chigi, P VII 9, f. 83 r). Reproduced in Heinrich Brauer and Rudolf Wittkower, *Die Zeichnungen des Gianlorenzo Bernini*, 2 vols. Berlin, 1931.

sion evoked great response in Bernini's own time. People often expressed concern and fear that the obelisk might collapse or that the structure would not hold. Through Bernini's innovations in illusionism here, he imparts to the obelisk new meaning as an artistic object, using the huge stone needle as an important emotional element in his creation.

A brief survey of the use of obelisks in Europe, whether the obelisk has been raised over a naturalistic rock or not, reveals that Bernini's arrangement in the Piazza Navona has fascinated architects everywhere. Bernini's model has been quoted so frequently that it may be safe to say that his fountain in the Piazza Navona is perhaps the most important such monument in modern times, and that from here important influences radiate.

Bernini was also commissioned to erect small obelisks. One that had belonged to the Temple of Isis was found in the cloister of the Dominican Monastery of S. Maria Sopra Minerva in 1665 and Pope Alexander VII, the Chigi pope, immediately gave orders to erect the obelisk in the square in front of the church. The work was begun in April 1666 and the finished monument was unveiled on 11 July 1667 (5–5, 6). Ercole Ferrata executed the design of Bernini. Bernini was commissioned just after his return from Paris. In developing his ideas for the project, he revived two projects that went back to the pontificate of Urban VIII – one, an elephant carrying an obelisk, the other featuring Hercules.

As early as 1632, Bernini had made sketches (a *bozzetto* from the period also exists) of an elephant carrying an obelisk for the gardens of the Barberini Palace. (That obelisk was finally erected in the garden area of the Piazza del Popolo in 1822.) He revived this idea, some thirty years later, for Alexander VIII's monument. The pope was reportedly very pleased with Bernini's design. William S. Heckscher has suggested that the pope's response must be understood within the context of the symbolism embodied in the monument. It is a tribute to Bernini's greatness, Heckscher feels, that perhaps the greatest artist of the period could portray – in a wild beast and a pagan obelisk – the mental and spiritual aspirations of a forever ailing, scholarly pope, and at the same time humanity's yearning for the intangible realm of Divine Wisdom.

The second idea that Bernini revived while developing his design for the square of S. Maria Sopra Minerva involved Her-

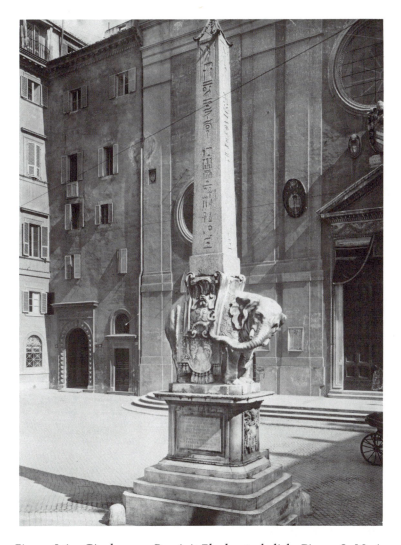

Figure 5-6. Gianlorenzo Bernini. Elephant obelisk. Piazza S. Maria Sopra Minerva, Rome. 1667. Obelisk from Temple of Isis. Found 1665 in garden of Dominican monastery. (See 5–2.) Alinari/Art Resource.

cules supporting the obelisk in a precarious position on a rock (5–7). The obelisk balanced off its vertical axis is a dramatic contradiction to the architectural masses. The extremely precarious relationships that Bernini deals with in these drawings (5–8) reflect concepts significantly amplified but nonetheless

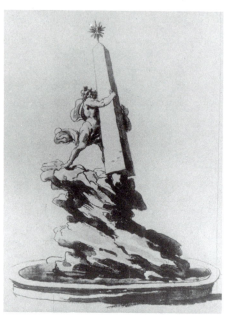

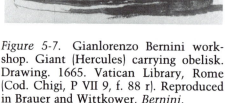

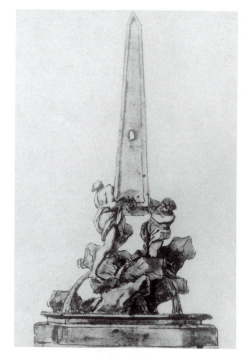

Figure 5-7. Gianlorenzo Bernini workshop. Giant (Hercules) carrying obelisk. Drawing. 1665. Vatican Library, Rome (Cod. Chigi, P VII 9, f. 88 r). Reproduced in Brauer and Wittkower, *Bernini.*

Figure 5-8. Gianlorenzo Bernini. Obelisk carried by two men. Drawing. 1665(?). Vatican Library, Rome. Reproduced in Brauer and Wittkower, *Bernini.*

tied directly to his great achievement in the Piazza Navona. The elephant carrying the obelisk seems quite tame by comparison.

It would be well to point out here that Carlo Fontana, who became the great international architect of the end of the century, was working in Bernini's studio and was an executive hand in preparing the design for the obelisk on the elephant. He was also conversant with Bernini's Hercules idea. Indeed, in 1706, he revived some of these ideas of Bernini from 1665.

Bernini conceived the idea of Hercules holding the obelisk as an alternative to the elephant design, as his sketch of that time shows. It was an extraordinarily bold idea to plan an obelisk – not over an open cave now but being handled so precariously by Hercules. It seems that Bernini had experimented

with this at a time when he was also concerned with the Trevi Fountain. When he could not place an obelisk in the Barberini gardens he tried to place it in the Trevi Fountain.

This concept Carlo Fontana took up in 1706 (5–9–11), as a possible solution for erecting an obelisk discovered on 21 March of that year in the area of the present day Ludovisi gardens. Fontana elaborated on these designs and developed numerous variations, as his drawings show. Not only are his drawings dated (1706) but inscriptions are even included, leaving no doubt of his plan to incorporate the newly discovered obelisk in 1706 into the Trevi Fountain. A remarkably complete drawing includes medallions, allegorical figures, and a plastic handling of the rock that is strongly reminiscent of Bernini. When the obelisk was uncovered (in 1706), Fontana immediately prepared extensive and precise drawings of the condition of the obelisk, how it should be restored, and how it might be erected. Eighteen or nineteen drawings alone exist that deal with the placing of the obelisk.

Fontana's plan for the Trevi Fountain was not executed. In fact, it was another half century before the project was finally executed – and then quite differently from Fontana's plan.

Interest in fountains and obelisks continued in Rome through the eighteenth century. Clement XI erected an obelisk in front of the Pantheon, over a fountain, in 1711 (5–12). The influence of Bernini is evident in the handling of the base, but it is somewhat less daring than Bernini's creation and more simplified. This obelisk also came from the Temple of Isis and had already been erected in 1551, not far from its present location, near the church of S. Ignatio.

The obelisk on the Piazza del Quirinale (4–13) was placed there in 1786 between the great Horse Tamers; this was the second obelisk from the tomb of Augustus (the first one was placed near the apse of S. Maria Maggiore, as discussed previously). The final one that I will mention is the Trinità dei Monti obelisk erected in 1789 on the Spanish Steps (5–13), which fits nicely here and works to form a total visual unit.

These are not all of the obelisks that found monumental dwelling places at this particular time: The interest in and shifting around of obelisks continued throughout the seventeenth and eighteenth centuries. However, the main periods for the rediscovery of obelisks were, first of all, the great moment of the visionary urban ideas of Sixtus V (all of which were

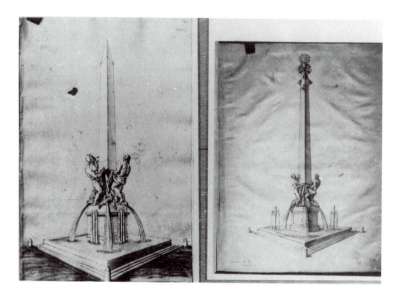

Figure 5-9. Carlo Fontana. Trevi Fountain project. Drawing, no. 534 (*left*), no. 535 (*right*). 1706. Royal Library, Windsor Castle.

Figure 5-10. Carlo Fontana. Trevi Fountain project. Drawing, no. 526 (*left*), no. 528 (*right*). 1706. Royal Library, Windsor Castle.

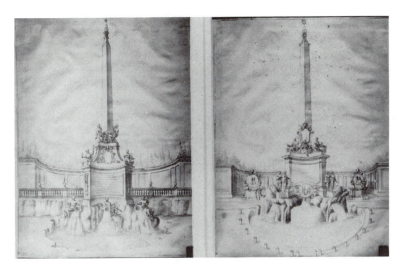

Figure 5-11. Carlo Fontana. Trevi Fountain project. Drawing, no. 532 (*left*), no. 531 (*right*). 1706. Royal Library, Windsor Castle.

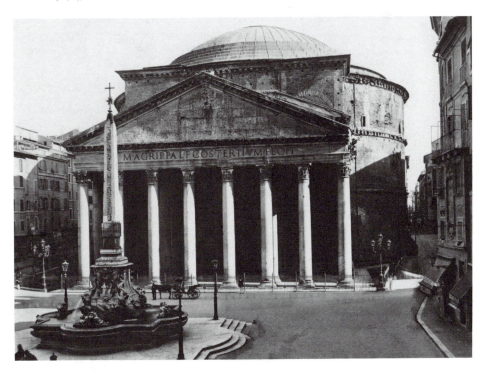

Figure 5-12. Obelisk. View in front of Pantheon, Rome. Erected 1711. From Temple of Isis, Campo Marzio. 1551, placed before S. Marento next to S. Ignazio. Anderson/Art Resource.

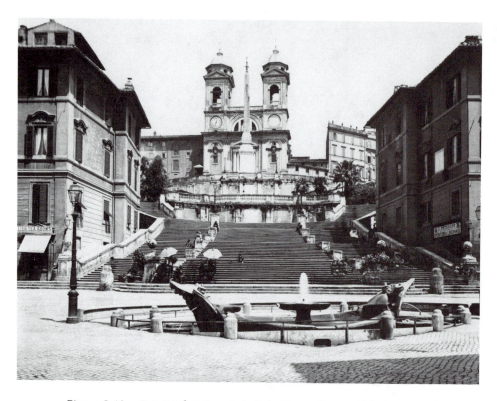

Figure 5-13. Trinità dei Monti obelisk, Rome. Erected 1789. View of Spanish Steps. Piazza di Spagna. From the garden of Sallustius. Was lying between Porta Salaria and Pinciana. Anderson/Art Resource.

Figure 5-14. Vincenzo Scamozzi. Villa Pisani, Lonigo. 1576.

executed ostensibly in the service of God); second, the time of Bernini's innovations in the seventeenth century, which marked achievements of rare magnitude and import that had far-reaching and lasting effects beyond Rome; and third, the late eighteenth century, yet to be discussed.

In spite of this constant interest in the original obelisk, there was little concern for the use of obelisks in buildings. Not surprisingly, such use occurs during the papacy of Sixtus V – for example, in the famous Moses Fountain erected by Domenico Fontana near the little church of San Bernardo. The obelisk is used at the corners of the structure; interestingly, in the Acqua Paolo, which was more or less copied after it by Flaminio Ponzio during the reign of Paul V, thirty years later, the obelisks were omitted.

Effective use of the obelisk in the north was made by Scamozzi, who was a pupil of Andrea Palladio. Palladio himself did not use obelisks, but Scamozzi went back to Serlio and Peruzzi whose influences inspired his use of the obelisk, especially in some of his famous villas – for example, in the Villa Pisani in Lonigo, which appeared in his treatise of 1615, *L'Idea della Architettura Universale*... (Venice; 5–14). It was erected in 1576 and the obelisks there are very important, as they are also in his Villa Badoeri in Peraga near Padua (5–15), built in 1588. His use of the obelisk in his villas is in striking contrast to the use of the form in the church facades in the north, discussed previously. In the latter, the obelisk makes some sense as a finishing element of vertical thrusts. This is surely not the case in Scamozzi's villas in which the obelisk becomes such a visually important feature.

The villas in the north of Italy, in contrast to those in central Italy, around Rome, are in line of succession to the style established by Scamozzi, at least in regard to that decorative aspect. The villa Foscarini, near Vicenza, is a typical example of this influence of Scamozzi (5–16).

Obelisks became common in areas beyond the borders of Italy. Indeed, it seems that there may be a line of influence extending over several centuries from Scamozzi's work in Italy through German and Flemish designs into England. This pattern is not astonishing, because in the latter part of the eighteenth century there was, properly speaking, an Egyptian revival that continued on into the nineteenth century, and it was at this time in particular that most towns and cities in

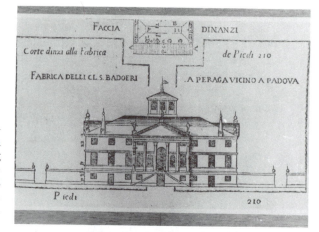

Figure 5-15. Vincenzo Scamozzi. Villa Badoeri, Peraga near Padua. 1588. Drawing from his treatise, *L'Idea Architettura Universale...*, 2 vols. Venice: Lautore, 1615. Reprint: Ridgewood, N. J., 1964.

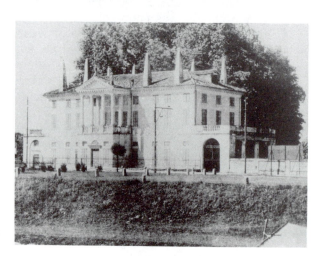

Figure 5-16. Villa Foscarini. Vincenza.

Europe (and to a certain extent also in America) erected their obelisks. Some were newly made, but the relish was for authentic obelisks and so the few that had remained in Egypt were shipped to new lands; for example, the enormous obelisk from Luxor was transported to France by Napoleon and was finally placed in the Place de la Concorde, in Paris, in 1837. Obelisks were shipped to London and New York as well – and the craze for things Egyptian seems to continue even today as we see whole temples being shipped to museums.

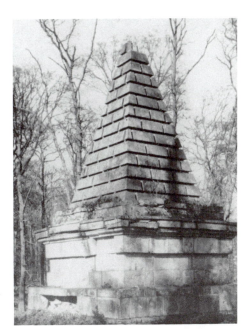

Figure 5-17. Nicholas Hawksmoor. Pyramid in Pretty Wood. Castle Howard, Yorkshire. 1720s. Published in Kerry Downes, *Hawksmoor,* 2nd ed. London, 1959.

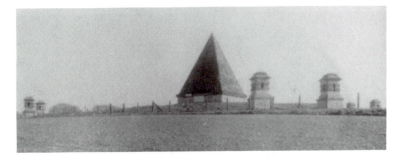

Figure 5-18. Nicholas Hawksmoor. Pyramid with monument. Castle Howard, Yorkshire. Published in Downes, *Hawksmoor.*

Perhaps the most interesting revival of this fashion occurred in England, most notably in some structures of the early eighteenth century by Vanbrugh and Hawksmoor (who worked together for a while). I think of Castle Howard, the great country house in Yorkshire, which is still standing unchanged. The large gates in a heavy, powerful style date from about the late

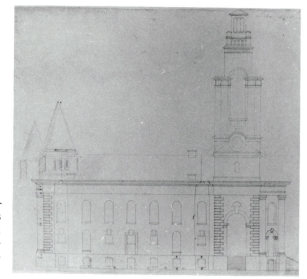

Figure 5-19. Nicholas Hawksmoor. Design for St. Anne's Lime House, London. 1714. British Museum, London. Published in Downes, *Hawksmoor.*

Figure 5-20. Nicholas Hawksmoor. Design for a church based on Mausoleum of Halicarnassus (*left*). All Souls College, Oxford. Design for church based on Mausoleum of Halicarnassus (*center*). Design for St. George's of Bloomsbury, London (*right*). 1720s. Steeple is based on Mausoleum of Halicarnassus. Published in Downes, *Hawksmoor.*

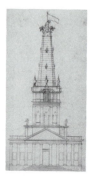

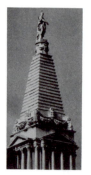

1720s. The gardens are especially picturesque, with virtually every hill crowned by Egyptian features. A large rusticated pyramid is impressive in its setting (5–17), and another great pyramid is actually a tomb that contains a monument inside to one of the Howards (5–18).

Churches also reflect the Egyptian influence in England – for example, in a design for St. Anne's Lime House, dating from 1714 (5–19), where Hawksmoor introduced pyramids on the apse and the facade. Perhaps the strangest of all Hawksmoor's designs are those for St. George's of Bloomsbury, which date from the 1720s (5–20, 21). The steeple with a statue of George

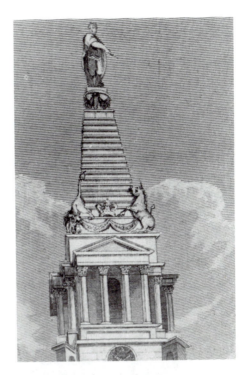

Figure 5-21. Detail of 5-20: steeple.

Figure 5-22. Nicholas Hawksmoor. St. Luke's, London. 1730.

Figure 5-23. Sphinx. Gardens of Lord Burlington's Villa, Chiswick. 1720s.

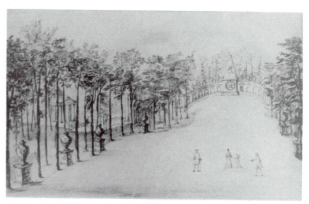

Figure 5-24. William Kent. Drawing of gardens. Chiswick House, London. Chatsworth Settlement. Reproduced in Michael I. Wilson, *William Kent: Architect, Designer, Painter, Gardener, 1685–1748.* London, 1984.

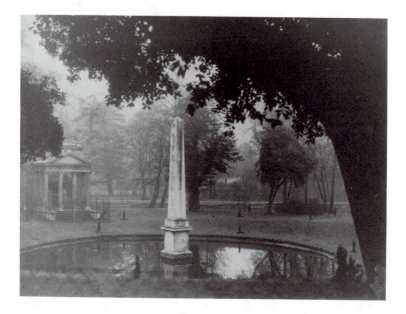

Figure 5-25. Obelisk, pond, and classical temple. Gardens of Lord Burlington's villa. Chiswick House, London. Reproduced in Wilson, *William Kent.*

III at the top was built in 1723, and is a tentative reconstruction of the Mausoleum of Halicarnassus.

Hawksmoor's apparent obsession with Egyptian material is dramatically reflected in such churches as St. Luke's Old Street in London (1730), where he has devised a fluted obelisk

as the steeple surmounted by a sphere topped by the cross (5–22). His obelisks in such designs as this bear a close resemblance to the obelisk in the Piazza Navona. We have many of his designs, for projects not executed, that illustrate his intense interest in things Egyptian.

Finally, we move away from Hawksmoor, this strange Mannerist artist, to the orbit of the Classicist Lord Burlington, whose villa at Chiswick serves as an excellent example of a quite different taste of the period and yet one that also incorporates things Egyptian. Although predominantly Palladian in flavor, Burlington recalls Scamozzi's villas in the north of Italy in using obelisks as chimney pots. The walk from the house into the garden is flanked by sphinxes (5–23), and the layout of the gardens by William Kent features pyramids and obelisks picturesquely placed (5–24). Perhaps the crowning feature of the ingeniously landscaped gardens is a curiously engaging tripartite complex of an obelisk, pond, and Classical temple (5–25) that tellingly unites Burlington's feeling for Palladio and things Egyptian.

SIX

Hieroglyphics I
THE CONCEPTUAL IMPACT OF EGYPT
FROM THE FIFTEENTH CENTURY ONWARD

Egypt had such enormous influence on Western thought and the conceptual side of the West's artistic creation from the fifteenth century onward, because philosophers and humanists of the period believed that behind the philosophy of Plato were the teachings of Moses, Orphic hymns, Chaldean and sibylline oracles, and a broad spectrum of Eastern literary sources that they considered to be very ancient.

Long before the Italian Renaissance, Alexandrian Neoplatonism had combined all esoteric oriental traditions with the aid of allegory, and Marsilio Ficino, the illustrious Florentine humanist who was favored by the Medici, attempted to do something similar in the fifteenth century. He wanted to show that Plato's teachings and pre-Christian thought attested to the truth of Christianity by means of veiled mysteries.

Other thinkers pursued this goal also. Pico della Mirandola maintained that Moses and the Greeks had derived their wisdom from Egypt, that they had tried to discover in what visual form ultimate truth is revealed. Plotinus had written that Egyptian sages manifested ideas by drawn pictures and carved reliefs that corresponded to everything contained in

their temples. Each picture, then, did not reflect or represent discursive reasoning and deliberation but actually embodied understanding, wisdom, and substance. For example, the Egyptian image of time that portrays a winged serpent biting its tail does not signify the concept of time, but embodies that concept. Thus, the whole, the entire object, is presented in one complete image. Egyptian priests used pictures to symbolize divine things because God had knowledge of things not through thought but through a simple apprehension or grasp of them.

Marsilio Ficino maintained that Hermes Trismegistus, an Egyptian sage and either a contemporary or predecessor of Moses, had attained a knowledge of these things surpassing even that which was revealed to the Hebrew prophets. Trismegistus, who enjoyed an important place in Italian Renaissance literature, was credited with the invention of hieroglyphics and writing. His image is depicted with sibyls in an inlaid panel in the floor of Siena Cathedral (6–1).

A modern sixteenth-century type of hieroglyph by Pierio Valeriano reflects the conceptual influence of hieroglyphics at that time (6–2). It depicts a child, an old man and a bird, fish, and rhinoceros, and signified that there is portrayed the process of life: We are born, we grow old, we live and die as a result of nature's ambivalence. These modern hieroglyphs curiously reflect no stylistic characteristics of their Egyptian sources.

In the first half of the fifteenth century, scholars believed that deciphering Egyptian hieroglyphs was of paramount importance because then one could find out how to express the essence of an idea – a Platonic form of idea. For Ficino, Egyptian wisdom, Neoplatonic philosophy, and humanistic studies were united with Christianity by a common aim: the knowledge of God and of his revelation. A substantial literature from the period of Herodotus onward is consistent in reflecting the conviction that hieroglyphics embodied general truth in symbolic or allegorical form. Classical writers erred, however, in not knowing that hieroglyphic writing was also phonetic.

Humanists learned from Pliny and Plutarch that hieroglyphs contained a sacred code, known only to the priests, that explained Egyptian philosophy. They also discovered that Egypt's sacred mysteries, not to be revealed to the profane, were believed to shine through the veil of hieroglyphic images and were considered therefore to be much grander. From Plutarch's

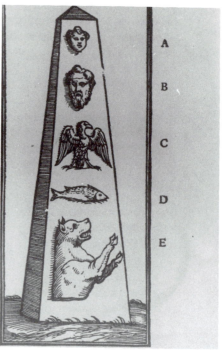

Figure 6-1. Pavement depicting Hermes Trismegistus Handing over the Tablets of the Law to the Egyptians. Siena Cathedral. 1482–3. Reproduced in Erik Iverson, *The Myth of Egypt and Its Hieroglyphs.* Copenhagen, 1961.

Figure 6-2. Pierio Valeriano. Obelisk with hieroglyph depicting a child, and old man, and a bird, fish, and rhinoceros: the process of life. From *Hieroglyphica*, 1556. Reproduced in Iverson, *Myth of Egypt.*

descriptions of Greek travels, a physical link between Greece and Egypt was established that helped the humanists to trace the migration of Egyptian thought and images.

The secret of the Egyptian hieroglyphic code was believed to have been broken about 1419 with the discovery of the *Horapollo Hieroglyphica* that was probably written about the fourth century A.D. According to its introduction, this book was originally written in Egyptian and later translated into Greek. Christophorus, a Florentine priest, brought the manuscript to Florence from Greece where it was found, and gave it to Poggio Bracciolini, the scholar and translator, who consulted

with the humanist, Niccolò Niccoli, in studying it. When the Greek manuscript was investigated in Florence, it was found to contain 189 descriptions of hieroglyphs with interpretations.

The *Horapollo* soon became the standard work on hieroglyphs, and its reliability was undoubted for two hundred years. The Greek edition was printed in Venice in 1505 and some thirty later editions appeared from 1515 onward. The most celebrated edition is that of the German humanist, Willibald Pirckheimer, who in 1514 presented Maximilian'(reign, 1493–1519) with his edition, a Latin translation, with illustrations by Albrecht Dürer. In the decade 1890 to 1900, Karl Giehlow found a copy of the Pirckheimer–Dürer manuscript in the Vienna Library and published it. Few original Dürer illustrations have been traced.

In one of Dürer's illustrations for Pirckheimer's edition of the *Horapollo* (6–3) of 1514, there are portrayed a dog, two men, and a bucket with flame. The dog, illustrated with a stole around its neck, is meant to express the embodiment of an excellent prince and judge. He wears a stole because when he enters a temple he gazes at sacred images. The man on the stool with a rod represents a guard. The man with the hour glass in his mouth is a man eating the hours and refers to a horoscopic reading. The illustration of the bucket and fire depicts purity, for by means of water and fire things are purified.

Dürer's illustrations are executed in contemporary style, and there is no attempt to imitate Egyptian stylistic characteristics. In spite of growing Egyptian taste and increased use of Egyptian features, Egyptian principles of style are hardly ever encountered.

From the middle of the fifteenth century there are revealing discussions of hieroglyphics. Leone Battista Alberti, about 1452, held that letters of a language eventually fade into obsolescence, as had happened with Etruscan characters that no one could understand, but that expressing sense by symbols must always be understood by learned men of all nations. And the Egyptian method had been employed by other nations. The Romans, for example, recorded exploits of men by carving illustrations of them on marble columns and arches as the Egyptians carved their hieroglyphics on and in their monuments.

In Book XII of his *Trattato d'Architettura* (1461–4, Milan), Antonio Filarete, in discussing Roman theaters, mentions an

Figure 6-3 (left). Albrecht Dürer. Illustration depicting a dog, two men, and a bucket with flame. From *Horapollo Hieroglyphica* (Latin translation by Willibald Pirckheimer, ca. 1514). Print Room, State Museum, Berlin. Reproduced in Karl Giehlow, "Die Hieroglyphenkunde des Humanismus in der Allegorie der Renaissance," *Jahrbuch Kunsthistorischen Sammlungen des Allerhöchsten Kaiserhauses* 32. Vienna, 1915.

Figure 6-4 (right). Roman temple frieze, from San Lorenzo fuori le mura. Capitoline Museum, Rome. Reproduced in Iverson, *Myth of Egypt*.

obelisk carved with Egyptian letters. He did not understand the pictographs and thus made no explanation for the hieroglyphic characters.

A Roman temple frieze, now in the Capitoline Museum (6–4) but in the fifteenth century in S. Lorenzo, was believed to have hieroglyphic meaning. A frieze from the Temple of Vespasian (6–5) enjoyed an enormous reputation in the Quat-

Figure 6-5. Fragment of temple of Vespasian, Rome. Temple begun by Vespasian's son Titus at death of Vespasian A.D. 79, and completed by Domitian (Vespasian's second son) on Titus's death A.D. 81. Reproduced in Ernest Nash, *Pictorial Dictionary of Ancient Rome.* London, 1961. Alinari/Art Resource.

trocento. It was studied and used by Renaissance artists such as Mantegna and Giulio Romano. In fact, it may have started Francesco Colonna, the most gifted inventor and interpreter of Renaissance hieroglyphs, on his daring hieroglyphic exploration. It appears in his *Hypnerotomachia Poliphili* (Venice,

1499), the most splendidly illustrated Italian work on the subject (6–6). He illustrates fourteen hieroglyphs on the base of a mausoleum and interprets them as follows:

> Sacrifice your toil generously to the God of nature. Little by little you will then subject your soul to God, and he will take you into his firm protection, mercifully govern your life and preserve it unharmed.

The book abounded with similar hieroglyphic texts that resembled an additive picture script whose parts had to be read like words and sentences of a discursive language. The scholars, although far away from Egypt, were convinced that they had fully recaptured Egyptian mysteries. Actually, they repeated the procedure that Alberti had observed in Roman times and they applied that practice to their own purposes.

Was the concept of intuitive understanding an irrational dream? No. Contemporary opinion held that the meanings of hieroglyphics were reconcilable with the meanings of classical myths and Christian revelation. However, only an elect few were thought capable of the heightened experience required to perceive the true but veiled meanings of the hieroglyphics.

The Renaissance medal must be seen in this light. It was made for a small and select circle as a vehicle for the communication of esoteric ideas. The medal was commemorative and communicated ideas that were meant to remain dark to the public at large. And this is what they thought the Egyptian hieroglyphics were meant to do. In a medal of about 1450 by Matteo de Pasti (6–7) featuring, on the obverse side, the self-portrait of Alberti dating to about 1438, there is an illustration of an eye surrounded by a large laurel wreath with a motto under the eye, from Cicero: "Quid Tum" ("What Then?"). The winged eye as a symbol appears in Alberti's dialogue in which he describes the wreath as a symbol of glory and the eye as a symbol of God's omniscience, a symbol reminding us to be as wide-awake as our intellect allows. An older interpretation held that after death we appear before God's judgment and "what then?" also refers to this.

The greatest medalist of the Quattrocento, and indeed of all time, was Pisanello. He was uniquely successful at interweaving hieroglyphics with medieval as well as older traditions. A particularly effective example of his work is his medal of Alphonso V (1449), King of Aragon and Sicily (6–8). On the

Figure 6-6. Hieroglyph. In Fra. Francesco Colonna, *Hyp-nerotomachia Poliphili.* Venice, 1499. Reproduced from Appel, *Dream of Poliphilus.*

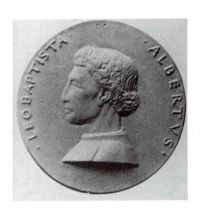
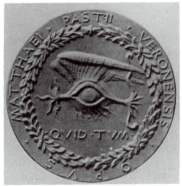

Figure 6-7. Matteo de Pasti. Medal with portrait of Alberti (obverse). ca. 1450. Reverse: eye surrounded by laurel wreath. Reproduced in George Francis Hill, *A Corpus of Italian Medals of the Renaissance before Cellini,* 2 vols. London, 1930.

reverse side of the medal, an eagle, flanked by birds of prey, is perched on a tree stump with a dead deer underneath. The words, divided by the eagle, "Liberalitas Augusta," were meant to symbolize the king's liberality, according to Pliny, who was the ultimate source for Pisanello's subject.

The motif spread to late medieval material and is found in the *Flowers of Virtue,* a moralizing Tuscan text of animal stories that is probably the illustrative source for Pisanello's

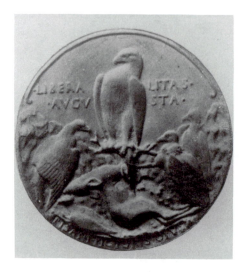 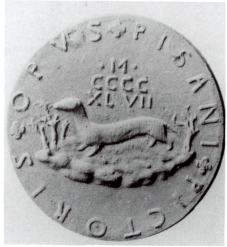

Figure 6-8. Pisanello. Medal with portrait of Alfonso V, King of Aragon and Sicily (obverse). 1449. Reverse: eagle, flanked by birds of prey. National Gallery, Kress Collection, Washington, D.C. Reproduced in Hill, *Italian Medals.*

Figure 6-9. Pisanello. Medal with portrait of Belloto Cumano (obverse). 1447. Reverse: ermine. Reproduced in Hill, *Italian Medals.*

motif. There were several illuminated editions of the fourteenth century in Italian. Leonardo had a copy and wrote a commentary on it in which he noted, from the Tuscan text, that the eagle leaves part of his prey to the birds around him.

Pisanello's medal of the scholar Belotto Cumano, struck in 1447, bears an illustration of an ermine on the obverse side (6–9). The image was charged with various levels of meaning and is found in Pliny. It was used as a symbol of purity in the *Flowers of Virtue.*

Leonardo employed the ermine in his *Portrait of a Woman,* about 1483, in Cracow (6–10). His use of the ermine here must be seen hieroglyphically. It represents Cecilia Gallerani, the mistress of Ludovico Il Moro, who used the ermine as his personal emblem. "Ermine" in Greek is "gallei" and thus there is seen here a punning reference made to the name of the sitter as well as to her virtue. The people of Il Moro's court were expected to understand immediately this hieroglyphic mode of thought.

Other animal forms are read hieroglyphically. For exam-

ple, on the obverse side of a medal by Francesco di Giorgio bearing the image of Antonio Spannocchi of a Sienese banking family, the salamander is portrayed in flames (6–11). According to Aristotle, this illustrates the salamander's power to survive fire and symbolizes longevity. This legend was disseminated in Christian Europe through bestiaries. In medieval manuscripts, the salamander symbolizes the righteous man who is not consumed by the fire of lust. The flames were also identified as representing torrents of love. The inscription, "Ignis ipsam recreat et me cruciat" (Fire invigorates him but torments me), was identified with the Spannocchi family.

Another medal attributed to Battista Elia da Genova represents Doge Battista (6–12). On the reverse side, a little bird is represented flying into the open jaws of a crocodile. Ancient writers such as Herodotus and Pliny described this bird that feeds by picking crumbs from the teeth of sleeping crocodiles. The story was also included in the *Physiologus* and the motto that this illustrates is "sustenance through boldness." Both the hieroglyphic and the *Physiologus* traditions were used for the same purpose: to convey a concept by means of a pictograph.

The adviser to the Doge was Fra Giovanni Nanni da Viterbo, who was also the adviser to Pope Alexander VI. He won notoriety for his forgeries of Egyptian, Greek, and Roman texts that were first published as *Commentaries on Antiquity* in 1498. Nanni was responsible for constructing a genealogical link between the Apis Bull and the Borgia family, and he devised the program for the Pinturicchio cycle of frescoes in the Vatican (6–13). Illustrations from the story of Isis and Osiris include *The Murder of Osiris and His Reincarnation as the Apis Bull*, *The Christianized Bull Venerating the Virgin*, and *The Bull Kneeling Before the Pope, the Vicar of Christ*, illustrating that a pagan connection with the family of the pope exists.

The emperor Maximilian also regarded his genealogy as being traced back to antiquity – in fact, he believed his lineage could be traced to Noah. Dürer's *Triumphal Arch of Maximilian* (6–14, 15) of 1515 is the largest woodcut ever created. Its overall dimension is eleven feet six inches by nine feet nine inches, and it is composed of 192 separate blocks. Its crowning feature is the image of the emperor Maximilian, seen in Pirckheimer's *Horapollo*, enthroned and surrounded by strange symbolic animals. All of these images are gleaned from the

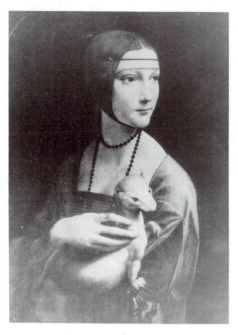

Figure 6-11. Francesco di Giorgio (?). Medal with portrait of Antonio d'Ambrogio Spannocchi (obverse). 1494(?). Reverse: salamander in flames. British Museum, London. Reproduced in Hill, *Italian Medals.*

Figure 6-10. Leonardo da Vinci. *Portrait of a Woman with Ermine* (Cecilia Gallerani). ca. 1483. Museum Narodowe w Krckowie, Czartorysky Collection, Cracow.

Figure 6-12. Battista Elia da Genoa (?). Medal with portrait of Doge Battista II di Pietro di Campofregoso (obverse). 1478–83. Reverse: bird and crocodile. Reproduced in Hill, *Italian Medals.*

Figure 6-13(a–d). Bernardino Pinturicchio. Isis and Osiris fresco cycle. Borgia Apartments, Vatican. Reproduced in Franz Ehrle, *Les Fresques du Pinturicchio dan les Salles Borgia au Vatican...* Rome, 1898. Alinari/Art Resource.

Horapollo, and the message can be decoded. Maximilian is a prince (dog with stole) of great piety (star), most magnanimous, powerful, and courageous (lion), ennobled by eternal fame (basilisk on crown), descending from an ancient lineage (papyrus), a Roman emperor (double eagle) endowed with all gifts of na-

Figure 6-13b

ture, ruler of a great part of the terrestrial globe (in his hand),
has, with warlike virtue (bull) and great discretion won a shin-
ing victory (falcon) over the king of France (cock on serpent)
and thereby watchfully protected himself from the stratagems
of the enemy. Thus, the pictograph reads as a discursive text.
It also serves to illustrate the interest Maximilian had in this
symbolic language; it was through the humanists in Maximi-
lian's court that an interest in hieroglyphics was firmly estab-
lished in Germany.

Figure 6-13c

Figure 6-13d

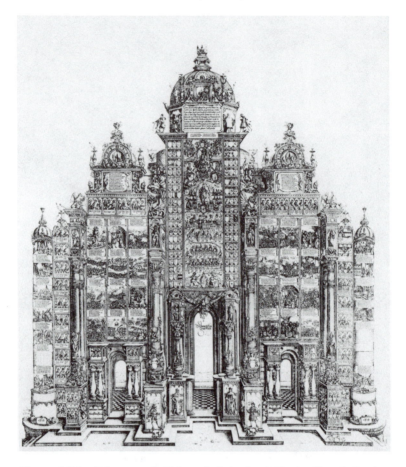

Figure 6-14. Dürer et al. Triumphal Arch of Maximilian I. Design completed, 1515. Woodcut. Nationalbibliothek, Vienna (Cod. 3255). Reproduced in Erwin Panofsky, *Albrecht Dürer*, 2 vols. Princeton, 1948. Marburg/Art Resource.

Mantegna's cartoons of about 1490 for his frescoes of the *Triumph of Caesar*, now at Hampton Court, incorporate signs from the ancient temple frieze of Vespasian. The frieze abounds with symbols taken from the *Horapollo* and other hieroglyphic sources. No attempt has been made to read the representation, but behind Caesar is an orb with a cornucopia signifying the affluence of the world under Caesar. However, more important than the interpretation of these symbols is the fact that a broad

Figure 6-15. Detail of 6-14.

Figure 6-16. Hieroglyph. From Francesco Colonna, *Hypnerotoma-chia Poliphili*. Venice, 1499. Reproduced in Appel, *Dream of Poliphilus*.

movement at the time tried to reconcile hieroglyphics with Christian thought.

Other examples that illustrate this movement include woodcuts of frescoes found in the cloister of S. Giustiana in Padua by Bernardo Parentino, begun before 1500 and completed in the 1540s, that incorporate types of hieroglyphs found in the *Hypnerotomachia*.

An illustration of a woman with one foot raised and one engaged, with one hand winged and the other holding a tortoise (6–16), means temper speed by sitting and inertia by getting up. Two genii holding the center of a circle suggest that it is wise to keep to the middle road.

Hieroglyphs from the *Horapollo* have also been traced to a room decorated by Alessandro Araldi in 1514 next to Correggio's frescoes in S. Paolo of 1518–9 at Parma, discussed by Panofsky (1961). Correggio drew heavily on classical themes, as many artists did; moreover, he expressed ideas accessible only to the learned. His language is hieroglyphic implicitly if not explicitly.

Andrea Alciati who studied in Bologna incorporated hieroglyphs in verses, and published his *Emblemata* in 1531 (6–17). These illustrated editions competed in popularity at this time with the *Horapollo*. For Alciati, an emblem was an esoteric means of expressing a conceit, through picture and word. He declared symbols and hieroglyphs to be the same thing and in this bold stand anticipated the work of Pierio Valeriano.

The *Hieroglyphica* of 1556 by Pierio Valeriano (known also as Giovanni Pietro della Fossa) remained the unchallenged "modern" authority on hieroglyphic questions until the beginning of the eighteenth century (6–18). A friend of Francesco Colonna, he was the center of a circle of Venetian scholars dedicated to the study of hieroglyphics. Valeriano was a tutor of Ippolito and Alessandro Medici, and he became the private secretary to Giulio de Medici as well as tutor to Giovanni de Medici who later became Pope Leo X. His *Hieroglyphica*, influenced by Ficino and the Neoplatonists, consisted of fifty-eight books, each dealing with the symbolic significance of one or more hieroglyphics. From the *Horapollo* he takes the allegorical method to explain hieroglyphics, while at the same time a basic Christian attitude is reflected in his ethical and moralizing tendencies that is foreign to the *Horapollo*. It is closely related to the *Physiologus*, the *Bible*, the *Cabala*, and bestiar-

Figure 6-17. Andreae Alciati. *Emblemata cum Commentariis.* 1531 and 1551. A posthumous edition of 1621. Reprint: New York, 1976.

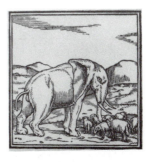

Figure 6-18 Hieroglyphs. From Pierio Valeriano (Giovanni Pietro della Fossa), *Hieroglyphica.* 1556.

ies. Valeriano made the point that there was no difference be-
tween hieroglyphics and symbols and agreed with Pico della
Mirandola that the Old Testament was written in allegory and
that Homer contained hieroglyphics. For him, to speak hiero-
glyphically was nothing else but to disclose the true nature of
things divine and human.

Valeriano had an enormous following and although he
proposed no revolutionary ideas, he was instrumental in trans-
forming a philosophy of hieroglyphics to a philological disci-
pline. He taught Vasari and he dedicated his *Hieroglyphica* to
Cosimo de Medici.

Ficino had closed the gap between Egyptian and Christian
symbols, and the *Hieroglyphica*'s dedication to Cosimo de
Medici returned the focus on this discussion to Florence.

SEVEN

Hieroglyphics II
SEVENTEENTH AND EIGHTEENTH
CENTURY PHILOLOGICAL CONCERNS

Interest in the symbolic language of pseudohieroglyphics developed by the philosophers and humanists of the Renaissance was carried over into the seventeenth century. The emphasis, however, shifted and hieroglyphics attracted greater philological concern.

One man among the Egyptologists of the seventeenth century deserves special attention – Athanasius Kircher, who was born in Germany in 1601. He was educated by the Jesuits, and at an early age he became involved in Egyptology. He was also engaged with Coptic manuscripts at the time, and he published a grammar of the Coptic language. Kircher maintained that Coptic writing and Egyptian hieroglyphic writing were basically the same, and he spent the rest of his very active life working from this incorrect assumption. Kircher went to Rome in 1633, and was appointed to a chair of mathematics at the Jesuit College of Rome. From that time on, he devoted his spare time to his favorite hobby – the solution of the hieroglyphic problem.

In this context, it is perhaps interesting to note that the basic point from which Kircher started was still a Neoplatonic concept. He saw hieroglyphics as visual emanations expressing

the thought of the symbol. He completely subscribed to the ideas with which we are familiar now that hieroglyphs contained the esoteric knowledge of the Egyptians.

Even though Kircher is often ridiculed nowadays, he was a great scholar and did advance our knowledge of hieroglyphics to some extent, but that is not the most interesting side of this problem. Of principal concern here is that he had the standing of a scholar of exceptional wisdom and that he was very close to the papal court. Two popes – Innocent X and Alexander VII – relied on him to publish the obelisks and explain their meaning, first the obelisk placed by Bernini in the Piazza Navona, and then the obelisk placed by him in front of S. Maria Sopra Minerva. From these two examples, it may be seen that connections existed between the Neoplatonic scholar Kircher, the pope himself, and Bernini, and that these interconnections exerted a significant formative influence in shaping contemporary interpretation of such monuments as these in symbolic terms. For example, it seems evident that the monument in front of S. Maria Sopra Minerva must be seen and explained in hieroglyphic terms. Now the elephant carrying the obelisk, of course, had a pedigree, as did the obelisk as a symbolic form.

Emblematic antecedent for the obelisk appears, for example, in the Bolognese humanist Achillis Bocchi's *Symbolicarum* ... (7–1), a book about symbolic problems that appeared in 1555 (Bologna) and was published again in 1574. An engraving from his publication illustrates an instructive emblematic conceit – a memorial dedicated to a young man and bearing the inscription "Vera Gloria" – in other words, the obelisk here is a monument of an emblem of true glory. The monument to Cardinal Francesco Sfondrato in Cremona of 1550, discussed previously, also stands in the emblematic tradition, but unfortunately it has never been properly published; consequently the inscription cannot be read in the available material.

Another monument of approximately the same time demonstrates the use of the obelisk and beast (7–2). The obelisk, raised on the back of a rhinoceros, was erected at the entry into Paris of Henry II of France in 1549. It was, of course, not made of permanent material, but consisted of wood and canvas; then, it was painted as if it were a permanent monument. The artist who was responsible for the monument was Jean Goujon, who also probably executed the illustrations for the French edition of the *Hypnerotomachia Poliphili,* published in 1546, which

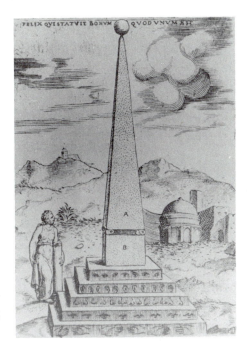

FELIX QVI STATVIT BONVM QVOD VNVM EST

Figure 7-1. Achillis Bocchi. *Symbolicarum Questionum... Libri.* Bologna, 1555, 1574. "Resurexit ex Virtute Vera Gloria." Book II, Symb. XLVIII.

included an illustration of an elephant, the rare and exotic animal traditionally famed for his strength, carrying an obelisk.

In an article in the *Art Bulletin* of September 1947, William Heckscher gives a full discussion of the elephant and the obelisk, and in his analysis he develops a very credible explanation of why a rhinoceros rather than an elephant was selected for Goujon's monument to Henry II.

Not long before Goujon's monument to Henry II was executed, the pope, who owned both an elephant and a rhinoceros, wanted to know which great beast would be victorious in a fight. The result of the encounter was that as soon as the elephant was confronted by the rhinoceros, he refused to do battle – in fact, he took to flight. Heckscher argues (I think correctly) that, because the elephant had not shown the prowess that was expected of him and because the rhinoceros superseded the elephant in courage and strength, the rhinoceros was therefore selected as the appropriate animal to support the obelisk. After all, the monument (honoring Henry II's reign as king) was to represent the force and vigilance that should guard the realm.

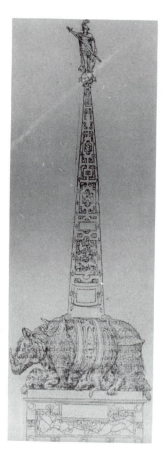

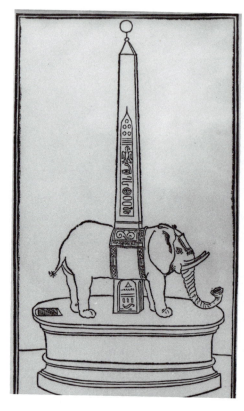

Figure 7-2. Jean Goujon. Reproduction of rhinoceros and obelisk. Erected for entry of Henry II to Paris, 1549. Reproduced in Iverson, *Myth of Egypt.*

Figure 7-3. Elephant and obelisk. From Francesco Colonna, *Hypnerotomachia Poliphili.* Venice, 1499. Reproduced in Iverson, *Myth of Egypt.*

The ideas and influences that shaped the erection of Bernini's monument in front of S. Maria Sopra Minerva differed greatly from those that crystallized around the execution of Goujon's monument in the previous century. Although both monuments had common origins in the *Hypnerotomachia Poliphili* (7–3), each artist employed Colonna's famous source quite differently. Behind Bernini's idea of the mighty elephant carrying the obelisk lay the more traditional hieroglyphic thought embodied in the *Hypnerotomachia* (there seems little

doubt that the illustration in the *Hypnerotomachia* in Pope Alexander VII's library served as the model for Bernini's monument). Kircher explains the significance of the union of elephant and obelisk in terms of an emblematic concept: "Let every beholder of the images engraven by the wise Egyptian and carried by the elephant, the strongest of beasts, reflect this lesson: be of strong mind, uphold solid wisdom."

Thus, Goujon, inspired originally by Colonna's great compendium of hieroglyphic forms, modified his model in response to contemporary exigencies, and Bernini, a century later, returned to the earlier model for his inspiration. The obelisk, symbolizing wisdom, and the elephant, signifying strength, are combined in Bernini's monument to form a symbol emblematic of a great pope. A poem published at the time the monument was erected reflects this spirit, and although it embodies a complex conceit, it is useful to illustrate the way people were thinking at that time, as well:

The Egyptian obelisk, symbol of the ways of the soul
Is brought by the Elephant to the Seventh Alexander, as a gift.
Is not the animal wise?
Wisdom has given to the world surely thee, oh Seventh Alexander.
Consequently, thou hast the gift of soul.

It may be observed then in the seventeenth century that on the one hand there was a continuation of Neoplatonic syncretism and decorative use of Egyptian material, while on the other hand, scholarly investigation of the material itself resulted in a stress on the philological interest in hieroglyphics as well as on their emblematic significance.

The emblematic use of Egyptian material was not restricted to Rome. It is found elsewhere. For example, in Paris the Porte St. Denis, which was designed by Nicolas Francois Blondel in 1672, is a classical piece of architecture in front of which the architect has placed two large obelisks with carvings that represent the victorious wars of Louis XIV.

Thus, in France of the seventeenth century there are expressions of Egyptian material that derive from fifteenth- and sixteenth-century concepts. Nobody has yet investigated the Egyptian elements of Blondel's structure in detail, but I am sure once one does that the emblems will begin to speak and tell us more in hieroglyphic language than we expect today.

This has been done with J. H. Mansart's Invalides Chapel in Paris (1680–91; 7–4).

In 1687, a general description of the project was published; an engraving of the design illustrates the lantern with an obelisk on top decorated with the symbolic lilies of France. The obelisk rests on three sphinxes and is topped by an orb, a crown, and a cross. This design is inspired by the *Hypnerotomachia* whose author maintains that the obelisk resting on three sphinxes is a symbol of the mystical Trinity. In a paper on the design of this church, in the *Journal of the Warburg and Courtauld Institutes* (1960), A. J. Braham explains that the symbolism of these elements is an allusion to the reigning house, thus, the crown over the orb refers to Louis XIV. The cross above signifies the perpetuity of a happy balance of power and influence among France, God, and the world (orb).

Thus, it is well to note that there is a good deal of this hieroglyphic material around, but scholars have not as yet become accustomed to reading it. Some paintings by Poussin are also found to contain elements that reflect the influence of Egyptian material. For example, his *Adoration of the Golden Calf* (7–5), painted in the 1630s and now in the National Gallery in London, has been the subject of a learned paper by Charles Dempsey, published in the *Art Bulletin* (1963), in which the author points out that Poussin's Golden Calf is quite evidently not the cow but the bull in the composition. Dempsey concludes (very convincingly) that this is an Apis Bull and thus behind this composition lies the syncretism encountered before in which the mystic teachings of the Egyptians, the wisdom of the Old and New Testaments, and the ideas reflected in the Neoplatonism of the age seem to merge and meld with contemporary Christianity.

In Poussin's *Moses Taken from the Water* of 1651, now in the Schreiber Collection in England (7–6), the artist embraces certain elements that reflect the Egyptian influences. He is careful in rendering the long Egyptian hair, he includes a temple that appears to be Greek except that it is surrounded by a wall, and there is a palm tree common in ancient frescoes within the enclosure that became, virtually, a hieroglyph for Egypt.

In his *Rest on the Flight into Egypt* (7–7) in the Hermitage in Leningrad (1655), Poussin illustrates in the background obelisks and a train of priests with heads shaved and crowned with leaves, carrying tambourines, in procession to the temple

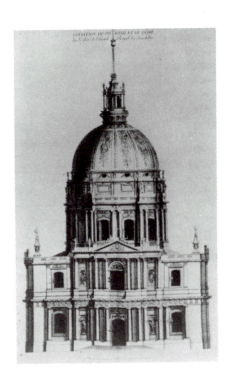

Figure 7-4. Jules Hardouin Mansart. Invalides Chapel, Paris. 1679–91. Engraving by Jacques Lepautre. 1687. Reproduced in Reutherward, *The Two Churches of the Hotel des Invalides: A History of Their Design.* Stockholm, 1965.

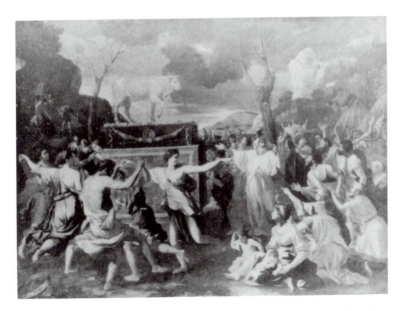

Figure 7-5. Nicholas Poussin. *Adoration of the Golden Calf.* 1636. National Gallery, London.

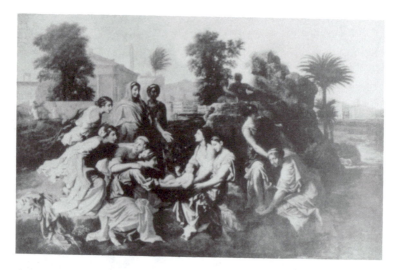

Figure 7-6. Nicholas Poussin. *Moses Taken from the Water.* 1651. Schreiber Collection, London.

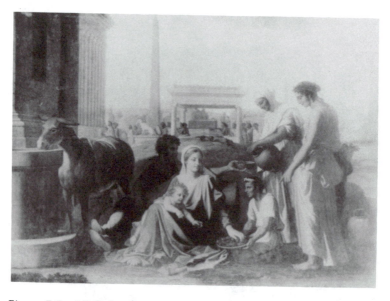

Figure 7-7. Nicholas Poussin. *Rest on the Flight into Egypt.* 1655. Hermitage, Leningrad.

of Serapis. This is not unlike the portrayal of the Priest of Isis in the Palestrina mosaics in procession to the Temple of Isis. He selects and transposes elements drawn from the Temple of Fortuna, Palestrina, in whose mosaics the history of Egypt is depicted. Poussin strove to achieve a correct rendering of the environment of Egypt, and for seventeenth-century Rome these were considered accurate pictorial accounts of Egypt. Dempsey sees in this attention to authentic detail a reflection of the contemporary investigations into Egyptian material and a heightened response, on the part of Poussin, to an archaeological interest in Egypt then very popular. This may be called an iconological reference to the derivation of Christianity and there may be also here a reference to the identity of Isis and the Virgin Mary.

In the beginning of the eighteenth century, a new attitude toward Egypt develops. In the seventeenth century, scholarly travels to Egypt had been few and far between, but in the course of the new century, many travelers went to Egypt and published reports of their trips and research. There were approximately forty accounts in English, as many in French, and somewhat fewer in other languages. The first substantial publication of this kind to appear, by Paul Lukas (French) in 1719, is particularly significant because it was used by Fischer von Erlach in developing his compendium of architectural styles. One of the most important travel accounts in English was by Dr. Pococke, based on his travels to Egypt in 1737–8 and published in 1743–5 as *Descriptions of the East*. Among the highlights of Pococke's book are some very reliable renderings of various types of Egyptian columns (7–8).

Perhaps the most distinguished publication, before Denon's report of Napoleon's expedition, is that of Ludwig Norden, a Danish naval officer who went to Egypt in 1737–8, but due to his early death the book appeared posthumously in 1755 (a later edition appeared in 1792). Norden points out that he is not an archaeologist and knows very little about such matters, but that he wants to give an accurate impression of the country and various aspects of life in the country. In spite of Norden's assurance that he knows little about archaeology, his account, *The Antiquities... of Egypt...*, is the most complete and reliable source up to that time. His book includes impressive illustrations (7–9) such as a reconstruction of the main entrance gate to the temple at Luxor (7–10). His illustrations are re-

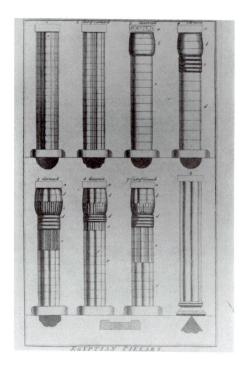

Figure 7-8. Egyptian columns. Plate LXVI of Richard Pococke, *A Description of the East.* London: W. Bowyer, 1743–5.

markably accurate from an archaeological point of view, and his presentation of illustrations, as a quick perusal verifies, has a kind of modern sensibility. Norden's publication articulates perhaps most effectively the character of this newly developing archaeological age.

In passing, it is interesting to note that private collectors had become interested in this material in the seventeenth century. Kircher had been, understandably, the greatest collector of Egyptian material of the century and had the reputation of being its greatest Egyptologist; his writings were regarded as above question for at least a hundred years. His collection, the envy of any museum, was later dispersed and pieces found their ways to Florence, Turin, Rome, and elsewhere. I recently encountered a catalog – until then unknown to me – of the Museo Muscardo, the private museum of Count Ludwig Muscardo of Verona, and dated 1672. This seemed to me to be revealing with regard to the extent of interest in Egyptian material.

From the mid-seventeenth century onward a great quan-

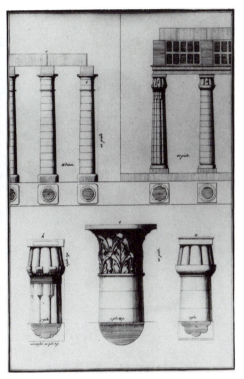

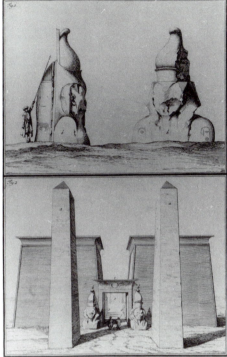

Figure 7-9. Egyptian columns and capitals. Plate LVI of Frederik Ludvig Norden, *Voyage d'Egypte et de Nubie.* Copenhague: Imprimerie de la maison royale des orphelino, 1755. In English: *The Antiquities, Natural History, Ruins, and Other Curiosities of Egypt, Nubia, and Thebes.* London: Jeffery, 1792.

Figure 7-10. Portal of Luxor. Plate CVI of Norden, *Voyage.*

tity of material was accumulated that had to be sifted and organized in an orderly way. B. Montfaucon, active as a publicist, and a great mind of the eighteenth century, effectively satisfied this need in *L'antiquité Expliqué* (1719–24). This fifteen-volume work included an enormous amount of material, rich with plates, ranging in scope from the gods and goddesses of antiquity to a critical assessment of Egyptological material. An English edition, somewhat shorter appeared in 1721 (7–11–13).

Montfaucon broke with the Neoplatonic thinkers of the Renaissance in his refusal to admire Egyptian wisdom. More-

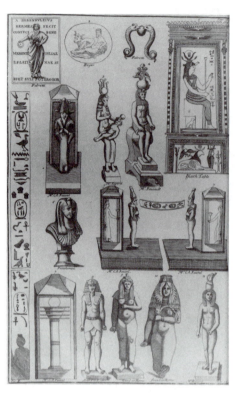
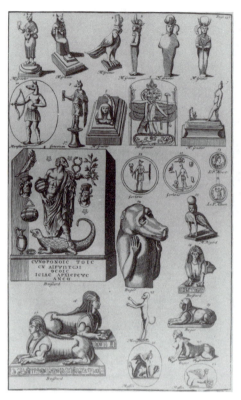
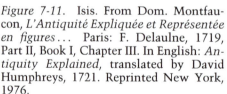

Figure 7-11. Isis. From Dom. Montfaucon, *L'Antiquité Expliquée et Représentée en figures...* Paris: F. Delaulne, 1719, Part II, Book I, Chapter III. In English: *Antiquity Explained*, translated by David Humphreys, 1721. Reprinted New York, 1976.

Figure 7-12. Anubis, a god with a dog's head, and sphinxes. From Montfaucon, *L'Antiquité Expliquée et Représentée en figures...* Paris: F. Delaulne, 1719, Part II, Book I, Chapter III. In English: *Antiquity Explained*, translated by David Humphreys, 1721. Reprinted New York, 1976.

over, he regarded Egyptian religion as monstrous and Egyptian art as horrible; he gave no consideration to style in Egyptian art. He refused to try to interpret hieroglyphics, and he even maintained that they could not be interpreted with any accuracy. In his attitudes and convictions, Monfaucon gave voice to a new spirit, a spirit that would be identified with eighteenth-century Rationalism. In this attitude, archaeological erudition went hand in hand with sober criticism and emotional disenchantment.

William Warburton, Bishop of Gloucester, and a literary

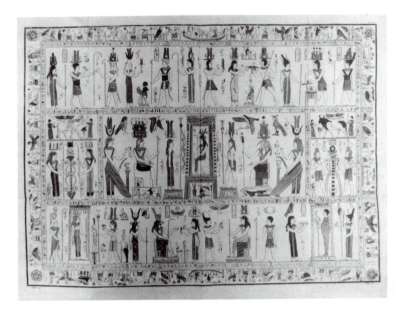

Figure 7-13. Table of Isis. From Montfaucon, *L'Antiquité Expliquée et Représentée en figures*... Paris: F. Delaulne, 1719, Part II, Book I, Chapter III. In English: *Antiquity Explained*, translated by David Humphreys, 1721. Reprinted New York, 1976.

figure of the period, shared Monfaucon's attitudes. He published a four-volume work, *The Divine Legation of Moses*, in which he discussed hieroglyphic writing. He derided Kircher for his Neoplatonic mysticism and for relying on forged literary sources to explain ancient monuments. Warburton suggested leaving these ideas alone, that their day had come to an end. The Age of Enlightenment then had no taste for a Neoplatonic view of the world.

Another important work of the period is that of the Count de Caylus, a collection of antiquities in seven volumes published a generation later, *Recueils d'antiquité egyptien* (1752–67). Caylus shows aesthetic interest in Egyptian material, which is the main difference between Monfaucon and Caylus. Caylus was an enthusiastic dilettante, collector, and intellectual. He used and adapted the theory of the succession of world empires, that is, one empire grows and then decays, and the process is continuous. In this framework, Caylus postulated the arts carried from empire to empire. Thus, massiveness,

barrenness, and grandeur were the essential features of Egyptian art. These characteristics were passed on to the Etruscans, who added detail. From the Etruscans this style migrated to Greece, where, based on earlier work, the Greeks developed the arts to their greatest perfection. Then Rome derived a style from Greek art that represented a decline.

The conviction that Egypt was the source of occult sciences, however, was hard to kill. It lived on as an undercurrent through the eighteenth century in secret societies such as the Rosecrucians and Freemasons. Symbolic ideas returned to the surface later in the century under Napoleon when an Egyptian symbol became an official pattern of the empire.

Although the spirit of Neoplatonism and mysticism heretofore associated with Egyptian material held little attraction for the eighteenth century, Egyptian art considered as a style made its entry into the period in a forceful way. There is a certain logic to this new interest also. As long as Egypt was a riddle and challenge that captivated man's thought, no serious attempt was made to grasp and imitate Egyptian art. When the spell was broken by archaeological detection, the door was open for a study of style in its own right.

EIGHT

Piranesi's Contribution to European Egyptomania

The first artist to appreciate the stylistic conception of Egyptian art was the Austrian architect Fischer von Erlach, whose *Entwurf einer historischen Architektur* was published in 1721 in Vienna (a second edition came out posthumously in 1725 in Leipzig). His principal aim was to show the continuity, or unbroken development, of the history of architecture to modern times. His work begins with the Temple of Serapis.

Erlach attempted to be as historically accurate as possible. He sought documentation to support his material and read all available travel accounts of the areas he was exploring. Thus, he relied on such sources as Paul Lukas. Because Erlach lacked sufficient information to reconstruct what had existed, his accomplishment is all the more remarkable.

Erlach was a practicing architect-artist who had an eye for the marvelous simplicity of Egyptian architecture (8–1). Thus, the question arises as to how much of his own stylistic feeling goes into his renderings. A perusal of his illustrations of the pyramids at Thebes and Memphis (8–2) are useful examples to consider in this regard. He believed that Egyptian pyramids – solid, rising like a flame to a point, slowly by

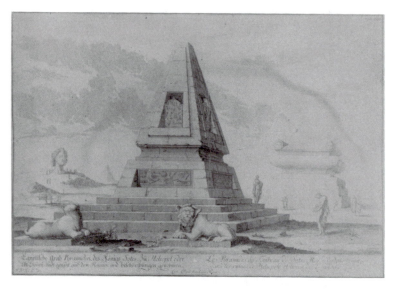

Figure 8-1. Tomb of Sothis with hieroglyphics from the *Hypnero-tomachia*. From Johann Bernhard Fischer von Erlach, *Entwurf einer historischen architectur . . .* , 2nd ed. Vienna, 1721. Reproduced in Iverson, *Myth of Egypt.*

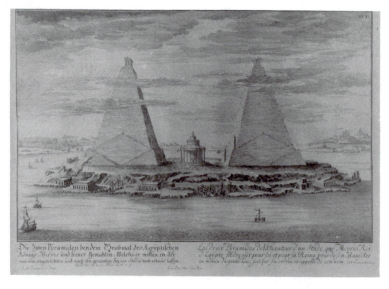

Figure 8-2. Pyramids of Memphis. From Fischer von Erlach, *Entwurf einer historischen architectur . . .* 2nd ed. Vienna, 1721.

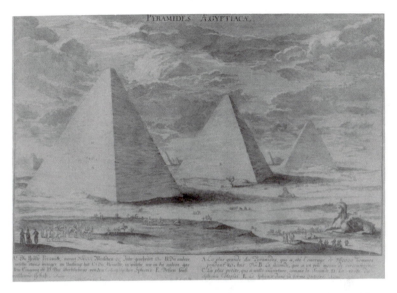

Figure 8-3. Pyramids. From Fischer von Erlach, *Entwurf einer historischen architectur*...2nd ed. Vienna, 1721.

degrees – had overcome the force of time (8–3). His descriptions set forth a language that had not been spoken before.

Erlach's reconstruction of the Mausoleum of Halicarnassus makes an interesting comparison with the material from England that I discussed, which is a little earlier but overlaps this period. It may be that Hawksmoor's late work at Castle Howard was done under the influence of Fischer von Erlach. It would certainly not be unusual. Erlach's publication was enormously successful and exerted a widespread and long-lasting influence. One of the more important figures influenced by Fischer von Erlach was Giovanni Battista Piranesi.

Piranesi was born in 1720 on the mainland opposite Venice. He was educated there and studied stage designs, which introduced him to a sprinkling of Egyptian material. He went to Rome in 1740 and began his career as a draftsman and maker of magnificent prints. He was an imaginative scenographer in the Baroque tradition of the Bibienas, as his first volume of etchings in 1743 shows.

In his *Carceri d'invenzione* (1745, first edition; 1760–1, second edition), Piranesi shows an unparalleled paroxysm of creativity, isolated at times, with no relationship to reality, a

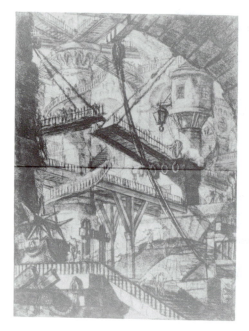 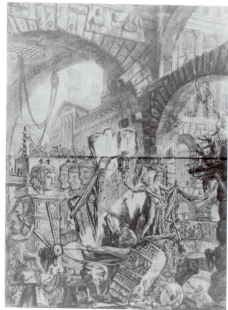

Figure 8-4. Prison view. From Giovanni Battista Piranesi, *Carceri d'Invenzione* (1745, 1760–1). Ashmolean Museum of Art and Archaeology, Oxford.

Figure 8-5. Piranesi, *Carceri d'Invenzione* (1745, 1760–1).

forerunner of the Romantic age (8–4, 5). But his imagination moved away from fantasies – he was absorbed with ancient and modern Rome and developed into the foremost topographical artist of his age. In 1748, he published his dramatic views of Roman ruins (another edition followed in 1756) in his *Vedute*, which included 137 etchings of ancient and modern Rome, and steeped himself in topographical renderings and data on Rome (8–6a, b, c).

Up to 1761, when he was forty-one, there was little indication that he would take a leading part in the vital controversies that went on in the second half of the eighteenth century. However, in the 1760s, he became outspoken in the defense of Roman architecture as opposed to the claims that were made for Greek architecture. He knew Caylus's work, but maintained that the Etruscans were the sole masters of building, not the Greeks. For him Etruscan architecture was similar to Egyptian architecture in the absence of adornment. He

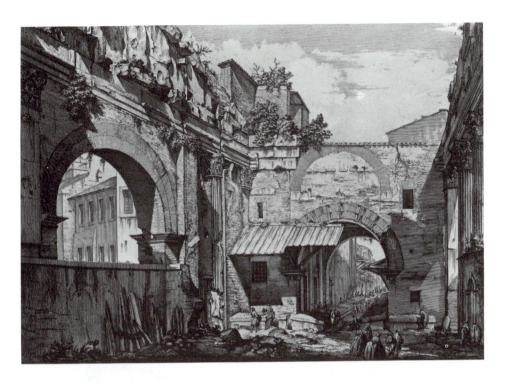

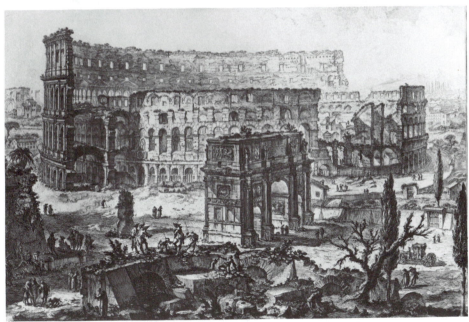

Figures 8-6a (top), *b* (bottom). Legend on following page, 8-6c

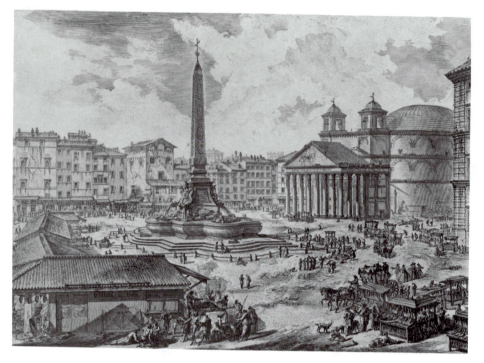

Figure 8-6a,b,c. Views of Antiquity. From Piranesi, *Antichità Ro-mane.* 1748, 1756. Alinari/Art Resource.

fought for reason, necessity, truth, simplicity – characteristics that he identified with Etruscan architecture and which, for him, explained why Etruscan architecture succeeded and Greek architecture failed.

In 1765, he shifted his position. Repudiating Vitruvius and rationalism, he said that the variety of Roman buildings should encourage free, imaginative use of ancient models. He intended to show how an entire heritage can be combined in a personal contemporary style. In one sense, archaeological material had become a weapon in the hands of a revolutionary modernist (8–7, 8).

In 1769, he published the *Diverse Manners of Decorating Chimney Pieces* (dedicated to a nephew of Clement XIII) in which he branched out into Egyptian modes (8–9–12). For him, the modern manner of beauty was unsatisfactory. He recommended the use of Greek, Egyptian, and Etruscan designs and the borrowing from their monuments to achieve the variety

Figures 8-7 (top), 8-8 (right). Piranesi, *Parere su l'Architettura.* 1765. Reproduced in J. Wilton-Ely, *Giovanni Battista Piranese: The Polemical Works, Rome, 1757, 1761, 1765, 1769.* London, 1972.

these models offer. Piranesi here introduces for the first time interior Egyptian motifs. They exhibit the same stylistic idiosyncracies of his exterior designs of 1765 (in *Parere sull'architettura*). His text clarifies the character of the designs and claims that ancient authority is on his side. Now he claims Rome united Greek and Etruscan creations. He maintains that

Figures 8-9–12. Piranesi, *The Diverse Manners of Decorating Chimney Pieces*, Rome, 1769. Reproduced in Wilton-Ely, *Piranese.*

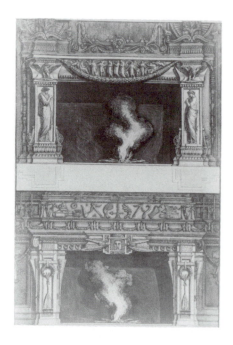

Figure 8-9.

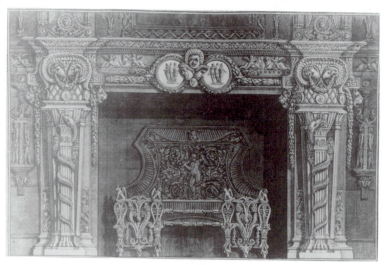

Figure 8-10.

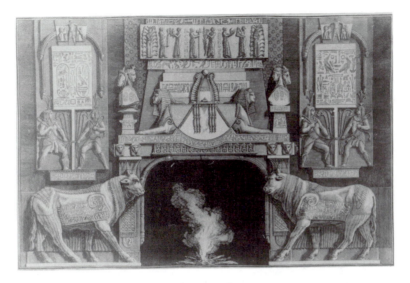

Figure 8-11. (Legend on preceding page)

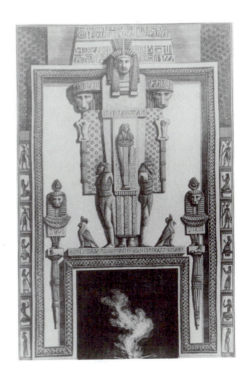

Figure 8-12. (Legend on preceding page)

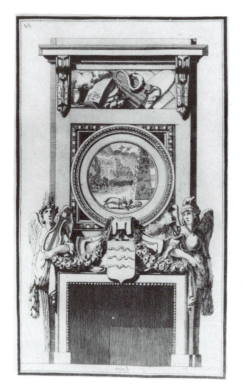

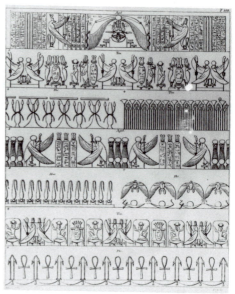

Figure 8-13. Piranesi. Wall painting in Egyptian style. English Coffee House. Piazza di Spagna, Rome. ca. 1765. Published in *The Diverse Manners.*

Figure 8-14. Emblems from Egyptian Temples. From Vivant Denon, *Voyage dans la basse et la haute Egypte.* Paris, 1802.

modern architecture must not copy works but must draw on the entire heritage of antiquity to create new decoration and new manners. Thus, a spirit of adventurous creativity entitled Piranesi to use ancient material in a personal way.

 The book also included engravings of the so-called English Coffee House in the Piazza di Spagna (8–13), which Piranesi had decorated in the Egyptian manner perhaps as early as 1765. Fortunately, the engravings published here have preserved for us the extraordinary interior design, and one wonders what the Romans said when they walked into this coffeehouse – and also what the English visitors thought who were there sipping coffee. They were now faced with something utterly different from anything that had been seen before in Europe. I do not know any reports of people's reactions to these decorations,

but even if by chance no letters or memoirs have been pre-
served, we can be sure that the design must have made a stun-
ning impression on the public. This was the first time that
Egypt seemed to be speaking with a true voice. But was it a
true voice? Actually, Piranesi simply accumulated Egyptian
material from what he knew in the Vatican and private col-
lections, and composed the elements in a very strange, yet
picturesque manner. Furthermore, Piranesi was familiar with
Robert Adam's designs, which were popular in England then.

Piranesi's chimneypieces or fireplaces are particularly
noteworthy. They usually reflect a variety of styles, but some
are composed of purely Egyptian motifs. A rational discussion
of this kind of thing, however, makes no real sense in terms
of Egyptian art, and in the introduction he also clearly states
that he was very much aware that this was not "Egypt proper,"
but that these designs reflected an adaptation of Egyptian ma-
terial "to our own manners and customs." He also expected
that people would take issue with him over the question of
overloading his designs. He made it quite clear that to his mind
these designs are not overloaded.

Modern art historians have not been very kind to these
designs; they just do not like them. It must be recognized
though that Piranesi started something of great importance
here, and that he was also capable of assessing Egyptian art
properly. He expressed it, of course, in eighteenth-century
terms. He believed that it was not necessary for things to be
beautiful in the sense of Classical Roman or Greek art.

For Piranesi, art could also be effective owing to its awe-
inspiring quality, strength, boldness, and stiffness (character-
istics of the stylized nature of Egyptian art), all elements that
were completely contrary to classical beauty. This is sublime
art (though Piranesi does not use the word) as Edmund Burke
defines the term in his treatise on *The Sublime and the
Beautiful.*

Here Piranesi makes a case for Egyptian art representing
the quintessence of the sublime. It must be emphasized again,
however, that this does not apply to Egyptian art in its pristine
state, but to Egyptian art as it was manipulated by Piranesi
in his own way. It was a way of bringing Egypt up to date,
but if you look back at all the material we have seen before,
it was an entirely new vision and we must grant Piranesi the
credit for starting the Egyptomania that kept the last decades

of the eighteenth century and first half of the nineteenth century busy with Egyptian monuments, interior decoration, and architecture.

In some of his designs he employed a hieroglyphic frieze, but for Piranesi these were not hieroglyphics. He regarded all this material as purely decorative and he insisted that even for the Egyptians much of this hieroglyphic material was decorative and had no meaning. For Piranesi, all this must be seen as an accumulation of decorative elements that would convey a sensation of sublimity.

In the Egyptian chimneypieces, Piranesi's own personal stylistic feeling in art can be defined very clearly. The personal quality of his designs is very important because from these designs there is a definite line of influence to England and from England (and perhaps even directly from Rome) to Paris. That is to say, I think, we have to recognize Piranesi as the main instigator of the Empire style that came along under Napoleon.

Napoleon put the whole question of Egyptology on a new basis with his campaign of 1798–9. He was accompanied to Egypt by 150 scholars and the result of the expedition was an immense publication, written by Denon, of great importance to the further history of Egyptology (8–14, 15).

Thus, although it is important to remember the role played by Piranesi in the development of a new style, it is also true that the proper Egyptian revival in this period tends to be much more archaeological than Piranesi wanted it to be. In an archaeological approach, there may be the danger of producing architecture and decoration that remains on paper and that does not become a living style. A few designs may be instructive here. Many of these Egyptian designs remained on paper because, trying to be as large as the pyramids, they reflect a kind of megalomania. The French Revolution, of course, destroyed the basis for such creations. A design by Étienne-Louis Boullée, one of the architects taken over by the Revolution, for the Assembly Hall for the National Parliament (8–16) is a typical example of these ideas.

Charles Percier and Pierre Fontaine are together responsible for the Empire style. They had both gone to Rome, recipients of the Grand Prix, where they met. After their return to Paris, they opened a common practice around 1794, which lasted for eighteen years. Napoleon made them his personal

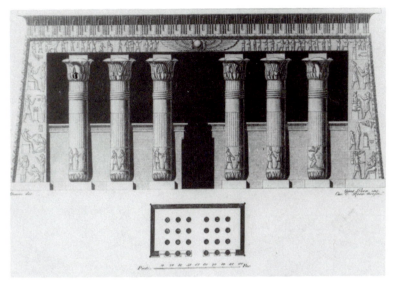

Figure 8-15. Tempio di Latopoli. From Denon, *Voyage dans la basse et la haute Egypte.* Paris, 1802.

Figure 8-16. Etienne-Louis Boullée. Design for Palais d'Assemblée Nationale. Bibliothèque Nationale, Paris. Reproduced in J.-M. Peronse de Montclos, *Etienne-Louis Boullee (1728–99): Theoretician of Revolutionary Architecture.* New York, 1974.

architects. Two examples of their work, a bookcase and a clock from 1812, illustrate how the Egyptian material has settled down, so to speak, when compared with the designs by Piranesi (8–17, 18). The style now becomes archaeological not only in the actual invention, but also in the calm manner in which it

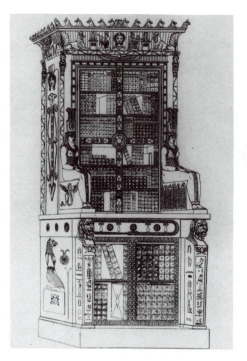

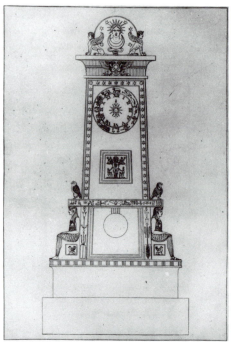

Figure 8-17. Design for Bookcase. From Charles Percier and Pierre Fontaine, *Recueil de decorations interieures...* Paris: C. Percier et P.F.L. Fontaine, 1812.

Figure 8-18. Design for Clock. From Percier and Fontaine, *Recueil de decorations interieures...* Paris: C. Percier et P.F.L. Fontaine, 1812.

is presented – a sharp contrast to the extremely lively designs of Piranesi. Very little of the Egyptian revival is still in existence.

The Hotel Beauharnais is an impressive example of the archaeological emphasis of the period (8–19, 20). Another example is an extraordinary building that unfortunately no longer exists, the so-called Egyptian Hall in Picadilly, London, built in 1812 by P. F. Robinson (8–21), an architect of otherwise not very great distinction. The building engendered a number of copies all over England. Nothing of this kind is in existence nowadays. One project of the period was executed by H. von Hallerstein, a gifted German architect who was born in 1774 and died in 1814. Hallerstein's design was entered in the competition for the Munich Glyptothek, a museum for ancient art (8–22). It was directly derived from an Egyptian model, a temple

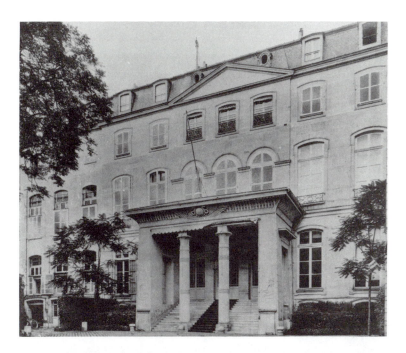

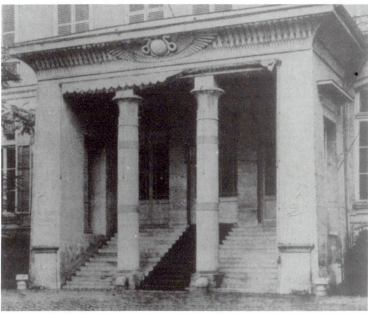

Figure 8-19 (top), 8-20 (bottom). Hotel Beauharnais, Paris. 1805. Reproduced in Hans Vogel, "Ägyptisierende Baukunst des Klassizismus," *Zeitschrift für Bildende Kunst* 62 (1928–9).

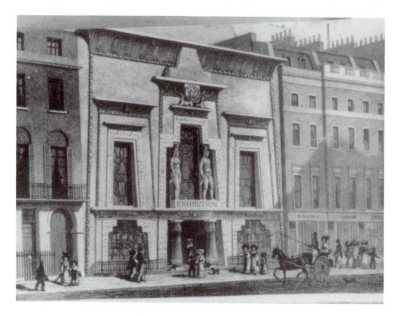

Figure 8-21. Peter Frederick Robinson. Egyptian Hall. Engraving. Piccadilly, London. 1812. See John Archer, "Robinson, P.F.," *Macmillan Encyclopedia of Architects*. New York, 1982.

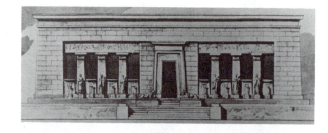

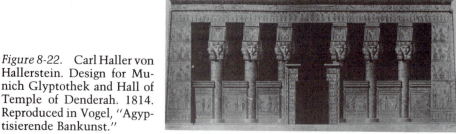

Figure 8-22. Carl Haller von Hallerstein. Design for Munich Glyptothek and Hall of Temple of Denderah. 1814. Reproduced in Vogel, "Agyptisierende Bankunst."

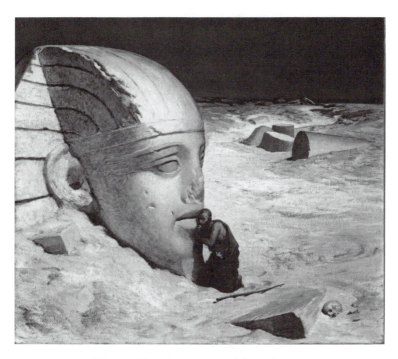

Figure 8-23. Elihu Vedder. *Questioner of the Sphinx.* 1863. Courtesy, Museum of Fine Arts, Boston.

at Dendera, but, as usual, the design was not executed because it was too grand. Consequently, a more modest classical design was chosen.

This part of the Egyptian revival comes to an end around 1850 when the power of the archaeological style was broken, but that is not the end of the entire story. Two features, although I will not explore them thoroughly here, should at least be mentioned: Egyptian Romanticism and secret societies.

With regard to Egyptian Romanticism, a painting by a famous American artist, Elihu Vedder, who only died in 1923, is not only rather characteristic of that painter but is also a good example of this Egyptian Romanticism (8–23). He went to Egypt and in the 1860s produced a type of picture in which the mystery of the sphinx is still alive, or had come alive in a new and different fashion – a Bedouin listening to the voice of the sphinx. This tradition that Egyptian material is not only decorative, as Piranesi pronounced, but had a certain emotional

message goes on through the nineteenth century. In addition (it should be observed), there is another element here that Napoleon himself revived – the emblematic meaning of Egyptian motifs.

Napoleon, of course, did not try to explain hieroglyphs in the sense in which sixteenth- and seventeenth-century scholars tried to cope with the problem. He incorporated into his own emblematic language certain elements that were taken from hieroglyphs, which served him as speaking emblems symbolizing his imperial majesty.

With regard to secret societies, such as Freemasonry and the Rosicrucians, these gained momentum beginning in the seventeenth century. The Rosicrucians, in particular, are still to a certain extent problematical. One of the characteristics of secret societies that makes it difficult to study them is, of course, their secrecy; however, they are all attached to Egyptian history, and their esoteric learning incorporates occult symbols that have their origins in ancient Egypt. This is a fascinating subject – one that awaits further study.

NINE

China and Europe I

EARLY CONNECTIONS

The earliest connections between China and the West are still somewhat mysterious. It is not unlikely that as early as the seventh century B.C. Scythian tribes traded Mongolian gold to the West. Such contacts are, however, of little interest to us. Nor was the silk trade, which became firmly established in the age of Augustus, instrumental in spreading cultural and artistic Far Eastern influences. The center of the Roman textile industry was in Syria. In exceptional cases, original Chinese silk fabrics may have reached the West and it was probably equally exceptional for Chinese patterns of design to be copied in Syria (though this happened, as a third-century A.D. fabric from Dura-Europos demonstrates). In his basic book on *Europe and China*, G. F. Hudson remarks that for Rome the trade in silk and trade with China were practically identical. With the decline of the Roman Empire, the Persians and Sassanians monopolized the silk trade with results that I have already discussed. It has also been seen how in the sixth century, under the Emperor Justinian, Byzantium became a silk-producing country. At that time, the link to the Far East was cut owing to the Arab ascendancy, though there are subsequent accounts of embassies being sent to China. On the whole, there was silence until the

Mongol conquest of Asia; nevertheless, a trickle of Chinese material reached the West through Byzantium probably from the tenth century onward, and this accounts for the fact that Chinese phoenixes, peacocks, and dragons appear occasionally at that early date (9–1, 2).

A change in the relations between China and the West came about at the time of the Mongol conquest: Jenghis Khan, bursting forth from the Mongolian steppes, swept through northern China, Turkestan, and Persia in one of the most extraordinary campaigns the world has ever seen. By 1224, he had overrun southern Russia. His successors drove on to the West, but in 1241 the Mongol armies were stopped in Silesia. For over a hundred years (until 1368), the *Pax Mongolica* held most of the world together in an empire that at the time of its greatest expansion was many times the size of the United States.

Europe established contacts with the Mongol rulers almost immediately. In 1245, Pope Innocent IV sent the Franciscan John del Piano di Carpino as envoy to the court of the Grand Khan. In 1253, William of Rubruck followed him as envoy of Louis IX of France. The brothers Nicolo and Maffeo Polo left Venice in 1255 and spent fourteen years in Asia. On a second journey (on which they set out in 1271), they were accompanied by Nicolo's son Marco, who traveled extensively in East Asia until 1295. Although the report of his journey has rightly always been regarded as the most interesting of all travelers' accounts, there were many others who have left fascinating records of their experiences, such as John of Monte Corvino, the founder of the Latin Church in China, who stayed there from about 1293 until his death in 1328; Andrew of Perugia, who was engaged in missionary work in Peking between approximately 1308 and 1318; Friar Oderic, who spent six years (from 1322 to 1328) in northern China; John of Marignola, who was in China between 1342 and 1353; and finally, Francesco Balducci Pegolotti, the agent of the Florentine house of Bardi, who wrote (in about 1340) a kind of merchant's manual concerning the trade with the East. According to Pegolotti, the long period of peace when the trade routes were secure, when Franciscan friars set up convents in China, and when Genoese merchants had a settlement at the port of Zaiton north of Canton, came to an end in 1368. In that year the Tartar dynasty was driven out by a revolution and

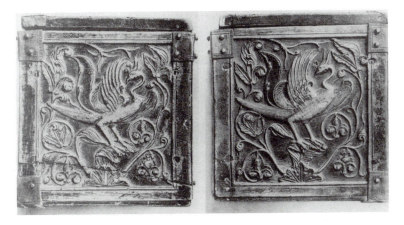

Figure 9-1. Ivory casket, Byzantine. Tenth century. Troyes Cathedral. Reproduced in Volbach, *Art Byzantin.*

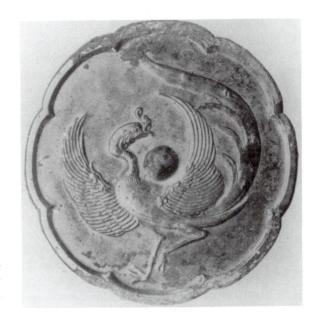

Figure 9-2. Bronze mirror with phoenix. T'ang Dynasty (618–906). Reproduced in Volbach, *Art Byzantin.*

replaced by the native Ming dynasty, which returned to the traditional antiforeign policy. Once again an iron curtain shut off Europe from China.

These dates are useful because they show that the contact

between China and the West lasted roughly a hundred years, from the mid-thirteenth century to the mid-fourteenth century. If we assume that during this period the connections were continuous and close, it seems that we have to answer the following four questions: First, what was the popular Western conception of Asia and the Far East? Second, to what extent did China influence the minor and decorative arts? Third, was there any Chinese influence on the major arts? Fourth, did the Far East help to introduce any new iconographical types into medieval Europe?

As to my first question, from the days of Alexander the Great onward, Asia had been a fabulous land of wonders for Europeans. Marco Polo was prepared to find wonders, and wonders he certainly did find. At the same time, however, he was a keen and accurate observer and in this respect he was, on the whole, far in advance of other travelers of his period. His comparative freedom and independence of observation left his readers unconvinced or incredulous for they were tied, just as we are, to patterns of thought created by tradition, education, cultural setting, and all kinds of conventions. Friar Oderic's stories (or those told by the notorious imposter, Sir John Mandeville, who concocted a travel book around 1370) were more readily accepted because they professed to be eyewitness accounts of marvels that people expected to hear of, marvels with which they were familiar through their encyclopedias, their geographical, scientific, and historical literature, and, above all, their romances.

A splendid cycle of illuminations in the early fifteenth century written for John the Fearless, Duke of Burgundy, shows that the pictures often imply a correction of the text so as to harmonize it with traditional concepts. For example, Marco Polo describes a fearful type of serpent that is haunting the Chinese province of Caragian (9–3), an enormous reptile with jaws wide enough to swallow a man. It has been surmised, probably correctly, that he was talking about crocodiles. The illustrator, working from a pictorial tradition, corrected Marco Polo's description and showed a choice collection of traditional dragons (in the foreground most prominently one with bat's wings) implying that it was such a monster that Marco Polo had in mind. Writing about the black population of the Andaman Islands north of Sumatra, Marco Polo assured his readers that the inhabitants had heads, eyes, and teeth

Figure 9-3. Serpents haunting Chinese province of Caragian. Early fifteenth century. Marco Polo ms. codex 2810, folio 55. Bibliothèque Nationale, Paris. Published in *Livre des Merveilles*. Paris, 1907. Illustrations from workshop of Boucicaut Master.

Figure 9-4. Cynocephali (dog-headed) people of Andaman Islands. Marco Polo ms. codex 2810, folio 76. Bibliothèque Nationale, Paris. In *Livre*.

resembling those of dogs. The artist represented these people as cynocephali (9–4), men with dog's heads, because the dog-faced race belonged to the unchallenged stock of Eastern marvels. The inhabitants of Siberia, according to Marco Polo, were a very wild race (9–5). The illuminator showed three specimens of the race: one, a headless man with his face placed between the shoulders; the second, a man lying on his back using the outsize foot of his one leg as a kind of umbrella; and the third, a one-eyed giant.

These strange creatures were not fanciful inventions by the artist. He simply depicted representatives of well-established fabulous races of the East whose pedigrees went back two thousand years. If Marco Polo was satisfied with the generic denomination "wild race," he was probably not fully or correctly informed – so the artist might have argued – and the picture had to put this right. Here the reader saw what he expected anyway: Wild races in the Far East look like this.

This popular tradition of the Far East as a land of marvels made the Western public susceptible to the intrusion and absorption of those genuine Far Eastern concepts and motifs that accorded with their image of the East, an image that changed only very slowly. One should not be misled by the fact that soberly observed Mongols appear in a few paintings and manuscripts from the mid-fourteenth century onward – for the first time probably in Ambrogio Lorenzetti's fresco *Martyrdom of Franciscan Friars* in S. Francesco of Siena, which dates around 1336 (9–6–8) and records the execution of China-bound missionaries.

A great deal of irresponsible speculation has crystallized around such examples. In a splendid paper published in the *Art Bulletin* in 1944, Leonardo Olschki stigmatized the alleged *fureur asiatique* at this period as a mere hallucination in the minds of modern scholars. He also gave a simple and convincing explanation for the realism of these Mongol types, which is particularly striking in Pisanello's fresco of St. George in St. Anastasia at Verona, painted before 1440. (The oriental here has been identified as a Kalmuck; 9–9, 10.) Tartars and other orientals were sold at the slave markets of Venice, Genoa, Florence, and Naples (their numbers in Florence, for example, were considerable), and it was these wretches who served as models. They hardly influenced the Western idea of China,

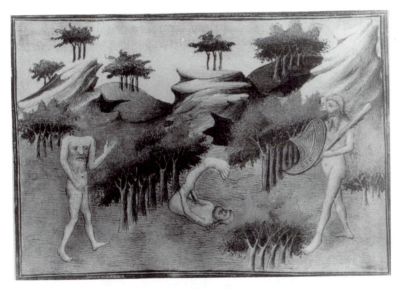

Figure 9-5. Monsters seen in Siberia. Marco Polo codex ms. 2810, folio 29. Bibliothèque Nationale, Paris. In *Livre*.

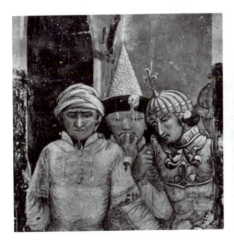
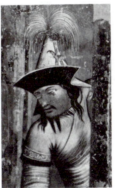

Figures 9-6 (left), 9-7 (middle), 9-8 (right). Ambrogio Lorenzetti. *Martyrdom of Franciscan Friars.* Details of Tartar and Mongol spectators. ca. 1326. S. Francesco, Siena. Anderson/Art Resource.

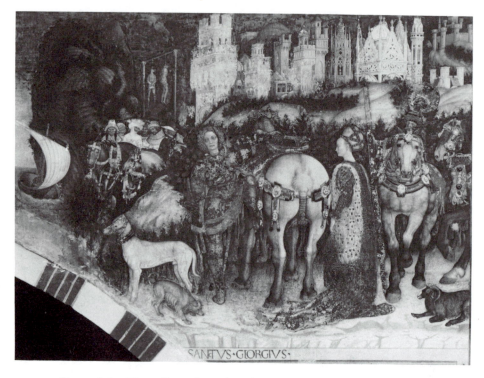

Figure 9-9. Pisanello. Kalmuck in fresco of the legend of St. George. Before 1440. Verona. Formerly S. Anastasia. Alinari/Art Resource.

however – it remained the land of wonders and marvels for another two centuries.

My second question addresses China's influence on the minor arts. During the hundred years of trade contacts with China, the West keenly purchased Chinese silk fabrics and garments, which became immensely fashionable, probably as a mark of oriental opulence and wealth. Emperor Frederick II of Hohenstaufen, for example, wore a Chinese dalmatic and others followed his example. With the Chinese fabrics came a new type of pattern. In fact, the newly rising Chinese fashion spelled the end of the symmetrically and geometrically arranged designs of Near Eastern derivation with their addorsed birds and animals and antithetical groups contained in circles. Exotic animals and birds, fire-breathing dragons and phoenixes with marvelous feathery tails, elephants with peacock feathers, deer with flaming manes, and the like are strewn over the entire

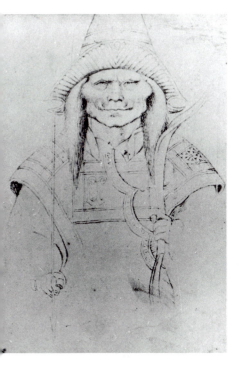

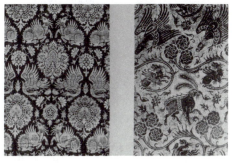

Figure 9-10. Pisanello. Study of Kalmuck
or 9-9. Louvre, Paris.

Figure 9-11. Textile, Italian. Fourteenth
century. Reproduced in O. von Falke,
Kunstgeschichte der Seiden Weberei. Ber-
lin, 1913.

field without containing frames (9–11, 12). In the fourteenth
century, the silk manufacturers in Venice, Florence, and, above
all, Lucca (the center of the Italian industry) thrived on
imitations of Chinese patterns.

We have seen in the first lecture that the hieratic
principles governing Near Eastern art were intrinsically akin
to the stylistic intentions of Romanesque artists and that for
this reason they made use of existing formulas as a welcome
guide to shaping their own visions. A similar claim can be made
for the interest in Chinese silks from the late thirteenth century
onward: The loose spread of unframed lively naturalistic motifs
appealed to the Gothic taste for free-flowing naturalistic
ornament. The new style did not owe its rise to the influence
of Chinese silk designs, but they were wholeheartedly accepted

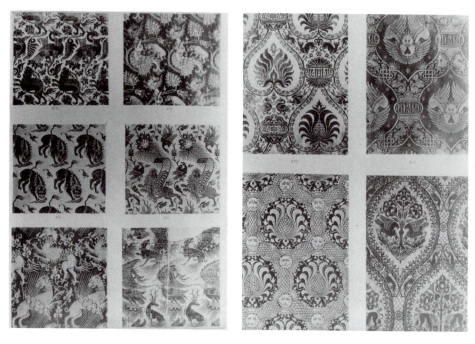

Figure 9-12. Textile, Italian (Luccan). Fourteenth century. Reproduced in von Falke, *Kunstgeschichte.*

Figure 9-13. Textile, Italian (Venetian). Fifteenth century. Reproduced in von Falke, *Kunstgeschichte.*

because they were in keeping with the new tendencies and offered a way out of the impasse of traditional patterns.

The more fantastic elements of Chinese fabrics were repudiated in the fifteenth century when the regular so-called pomegranate design came into fashion, a design that in its turn traced its descent from the Chinese version of the lotus (9–13, 14). First, the swinging rhythms of the thick stems as well as the seminaturalistic profusion of the heavy fruit were maintained. Endless variations in the design of pomegranate fabrics are well known from fifteenth-century paintings (9–15). Following the stylistic principles of the High Renaissance, pomegranate designs were symmetrically patterned in the course of the sixteenth century, and this more static form remained fashionable for some time. The choice, assimilation, and transformation of Chinese silk designs depended, in other words, on the general stylistic position in the West.

These observations implicitly betray my assessment of

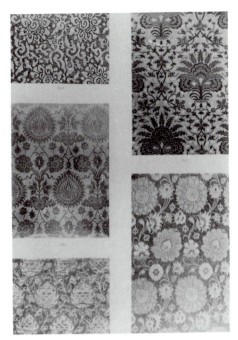

Figure 9-14. Textile, Chinese. Four-
teenth century. Reproduced in von Falke,
Kunstgeschichte.

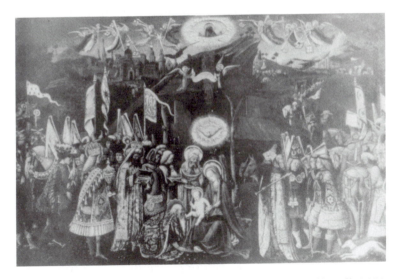

Figure 9-15. Antonio Vivarini. *Adoration of the Magi* (detail). 1444.
State Museum, Berlin.

the third question. I doubt that Chinese art had an important formative influence on the development of Western painting, as has been claimed. I am referring in particular to the alleged influence of Chinese scrolls on Sienese landscape interpretation in the fourteenth century. A variety of aspects in fifteenth-century painting as well as the history of later landscape painting have also been discussed in this context. Because Leonardo Olschki has rejected such claims authoritatively and Charles Sterling has devoted to them a most sensitive and objective analysis, I can abstain from further critical comment. Moreover, I believe it is permissible to conclude that in spite of the open trade routes with China between about 1250 and 1350 and in spite of the proved transmission of Chinese wares during this period, similarities in painting resulted from a convergence of stylistic feeling rather than from an assimilation of Chinese import.

But this does not exclude Chinese influence on Western iconography (my fourth and last question). East Asian dragons and monsters had always fired Western imagination. In some way specimens must have reached the West even before the direct trade routes were opened up, for fantastic creations of unmistakably Chinese design appear in twelfth-century manuscripts and other works of art (9–16–18). But Chinese demons with bats' wings do not seem to have made their entry into the Western repertory until the new wave of East–West contacts (9–19), and bats' wings became a firm iconographical component of all sorts of evil beings in the West. It cannot be denied that other Chinese motifs may have been absorbed at this time, although the many claims of Western dependence on Far Eastern prototypes – such as the Tree of Jesse or the aureole with angels – would seem to be unacceptable.

The majority of the artistic and iconographical similarities between China and the West in the fourteenth century must be regarded as unrelated convergences – or in some cases simply as unverifiable scholarly projections. Although the East made a definite and enduring impact on the West at the level of silk fabrics, the fourteenth century was much less a Chinese century in the West than the twelfth century had been a Near Eastern one. But China's time was to come. In the seventeenth century a completely new image of China began to develop. Whereas China had been the land of marvels and mystery throughout the Middle Ages, it now began

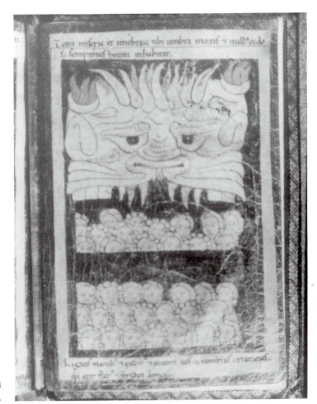

Figure 9-16. Monster. From Spanish Bible. 1197. Amiens.

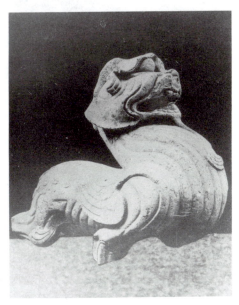

Figure 9-17. Chinese chimera. Han Dynasty (202 B.C.–A.D. 220). Wittkower archive.

Figure 9-18. Fantastic animals. Bayeux Cathedral. Reproduced in Victor Henry Debidour, *Le Bestiaire Sculpté du Moyeu Age en France.* Paris, 1961. Marburg/Art Resource.

slowly to be regarded as a country in which unequaled social, political, and religious wisdom and enlightenment reigned, and this view of China had important consequences for Europe.

In 1497, Vasco da Gama had opened the sea route to the

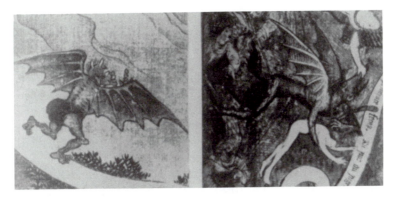

Figure 9-19. Rohan Hours *(Grande Heures de la famille Rohan).* Demon fighting archangel *(right).* 1430. Bibliothèque Nationale, Paris (ms. Lat. 9471). Tcheou Ki-tch'ang and Lin T'ing-kouei. Demon carrying the bones of Buddha, Chinese *(left).* ca. 1163–80. Museum of Fine Arts, Boston.

East by way of the Cape of Good Hope and seventeen years later the Portuguese reached China. In spite of Chinese reticence and seclusion, this was the beginning of a steadily growing commerce, which took on very considerable proportions even before the eighteenth century. Canton eventually became the great trading port, but apart from the Jesuit missionaries few Europeans were allowed to penetrate into the interior. Broadly speaking, the Portuguese controlled the China trade in the sixteenth century, the Dutch in the seventeenth, and the British in the eighteenth, while the French were most active in exploring China and publishing the results of their explorations.

The tone for the new interpretation of China was set in some late sixteenth-century publications that praised the governmental institutions, the exercise of justice, the material prosperity, the care for the sick and the poor, the beauty and comfort of the houses, the excellence of the roads and bridges, as well as the natural disinclination of the Chinese to wage war and their religious tolerance. Seventeenth-century missionaries prepared translations of the Chinese classics. The *Sapientia Sinica* of 1662 contained most of Confucius's works; an additional volume, incorporating also Confucius's biography, was published in 1687 with the title *Confucius Sin-*

arum Philosophus (Confucius, the philosopher of the Chinese)
and dedicated to Louis XIV.

Times were ripe for precisely the thought embedded in
Confucianism, which offered a theory of moral and political
order rather than a religion. The *philosophes* of the Enlight-
enment embraced wholeheartedly this alternative to Christian-
ity. The first symptom of this development was Leibniz's *Nov-
issima Sinica* of 1697, a work in which the great philosopher
advocated a universal religion derived from the natural theol-
ogy of Confucianism. It is interesting in our context that he
based his system on the Chinese book *I-Ching* (Changes),
whose author he tried to identify with the Egyptian Hermes
Trismegistus and perhaps with the Persian sage Zoroaster and
the Biblical Enoch. It looked as if history was repeating itself.
Renaissance thinkers had turned to the wisdom of the mythical
Hermes Trismegistus and of other spurious oriental sages in
their search for an all-embracing religious syncretism. Now the
West began to look to China for a new synthesis, in which
even the old names got mixed up. But in fact history did not
repeat itself, for in contrast to the Renaissance position the
new trend was anti-Christian and far removed from Neopla-
tonic mysticism. Voltaire, the greatest of the Enlightenment
philosophes in his *Entretiens Chinois* and his *Essai sur ... les
moeurs ...* expressed most fully the current thought that Con-
fucius's moral philosophy, based upon reason and tolerance,
would be a better foundation for our daily life than a revealed
religion with its fanaticism, obscurantism, and intolerance.
And the physiocrats who aimed at a society governed by natural
law shaped their ideal upon Confucian philosophy. Thus, this
Sinophilia took on extraordinary proportions and far-reaching
implications. One is inclined to conclude that, by re-creating
China (or pseudo-China) in art and architecture, as well as in
nature, people endeavored to establish the physical conditions
for a Chinese way of life. But the relationship of cause and
effect is not quite so simple, as will become evident. Surely,
the social, political, and religious aspects must have been pow-
erful stimuli in bringing about the Chinese vogue; they cannot,
however, explain the entire phenomenon.

TEN

China and Europe II
CHINOISERIE AND
THE ANGLO-CHINESE GARDEN

In the case of Egyptian fashion and the spell of hieroglyphics at the time of the Renaissance, we have observed that the style of European art as a whole was hardly affected. In the case of the Sinomania of the eighteenth century, on the other hand, China's visual impact on the arts was considerable. In this respect, too, history did not repeat itself. The truth of the matter seems to be that the autonomous development of European art had reached a stage at which the Chinese infiltration was welcomed. In other words, European and Chinese tastes converged and Chinese art and architecture could be rallied in support of the graces eagerly sought after in the West at this period.

Characteristically, it was now that the gentle aspects of Chinese art found a ready response. No longer was the interest focused on the fierce dragons and the grotesque and violent manifestations of Chinese art, which had almost exclusively impressed the Middle Ages. By contrast, the beauty and perfection, the delicacy and refinement of China's porcelain, lacquer wares, and fabrics were as much admired as the fragrant (one is inclined to say) and playful, seemingly artless, realism of their designs.

Chinese porcelain had, of course, always fascinated European collectors, but only a trickle of it seems to have reached the West in the fourteenth century. By the end of the sixteenth century there was a great demand for oriental porcelain, and as early as about 1575 imitation porcelain (so-called soft-paste porcelain) was produced for the Medici court in Florence. In the seventeenth century, the influx of Chinese merchandise vastly increased and the demand was such that from the beginning of the century onward European imitations of lacquer ware, furniture, and textile patterns appeared on the market (10–1–7).

By the middle of the century and for the next 150 years, Delft produced its blue-and-white pottery. At the beginning of the eighteenth century, Johann Friedrich Böttger made the first hard-paste porcelain for Augustus the Strong of Saxony and thereafter the porcelain factory at Meissen near Dresden exerted a strong influence on the rising new industry (Dresden china) that soon developed in most European countries. Similarly, the West slowly conquered other Chinese techniques, such as the lacquer technique. But the mastery of the techniques was not necessarily accompanied by a wish for close imitation of the oriental models.

Late Baroque Sinomania, which loomed large between 1660 and 1715, created a vast demand for original import ware. Displayed in porcelain cabinets and set in Baroque mounts, Chinese vases, jars, and plates appear in profusion on Baroque brackets symmetrically arranged and often contained by typically Louis XIV wall panels. A break with this taste came with the rise of the Rococo in the second decade of the eighteenth century and it is undeniable that the tenets of the style – such as asymmetry and delicacy of ornamentation and color – had a basic affinity to Chinese art (10–8, 9).

The question of whether Chinese objects were instrumental, or at least helpful, in developing the style, has been answered negatively by Fiske Kimball, the leading authority in the field. An attempt to take up this question anew here would lead back to the impenetrable problem of cause and effect. But familiarity breeds diversity and so, as eighteenth-century Chinoiserie developed, it moved farther away from the original products. Between the third and the sixth decades of the century, Chinoiserie became part and parcel of the Rococo style. Elegance and charm, sometimes a sophisticated coquetry and

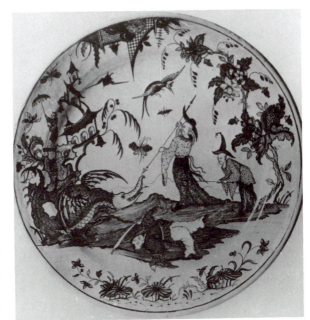

Figure 10-1. Faience plate, Chinoiserie, French (Rouen). Eighteenth century. Reproduced in Jacques Guérin, *La Chinoiserie en Europe au XVIIIᵉ siècle: tapisseries, meubles, bronzes d'ameublement, céramiques, peintures et dessins, exposés au Musée des arts décoratifs; quatre-vingts planches...* Paris, 1911.

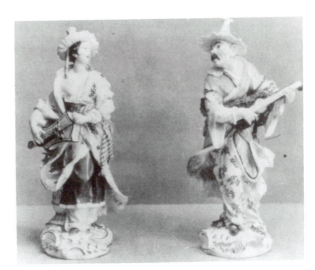

Figure 10-2. Porcelain figures, Chinoiserie, German. Eighteenth century. Reproduction in Jacques Guérin, *La Chinoiserie.*

Figure 10-3. Terra cotta fig-
ures, Venetian. Eighteenth
century. Wadsworth Athen-
aeum, Hartford. Reproduced
in Guérin, *La Chinoiserie.*

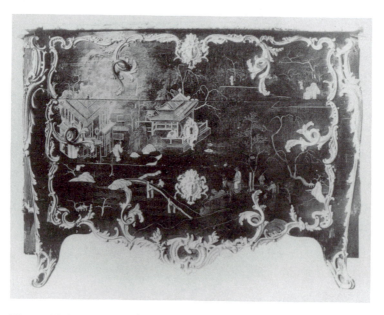

Figure 10-4. Lacquered commode, Chinoiserie, French. Eighteenth
century. Reproduced in Guérin, *La Chinoiserie.*

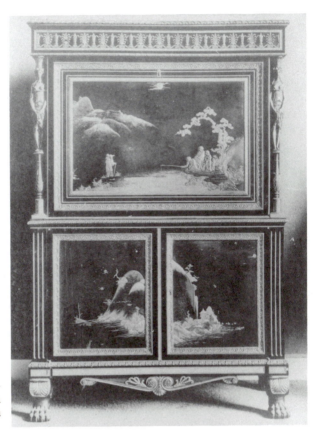

Figure 10-5. Secretary, Chinoiserie, French. Eighteenth century. Reproduction in Guérin, *La Chinoiserie.*

even prettiness, sometimes a playful and incongruous combination of Chinese ingredients, or even a willful display of fantastic richness are all diverse facets of Rococo Chinoiserie, which had little in common with the spirit of original Chinese creations (10–10 thru 10–19).

Let us turn to buildings in the Chinese taste. As early as 1670, Louis XIV commissioned his court architect Louis Le Vau to build a pleasure house, the *Trianon de Porcelain*, in the park of Versailles (the structure was soon demolished) for his favorite mistress Mme. de Montespan. Although it ushered in the taste for Chinese garden houses, pavilions, and temples, its exterior displayed the solemnity of the style of Louis XIV. In 1670, it was hardly known what Chinese architecture looked

Figure 10-6. Needlepoint panel, French. Eighteenth century. Reproduced in Guérin, *La Chinoiserie*.

Figure 10-7. Printed cotton textile, Chinoiserie, Spanish. Eighteenth century. Reproduced in Guérin, *La Chinoiserie*.

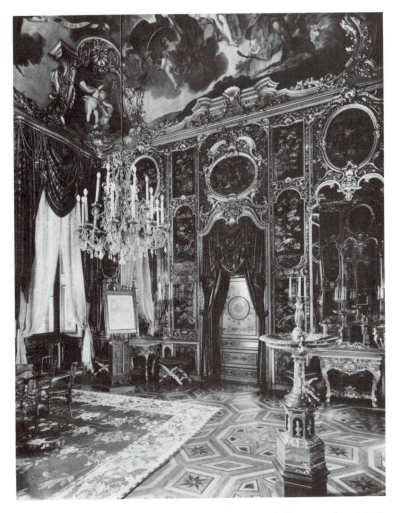

Figure 10-8. Gabinetto di Toeletta della Regina (Chinese Room). Palazzo Reale, Turin. 1733–7. Reproduced in Marziano Bernardi, *Il Palazzo Reale di Torino.* Turin, 1959. Alinari/Art Resource.

like, but even if Le Vau had studied Jan Nieuhof's then recently published work, it is doubtful that he would have liked to take his inspiration from it.

Nieuhof's *An Embassy from the East-India Company to the Grand Tartar,* amply illustrated, appeared first in Amsterdam in 1665 and then in an English translation in 1669 (10–

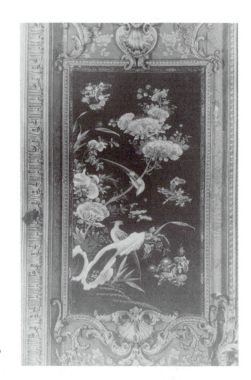

Figure 10-9. Chinese Room. Palazzo Reale. Detail of 10-8.

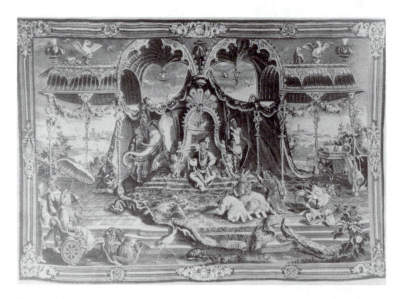

Figure 10-10. Beauvais tapestry. *The Audience.* Woven after design by J. B. Fontenay and J. J. Dumas. ca. 1725–30. Munich Residenz-museum. Reproduced in Guérin, *La Chinoiserie.*

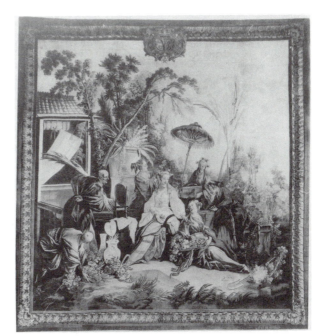

Figure 10-11. Beauvais tapestry. *La toilette.* Woven after design by Boucher. ca. 1743. Reproduced in Guérin, *La Chinoiserie.*

Figure 10-12. Watteau. *Chinese Dance.* ca. 1718. Longhi Collection, Florence. Reproduced in Jacques Mathey, *Antoine Watteau: Peintures Réapparues, Inconnues on Négligées par les Historiens.* Paris, 1959.

Figure 10-13. Boucher. *La danse Chinoise.* Engraving. ca. 1740. Reproduced in Guérin, *La Chinoiserie.*

Figure 10-14. Watteau (after). *Goddess Ki Mao Sao.* Engraving by Aubert. 1719. Reproduced in Émile Dacier and Albert Vuaflart, *Jean de Jullienne et les graveurs de Watteau au XVIIIᵉ siècle.* Paris, 1921–9.

Figure 10-15. Watteau (after). *Chinese Emperor.* Engraving. ca. 1729–30. Reproduced in Dacier and Vualflart, *Jean de Jullienne.*

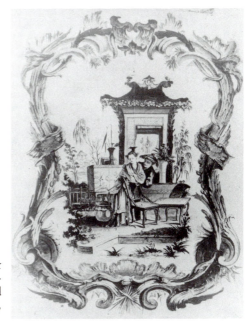

Figure 10-16. Jean Pillement, *Panneaux* [de Chinoiserie style] "d'Après les Originaux (Pillement-Boucher)." Invented and engraved by Pillement. Paris: Calavas, 1880.

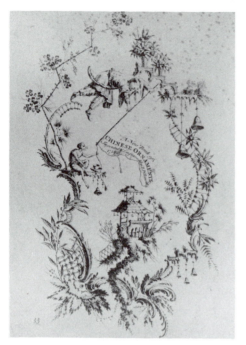 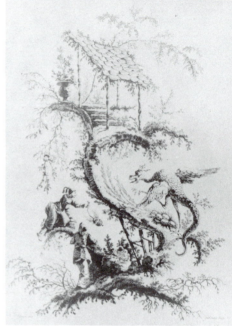

Figure 10-17. Pillement, *Panneaux* (de Chinoiserie style) "d'Après les Originaux (Pillement-Boucher)."

Figure 10-18. Pillement, *Panneaux* (de Chinoiserie style) "d'Après les Originaux (Pillement-Boucher)."

20, 21). The importance of Nieuhof's work cannot be overestimated. Many, though not all, of his illustrations seem to have been based on drawings made at the sites. It was these illustrations on which Fischer von Erlach still had to rely over fifty years later for the Chinese buildings in his *Entwurf...* of 1721. True to his plan of surveying the entire field of architecture, Erlach borrowed from Nieuhof what seemed to him important to give a rounded-off view of Chinese building practices.

Erlach showed not only monumental buildings such as the imperial palace in Peking and the famous nine-story porcelain pagoda at Nanking (10–22), but also small garden-style buildings, a hanging bridge, and an example of the artificial rocks that (in Nieuhof's words) "are so curiously wrought that Art seems to exceed Nature: These Cliffs are made of a sort of stone... and so rarely adorned with trees and flowers, that all that see them are surprised with admiration. Rich people, es-

Figure 10-19. Pillement, *Panneaux* (de Chinoiserie style) "d'Après les Originaux (Pillement-Boucher)."

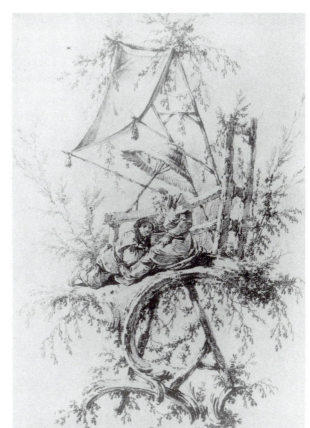

Figure 10-20. Pagoda. From Jan Nieuhoff, *An Embassy from the East-India Company to the Grand Tartar.* 1665; English edition, 1699.

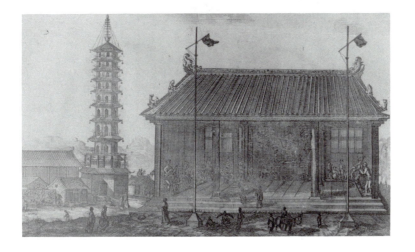

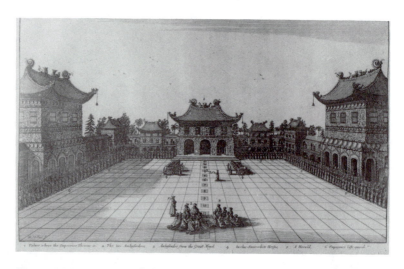

Figure 10-21. Court of the Emperors, Palace at Peking. From Nieu-hoff, *An Embassy from the East-India Company to the Grand Tartar.* 1665; English edition, 1699.

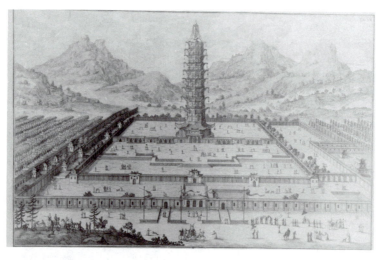

Figure 10-22. Nine-story porcelain Pagoda, Nanking (destroyed 1853). From Erlach, *Entwurf.* Copied from Nieuhoff.

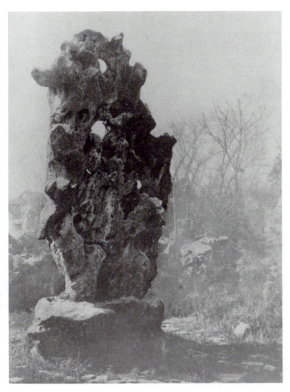

Figure 10-23 (left). Garden at Wang School, Suchou. A perfect T'ai-Hu stone. Published in Osvald Sirén, *Gardens of China.* New York, 1949.

Figure 10-24 (right). A T'ai-Hu stone. Attributed to Hui Tsung (1082–1135) but later. National Museum, Stockholm. Published in Sirén, *Gardens.*

pecially the great Lords and Mandarins, have for the most part such Rocks in their Courts and Palaces, upon which they squander good parts of their Estates" (10–23, 24). Artificial rocks, pagodas, and Chinese teahouses fired the imagination of later designers, and there was almost no limit to their flights of fancy until Sir William Chambers tried to conform accurately to Chinese models. But his angry reproof of the corrupt taste of his contemporaries left many unmoved.

In spite of its many fascinating aspects, one must be careful not to overstress the Sinomania of the eighteenth century. It is well known that by the middle of the century, European art and architecture had entered a radically new phase. The time of the relatively homogeneous styles had come to an end,

a situation that had been developing from the beginning of the century when a kind of deliberately historicizing and neutralizing attitude toward style had set in – a phenomenon that had not existed before in the history of European art.

Fischer von Erlach's work is, of course, a primary document in reflecting and embodying this changing attitude. Artistic expression was open to an ensuing chaos of styles. Around 1750, the classical style in its various emanations – such as Neo-Palladian, Neo-Roman, and Neo-Greek – could lead a more or less peaceful coexistence with the Rococo, the Neo-Gothic, Chinese, Egyptian, and Indian styles (10–25–35). In the last analysis, this changing attitude toward style and its consequent expression in various stylistic combinations signaled a fundamental break with the classical tradition. It was mainly among English eighteenth-century philosophers and writers that the objective aesthetics of the classical doctrine, which had not seriously been challenged for four hundred years, was turned into subjective sensibility.

Hume in his *Treatise of Human Nature* of 1739 had propagated the revolutionary thesis that the distinguishing character of beauty consists in giving "pleasure and satisfaction to the soul," whereas according to classical aesthetics beauty was an unalienable property belonging to the object. The new position was elaborated by men like Burke, Lord Kames, and Alison and was generally accepted in spite of the resistance of many classical diehards. It was the destruction of classical aesthetics at its root that opened the door to the chaos of styles (10–36–39).

The new position was also reflected in what would seem to be the most important Chinese penetration in the eighteenth century – the landscape garden. The history of the Anglo-Chinese landscape garden, as the movement is usually called, has received a great deal of attention and has been the subject of a number of excellent studies in recent years. But, so far as I can see, some of the strange paradoxes to be found in its inception and development have never been exposed.

The movement started after 1720 in the circle of Lord Burlington, the staunch upholder of the classical doctrine who pleaded with unprecedented conviction and tenacity for a return to a pure Palladian architecture and who was instrumental in keeping a whole generation of English architects to the path of classical virtue at a time when the Continent was indulging

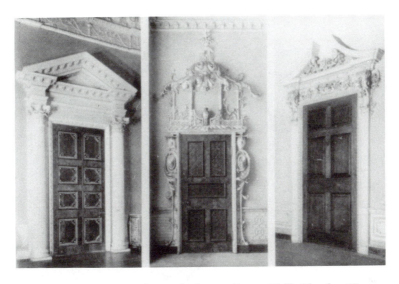

Figure 10-25. Doors, Salon and Chinese Room Hall, Claydon House. Sir. T. Robinson. Buckinghamshire. 1768–71. Lightfoot.

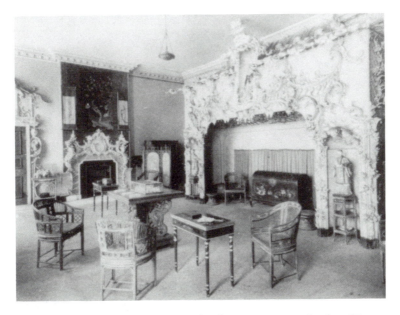

Figure 10-26. Carved wood relief. Chinese Room, Claydon House. 1768–71. Lightfoot.

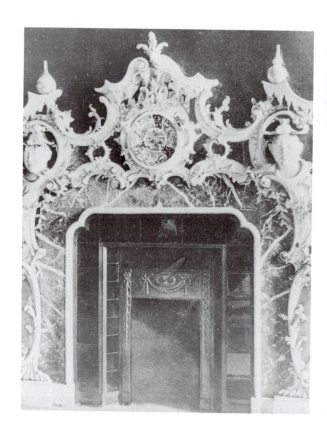

Figure 10-27. Chinese Room, Claydon House. Chimney-piece (detail).

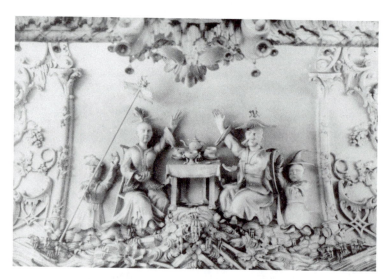

Figure 10-28. Chinese Room, Claydon House (detail).

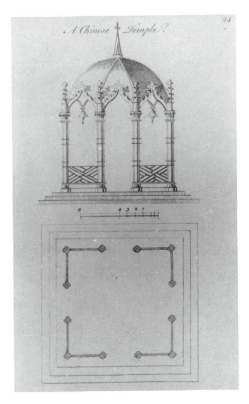

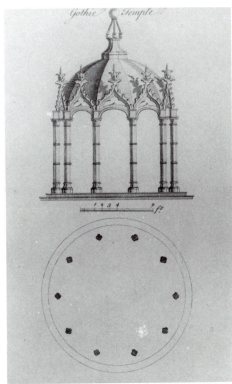

Figure 10-29. Chinese temple. From Charles Over, *Ornamental Architecture in the Gothic, Chinese, and Modern Taste.* London: Sayer, 1758.

Figure 10-30. Gothic temple. From Over, *Ornamental Architecture in the Gothic, Chinese, and Modern Taste.* London: Sayer, 1758.

in Rococo frippery. There would seem to be a contradiction between Burlington's obsession with reason and rule as far as architecture was concerned and the freedom he and his associates and friends (chief among them William Kent) advocated for the layout of gardens (10–40, 41).

Now Burlington's ideas were strongly colored by Shaftesbury, who in 1712 had propagated the creation of a national taste and a national style based on the spirit of national freedom that was vested in the British constitutional government. This national style was to be founded upon "the right models of perfection" by which he meant of course classical models produced under the tutelage of ancient liberty. Burlington's dream of a national style, a democratic classicism, was nourished by

Figure 10-31. A Gothic structure. From Paul Decker, the younger. *Gothic Architecture Decorated.* London, 1759.

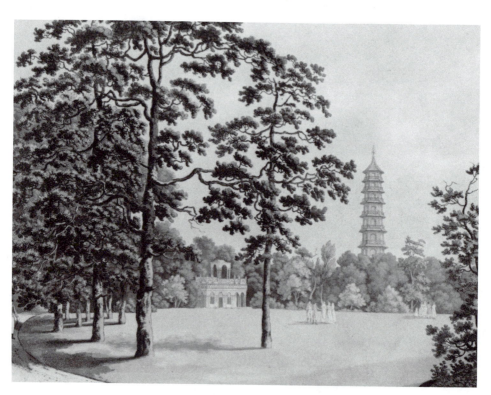

Figure 10-32. Kew Gardens, Aquatint. Sir William Chambers. *Plans, Elevations, Sections, and Perspective Views of the* *Gardens and Buildings at Kew in Surrey.* London, 1763. Reprint, London, Bridgeman/Art Resource.

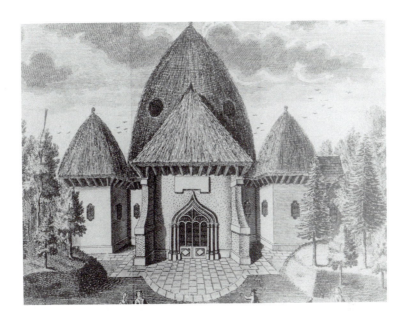

Figure 10-33. William Kent. Merlin's Cave. 1735. Kew Gardens, London.

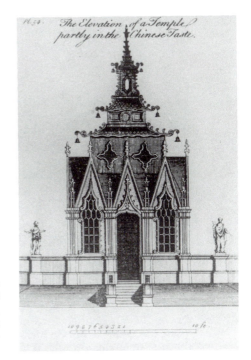

Figure 10-34. William Halfpenny. New Designs for Chinese Gates. 1752. The elevation of a temple partly in the Chinese taste. From *New Designs for Chinese Temples, Triumphal Arches, Garden Seats, etc.* London, 1750–2. Reproduced in Blom facsimile (1968) as *Rural Architecture in the Chinese Taste.*

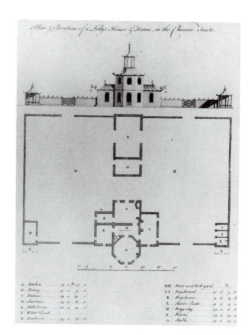

Figure 10-35. Thomas Lightoler. Farmhouse in Chinese Taste. From *The Gentleman and Farmer's Architect*. London: Sayer, 1764.

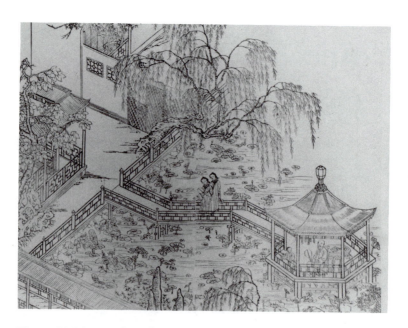

Figure 10-36. Pavilion for Contemplation of Moon in Ch'ing Yen Yüan, the garden of Lin Ch'ing, in Ch'ing Chiang P'u. Early nineteenth century. Reproduced in Sirén, *Gardens*.

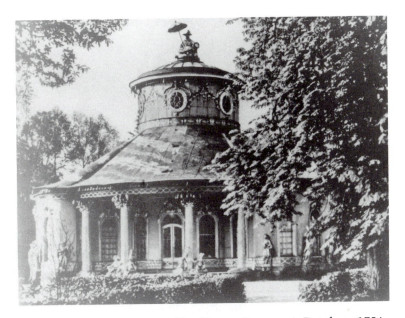

Figure 10-37. J. G. Buering. Tea House. Sanssouci, Potsdam. 1754–7. Published in Kurth, *Sanssouci ein Beitrag zur Kunst.*

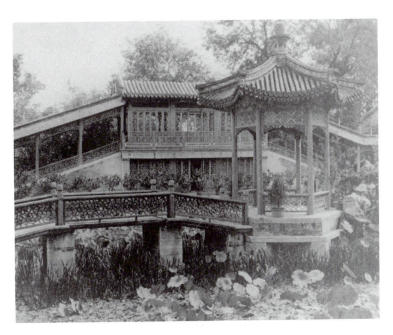

Figure 10-38. Part of private garden, Peking. Published in Sirén, *Gardens.*

Figure 10-39. François-Joseph Belanger. Pavilion du Philosophe Chinois, Bagatelle. 1782. Plans, 1775 by Belanger for Comte d'Artois, brother of Louis XVI. Published in Johann Karl Krafft, *Plans des plus beaux jardins pittoresques de France, d'Angleterre et d'Allemagne...,* Paris: Levrault, 1809. Reproduced in Jurgis Baltrušaitis, *Aberrations, quatre essays sur la légende des formes.* Paris, 1957.

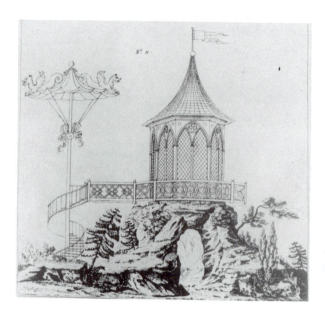

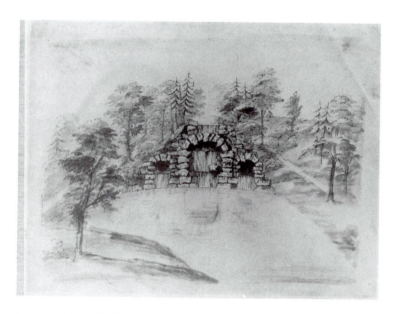

Figure 10-40. William Kent. Garden cascade, Chiswick House, Chatsworth Settlement. Reproduced in Wilson, *William Kent.*

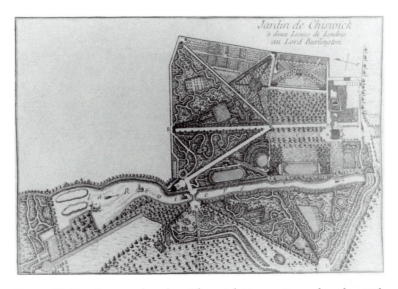

Figure 10-41. Layout of garden, Chiswick House. Reproduced in Wilson, *William Kent.*

Figure 10-42. Villa d'Este Gardens, Tivoli. Engraving. Sixteenth century. Published in Pietro Ferrerio, *Palazzi di Roma di pui celebri architetti...*, Rome, 1655. After Duperac engraving, 1573.

the political concept of the liberty of the people: "The great, the reigning passion of the free. That godlike passion!" to quote from James Thomson's poem *Liberty*, published in the mid-1730s.

The same concept of political freedom was brought to bear upon the concept of nature in Burlington's Whig circle. France, suppressed by a tyrannical government, forced nature into a formal straightjacket (10–42–45). There, according to Thomson, tyranny produces

> Those parks and gardens, where, his haunts betrimmed,
> And nature by presumptuous art oppressed,
> The woodland genius mourns...

Indignantly he exclaimed:

> Detested forms! that, on the mind impressed,
> Corrupt, confound, and barbarize an age.

In democratic England, he finds by contrast those

> sylvan scenes, where art alone pretends
> To dress her mistress and disclose her charms –
> Such as a Pope in miniature has shown,
> A Bathurst o'er the widening forest spreads,
> And such as form a Richmond, Chiswick, Stowe.

Classical architecture and the landscape garden were regarded as two interrelated aspects of a Renaissance in the arts fostered by the public virtue of a free commonwealth.

Informal gardens had existed before, in two widely separate civilizations that, in the eyes of early eighteenth-century interpreters, were both governed by wise, just, and temperate rulers to the benefit of the common people – namely, republican Rome and China. It seems that in Burlington's circle both these guides to the natural garden were carefully explored.

In 1728, Robert Castell, a member of the circle, dedicated a volume on the *Villas of the Ancients* to Lord Burlington, in which he showed that in the garden of the Elder Pliny's villa, "hills, rocks, cascades, riverlets, woods, and buildings... were thrown into such an agreeable disorder as to have pleased the eye from several views, like so many beautiful landscapes." The same idea was expressed poetically by Thomson who maintained that nature smiled at its free-born sons at the time of the Great Republic. It was then that Horace "mused along" in the wild groves of his villa Tibur

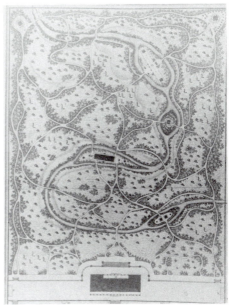

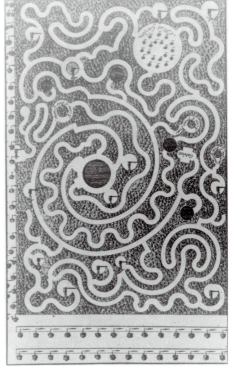

Figure 10-43a (top left) Palace layout. Versailles. Seventeenth century. Engraving by (Adam and Nicolas[?]) Pérelle. Plan with Le Notre's garden design, 1661–8. Published in *Les delices de Versailles* . . . Paris, 1766. *b* (top right) Plan of Chinese gardens outside Peking. 1810. Published in Krafft, *Plans des plus. c* (bottom) Batty Langley. Plan for Garden in New Style. From *New Principles of Gardening*. London, 1728.

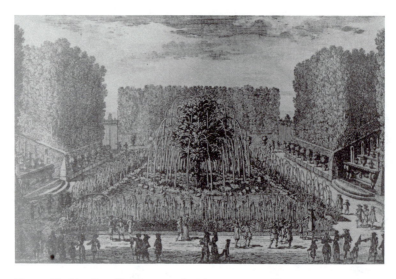

Figure 10-44. Perelle. Bosquet du Marais. Versailles. Engraving. 1674.
From *Les delices.*

Figure 10-45. Charles Hamilton. Pain-
shill Park, Surrey. Artificial lake, Turkish
tent, Roman mausoleum, temple dedi-
cated to Bacchus, Gothic pavilion, grotto,
Chinese type rockery and bridge. 1740s.
Reproduced in Sirén, *China and Gardens
of Europe.* New York, 1950.

> Where art and nature, ever smiling, joined
> On the gay land to lavish all their stores....

A description of the imaginative Chinese natural garden
was introduced into English literature in a well-known passage
of Sir William Temple's *Upon the Gardens of Epicurus,* pub-
lished in 1692. Two decades later, Addison in his *Spectator,*
using Sir William's description, advocated the judicious wild-
ness of the Chinese gardens as an escape from the artificiality

of the French formal garden. In addition to such literary rec-
ommendations there existed a more telling visual documen-
tation of Chinese gardens.

In 1713, Father Matteo Ripa, the Italian priest who was
attached to the mission to the Chinese Court between 1711
and 1723, engraved by order of K'ang-hsi, greatest of the Ch'ing
emperors, thirty-six views of the newly erected imperial pal-
aces and gardens at Jehol, about 150 miles northeast of Peking
(10–46–47). Upon his return to Europe in 1724, Father Ripa
spent some time in London, where he was invited and honored.

On this occasion, Burlington must have secured a copy
of Ripa's work. I may mention that very few copies reached
the Western world and it seems that only six or seven are
known at present, one of them in the United States. The one
recently acquired by the British Museum came from Burling-
ton's library at Chiswick. This is significant because the copy
reached Burlington at a decisive moment – when William Kent
(his close collaborator) began to plan the first important semi-
natural garden for Burlington's Chiswick villa (10–40, 41).

The Chinese testimony surely carried enormous weight,
particularly because Chinese society appeared, as already dis-
cussed, as the realization of Plato's utopian dreams of a state
ruled by philosophers (an opinion expressed by more than one
writer). It was precisely for this reason that the classical and
the Chinese evidences were taken to reveal the same truth.
The points of contact between antiquity and China seemed to
be so close that both civilizations converged to teach one and
the same lesson.

Moreover, to confuse the issue even further, those eigh-
teenth-century people saw pictorial realizations of the ancient
landscape where our archaeologically trained eye cannot all too
easily follow them. Because paintings of ancient landscapes
were unknown at the time, they believed that Pindar's, Hor-
ace's, and, above all, Virgil's pastoral delights had been given
expression in Claude's and Gaspar Poussin's dreamy scenes,
and Claude's landscapes were often recommended for imitation
in the English landscape. It may be pointed out, too, that the
same virtues of simple rusticity were discovered both in
Claude's Virgilian renderings of the Roman Campagna and in
Chinese landscapes.

But as early as the 1760s, when Claude, as well as Salvator
Rosa, were in vogue as models for the idyllic and the sublime

Figure 10-46. Imperial Gardens of Jehol. From Father Matteo Ripa, *Thirty-six Views of Jehol.* 1713. British Museum, London.

Figure 10-47. View of Jehol. From Father Matteo Ripa, *Thirty-Six Views of Jehol.* 1713. British Museum, London.

type of landscape garden respectively, Englishmen denied that they owed anything to the Chinese. Horace Walpole stigmatized the allegation as a malicious invention of the French, and Thomas Gray affirmed that it was "very certain that we copied nothing from them [the Chinese]." To be sure, in those very years the English approach to the natural garden changed. The era of the great gardens of the 1730s, 1740s, and 1750s, which had all been carefully planned as thoughtful Elysiums incor-

porating subtle conceits, and which had an inner affinity to Chinese gardens, was definitely over. Capability Brown, who monopolized the laying out of gardens between the 1760s and 1780s, introduced a new vision. His professionalism tended toward a mere exploitation of the features of the grounds and he was, indeed, utterly removed from things Chinese.

It was precisely in those years that the French coined the term *jardin Anglo-Chinois* and that the Anglo-Chinese garden conquered France, Germany, and Sweden. It was also in those years that Sir William Chambers erected the great Pagoda in Kew Gardens near London (between 1757 and 1762; 10–32) and that he exerted through his buildings and writings, particularly his *Dissertation on Oriental Gardening* of 1772, great influence on the development of the Anglo-Chinese garden on the Continent. But in England, he was regarded as an anachronism. His idea to imitate Chinese gardens for the production of horticultural lyric poems (to use Professor Lovejoy's phrase) was attacked and ridiculed.

We seem to be stumbling from paradox to paradox. But let me come back to the paradox with which I started. In Burlington's garden at Chiswick, dating probably from the late 1720s and early 1730s, we find only classical buildings and, in addition, obelisks and sphinxes; China, although a generating factor in the inception of the garden (as already noted), contributed no building.

The landscape garden at Stowe in Buckinghamshire, one of the largest ever layed out, had thirty-eight buildings, all finished around 1750. Most of them were classical, but there was also a Saxon and a Gothic temple, grottoes and caves, an obelisk and a pyramid – and a Chinese pavilion. As time went on, the English landscape garden became more and more a repository of buildings in many styles: Egyptian and Chinese, Palladian, Greek and Roman, Gothic, Turkish and Hindu – all were used to enrich the variety of the scene. The landscape garden seemed to invite vagaries for which there was hardly room within the built-up area of a town. The fashion lasted well into the nineteenth century. Alton Tower in Staffordshire, built between 1815 and 1827 for the fifteenth Earl of Shrewsbury, has in its garden a miniature copy of Stonehenge, an Indian portico, a Chinese pagoda, a Grecian temple, and a Gothic tower. Fischer von Erlach's historicism had come to life in the Anglo-Chinese landscape garden of the late eigh-

teenth century – a result unforeseen when the movement was ushered in by paying equal tribute to, and drawing inspiration from, classical and Chinese precedents.

This brief sketch of the history of the Anglo-Chinese garden, perhaps the most significant and most lasting artistic contribution of the eighteenth century, has brought us face to face with the intricacies of the quest I was concerned with in these lectures. At the level of artisan material such as textiles, porcelain, lacquer ware, and the like, it is relatively easy to establish routes of migration, transmission, assimilation, and transformation. Clarification at the level of the so-called minor arts is valuable for the major issues of cultural contacts and changes of taste. But when we have to deal with complex relations of a high order, the thought processes that have gone into them are often so tenuous that full contemporary documentation (as in the case of the landscape garden) is needed in order to arrive at a valid assessment of the foreign contribution.

A general statement is, however, permissible: We are only interested in works to which we are drawn by affinity. Not by chance did the Romanesque animal style fall back on the animal and monster typology of the Near East. Not by chance did such Egyptian symbols as the pyramid, the obelisk, and the sphinx fire people's imagination for four hundred years from the Renaissance onward. And not by chance were the late seventeenth and eighteenth centuries more attracted by Chinese art than by Near Eastern or even Egyptian art.

Each of these successive foreign penetrations was handled with supreme confidence. Misinterpretation is the real secret of the vitality of European cosmopolitanism in the arts. Misinterpretation (and I am now using the term in lieu of adaptation and translation) made it possible to incorporate the consecutive waves of non-European penetrations into the mainstream of European art.

The archaeologizing and therefore deadening attitude to style that arose in the early nineteenth century in the wake of the style-neutral attitude of the late eighteenth century was a brief intermezzo in the overall development of European art. After the mid–1850s, Japanese art became the craze in Paris and influenced artists from Manet to Van Gogh. Still later, in ever quicker and shorter waves Pacific, African, and pre-Columbian art made considerable impacts – which is what one would expect in view of the entire history of European art.

ELEVEN

Europe, India, and the Turks

Our early knowledge of India, although meager, goes back to prehistoric times and comes from travelers' reports that crystallize around the three ancient trade routes from the Far East to Europe: the northern route, across central Asia to the Caspian and Black Seas, ending at Byzantium; the middle route, through the Persian Gulf and Euphrates Valley ending at the Black Sea or such Syrian cities as Damascus; and the southern route, by water, around the southern tip of India, up the Red Sea, and overland to the Nile and northern Egypt.

In the fifth century B.C., Herodotus enriched the small store of information about the area with legends from Homer that were popular in his day. It was believed then that India was the easternmost border of the world. Two educated travelers to India in the fourth century B.C. brought back reports of an exotic land. Ktesias, from Greece, about whom little is known, had been a physician at the Persian court and on his return to Greece in 397 B.C. wrote a book on India (of which only fragments survive) in which he described the country as a land of fabulous races and mysterious elements. Megasthenes, a Greek ambassador, sent by Seleucus I to King Chandragupta (founder of the Maurya dynasty), resided at his court on the

193

Ganges River and also wrote a book on India in which he com-
mented on the Indians' dynastic lists (and their chronological
discrepancies) and legends of the gods and heroes of the people.

Alexander the Great invaded India in 326 B.C. and opened
the door wider. He had little idea of the geography of the area
and a confusion arose over the position of the Nile, a confusion
that prevailed until the Middle Ages. With a number of political
upheavals, subsequent to Alexander's invasion of the area, the
land route closed, but trade with the Ptolemys was maintained
and by the first century A.D. there was a flourishing trade be-
tween Rome and India, most notably in Indian pearls, jewels,
and spices (especially pepper).

The Moslem world was a considerable force in shaping
the history of this part of the world and its relations with
Europe. From the seventh century, the Moslems spread from
India into Persia, conquered North Africa, and penetrated into
Spain. In the fifteenth century, the Ottoman Turks conquered
Constantinople; they settled in Syria, Mesopotamia, and Egypt,
and the Ottoman Empire survived from its inception (in the
fourteenth to the sixteenth centuries) until World War II when
it was broken up. The Moghul Empire in India, composed of
Turks from the north, was begun in 1526 and remained in
power until 1858.

With the expansion of Turkish power to India, Moslem
concepts migrated also. Much of the art produced in India at
that time looks like Moslem art. The Taj Mahal, for example,
is incompatible with Indian architecture; it looks Moslem.
Eighteenth-century travelers did not make these distinctions,
however; to them, the Taj Mahal was Indian. The period pro-
duced Moslem-influenced Indian art created under Moghul
emperors.

Curiously, the influence of India receded until modern
explorations of the area in the eighteenth century generated
renewed interest. Even then, however, the nature of India's
influence on Europe differed strikingly from the way in which
the cultures of Egypt and China affected European manners
and artistic expression.

The major example of Indian influence on European ar-
chitecture in the nineteenth century is Brighton Pavilion
(1815–23; 11–1), which is extraordinary for England – or any-
where else, for that matter. It is described by Ralph Dutton in
The English Interior, 1500–1900 (1948) as, "a Chinese interior
within a fabulous Indian shell, it showed a light-hearted dis-

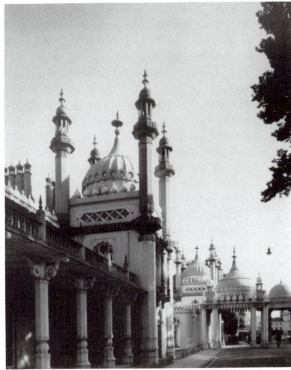

Figure 11-1a (top), *b* (bottom). John Nash. The Royal Pavilion, Brighton. 1815–23. Two exterior views. Reproduced in Terence Davis, *The Architecture of John Nash*. London, 1960. Bridgeman/ Art Resource.

regard for architectural ethics which rightly should have cul-
minated in confusion and failure, but the contrary is the case,
and the rich decoration and brilliant colouring of the ornament
give a fantastic beauty to the rooms."

A classical building is encased in, what was called at the
time, the Hindu Style. (The Prince of Wales had a particular
relish for Brighton, where he led a very gay life.) Attracted by
the so-called Hindu Style, and by the fact that Sezincote, built
for Sir Charles Cockerell (who had lived in India), had been
erected in that style, the Prince of Wales asked Humphry Rep-
ton, the architect and landscape gardener (known for his ex-
quisite renderings), to make designs for him (11–2). Ultimately,
John Nash, a particularly gifted architect many people despised
as too facile, organized the elements, based on Repton's designs,
into an incredibly unique composition, featuring tents and an
exquisite onion dome. The building is now restored very sat-
isfactorily. The interior is a maddening mixture of styles rang-
ing from classical to Chinese.

Another rich example of this pseudo-Indian architecture
is Sir Charles Cockerell's Sezincote House in Gloucestershire
(11–3–5), which was built to satisfy his desire for something
in the Indian style. He commissioned his brother, Samuel Pepys
Cockerell, to build this ca. 1805. An especially fertile imagi-
nation belonged to J. J. Lequeu, who created a striking example
of eccentric fantasy in his *Indian Pagoda Dedicated to Intel-
ligence* (11–6), which is quite far from the Indian style. He
created designs in the Gothic, Hindu, Moslem, and Egyptian
manner, and, interestingly, some of his renderings were in-
cluded in the show of *Visionary Architecture* at the Metro-
politan Museum of Art in 1967–8.

This general interest in India actually grew out of the
accounts and visual records of some painters and draughtsmen
who traveled to India in the eighteenth century. For example,
William Hodges, a student of England's great watercolorist,
Richard Wilson, went to India from 1779 to 1783 and, on his
return, published *Select Views in India* (1785–1788), which he
followed in 1793 with another series of Indian views entitled
Travels in India.

Thomas Daniell went to India with his nephew Will Dan-
iell, from 1786 to 1793, and they roamed up into the Himalayas.
Both excellent artists, they made exciting records of what they
saw, and to assure the greatest accuracy of their views, they

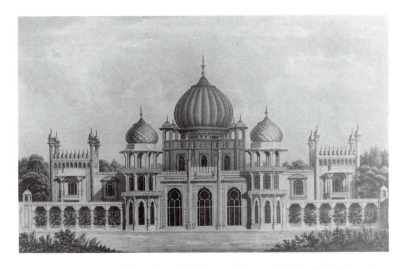

Figure 11-2. Royal Pavilion, Brighton. Front. Design by Humphry Repton (published by him 1808).

Figure 11-3. Samuel Pepys Cockerell. Sezincote House, near Moreton-in-the Marsh, Gloucestershire. ca. 1805.

Figure 11-4. Samuel Pepys Cockerell. Sezincote House. Aquatint by John Martin.

Figure 11-5. Samuel Pepys Cockerell. Sezincote House. Doorway, detail.

Figure 11-6. Jean-Jacques Lequeu. *Indian Pagoda Dedicated to Intelligence.* 1792. Collection of Gothic-, Hindu-, Chinese-, Moslem-, and Egyptian-style drawings. Bibliothèque Nationale, Paris.

Figure 11-7. Mihrab. Luster-painted glazed ceramic, Persian. 1226. State Museum, Berlin.

used the camera obscura. Back in England in 1794, they began to publish their works. *Oriental Scenery* was brought out between 1795 and 1808, and in 1810, they published *A Picturesque Voyage to India by Way of China.* They also exhibited in the Royal Academy when they returned, and their works exerted great influence, especially on contemporary watercolorists and topographical artists.

Johann Zoffany, born in Frankfurt in 1734/5, settled in England in 1760, where he became quite influential with his conversation pieces and theater scenes with the great actor David Garrick. Zoffany's stay in India from 1783 to 1789 influenced not only his own work but contributed to the growing interest in India in the late eighteenth century.

The influence of the Moslem world on European art is in some ways quite a remarkable phenomenon. An article by E. J.

Grube in *Oriental Art* (1962) on lustre-painted tiles from the thirteenth and fourteenth centuries is very enlightening in this regard. For example, tiles were regarded as great works of art by the Moslems; they were executed by the finest artists and were even dated. These tiles often carried exquisite linear designs – great emphasis was placed by the Moslems on cufic script as decoration, and this fashion penetrated into Europe (11–7). It appears early in Sicily, which had been under Moslem rule for 150 years. Moslem influence is notable in the Capella Palletina ceiling in Palermo, and cufic inscription is found from the twelfth century in Amalfi and Salerno. It is found in French cathedrals as well.

Cufic inscription as ornamental decoration without literary meaning appears in Italian painting from the Trecento on. For example, in the works of Cimabue, or in Duccio's *Rucellai Madonna* (1285; 11–8), cufic writing is visible in the border of the cloth of honor. In Gentile da Fabriano's Madonna in Pisa, cufic ornament goes around the robe and also appears in the halo, which becomes common in Quattrocento art. In Masaccio's Pisa altarpiece of 1426, for example, the halo of the Virgin bears cufic writing (11–9, 10). In 1449–50, Andrea del Castagno uses it on the hem of the Virgin's garment in the Assumption (in Berlin).

This practice goes on through the Quattrocento but dies out in the beginning of the Cinquecento. It ends with Signorelli, Perugino, and the early Raphael. However, arabesques and interlaced designs (11–11), also linear forms introduced from the Moslem world and commonly found in the West, continue to appear. Affinities may be seen to exist, for example, between interlace in ninth- and tenth-century mosques and fourteenth-century Moslem illumination and the designs of Leonardo and Dürer.

The inhabitants of the Indian world held great fascination for the West. Another group was much on people's minds, especially from the fifteenth century onward: The Turks kept Europe uneasy for over two hundred years as fighting occurred during the sixteenth, seventeenth, and eighteenth centuries, until their empire finally collapsed. The conquest of Constantinople in 1453 was one of the most significant events in the history of Europe, and the conflict between the Turks and Greeks resulted in many traditional elements of both cultures being transplanted to Italy.

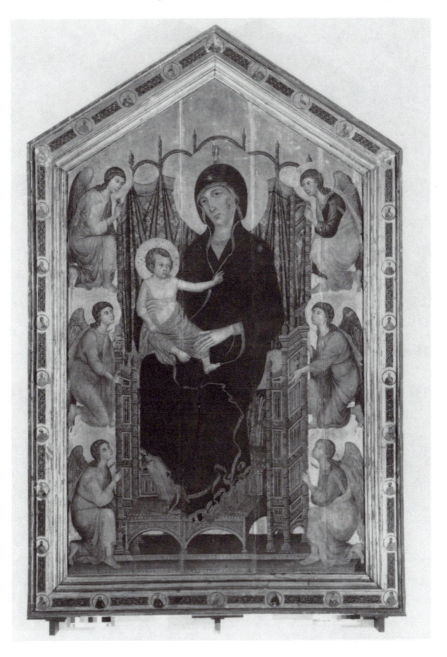

Figure 11-8. Duccio. *Rucellai Madonna*. 1285. Uffizi Gallery, Florence. Scala/Art Resource.

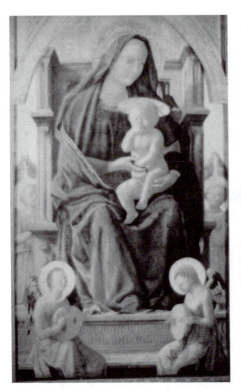

Figure 11-9 (left). Masaccio. *Madonna and Child.* Pisa Altarpiece. 1426. National Gallery, London. Art Resource. *Figure 11-10 (right)* Detail of 11-9.

Figure 11-11. Arco del Sabat. Mosque. Cordova. Ninth or tenth century.

Figure 11-12. Gentile Bellini. *Turkish Man.* Drawing. 1479–81. British Museum, London.

Figure 11-13. Gentile Bellini. *Turkish Woman.* Drawing. 1479–81. British Museum, London.

Contacts between Venice and Constantinople were particularly significant. When Mohammed II took Constantinople, he found the Venetians to be shrewd merchants interested in exploiting a changing world. They established commercial ties with the Turkish Empire that flourished in profitable trade and also made it possible for some of Europe's outstanding artists to record Turks for the Western world. Gentile Bellini, for example, went to Constantinople from 1479 to 1481 (Mohammed II died in May 1481). He painted two particularly handsome Turkish portraits of a man and a woman (11–12, 13). Bellini was a first-rate artist, and it is therefore unfortunate that very little of his work remains. These two portraits, then, cannot be overestimated; it is the first time a Renaissance man with a sharp eye had these strange people sitting for him.

It is generally maintained that the sitter's brocaded robe in Bellini's colored miniature portrait of a young Turkish artist in the Gardner Museum in Boston was executed by a Turkish artist, but Bellini was certainly capable of doing this. Indeed, his drawings for the portrait carry notes in Venetian dialect that make it clear that they are entirely his work. There has

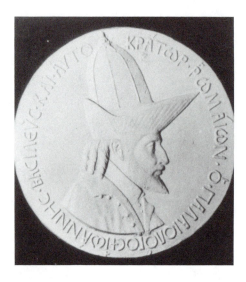

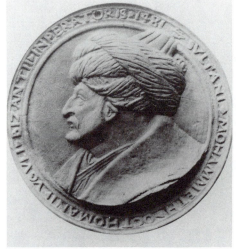

Figure 11-14. Pisanello. *John VIII, Palaeologus. Emperor of Constantinople.* Made at Council of Ferrara, 1438. British Museum, London. Reproduced in Hill, *Italian Medals.*

Figure 11-15. Costanzo da Ferrara. *Sultan Mohamed II.* 1481. British Museum, London. Reproduced in Hill, *Italian Medals.*

been some discussion that these drawings were executed by Pintoricchio, but the evidence is not convincing.

Important Turks were recorded in bronze as well. Pisanello's relief portrait of John VIII (1438), emperor of Constantinople, shows the emperor when he traveled, in despair, to the Ferrara Council in Italy (11–14), to discuss the unification of the East and West churches and to gain support from the West. Later, he died in the defense of Constantinople.

Mohammed II knew of Pisanello's talent and reputation as a medalist and wanted to be honored the same way as the emperor. The relief in the London National Gallery, executed in 1480, appears to be partly reworked. It is possible that this is a copy made by Costanza da Ferrara (11–15), a painter and medalist, who worked in Naples after 1475. He was invited to Constantinople by the Sultan to paint his portrait and create a medal for him. Ferrara executed his medal in 1481, the year Mohammed II died.

Lorenzo de Medici also became involved in this subject about 1480, when he commissioned a portrait medal of the Sultan. He was in close diplomatic contact with Constanti-

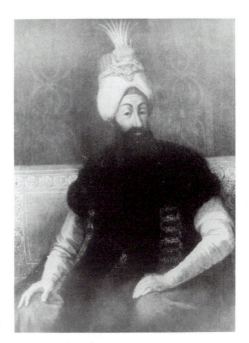

Figure 11-16. Titian (once attributed). *Portrait of Sultan Abdul Hamid I.* 1774–89. Brass Collection, Vienna. Reproduced in P. Cellini, *Arte Antica e Mod.*, 1961.

Figure 11-17. Carpaccio. *St. George Killing the Dragon.* 1505. Scuola de S. Giorgio degli Schiavoni, Venice.

nople, and to please the Sultan, he had his court artist, Bertholdo (who was never in Constantinople), make a copy of Gentile Bellini's portrait for Mohammed II.

A portrait of the Sultan (in the Brass Collection) in Vienna (11–16), which Berenson attributed to Titian, was questioned by Pico Cellini, who noted that the turban the Sultan wears in the portrait is in the fashion of the eighteenth century, and

through further investigation he dates the painting 1774–89. He has published his research and conclusions in *Arte Antica e Moderna* (1961).

In view of the important commercial ties that Venice had with Constantinople, it is not surprising then that Turkish manners played an important role in the art of Venice. In *The Preaching of St. Mark* (1504) painted by Gentile Bellini for the Scuola de San Marco, now in the Brera in Milan, the artist shows a long procession of women with a large group of Moslems intermingling with the aristocracy of Venice, a scene certainly not strange to sixteenth-century Venetians. Other features, however, are curious and yet reflect the widespread nature of the Eastern influence. There is a camel in the piazza, for example, symbolic of Egypt, which is not a common feature, and the architecture is particularly puzzling. The Church of St. Mark, centrally positioned, is embellished by strange motifs, and in the background is a three-tiered minaret. It is noteworthy that all of these architectural details are portrayed with surprising accuracy.

Carpaccio's perceptive recording of Eastern material is reflected in his *St. George Killing the Dragon* (11–17) of 1505, in the Scuola de S. Giorgio, a scene that he characteristically places against an architectural setting. In the center is an octagonal building that refers to the Church of the Rock in Jerusalem. He has portrayed oriental features in the architecture as well as in the dress of the figures he includes in his composition. In *St. Stephen Preaching Outside Jerusalem* (ca. 1511) in the Louvre, Carpaccio shows the city in the background and gives a careful rendering of the architecture of Jerusalem with some Roman reminiscences (triumphal arch) included. He portrays in his figures a curious mixture of oriental and Jewish types. Both Carpaccio and Bellini had a great influence on shaping the oriental taste of the period. Mantegna and Pollaiuolo, as well as Pintoricchio (who drew directly from Bellini's drawings), drew inspiration from these two artists.

Antonio Filarete's imaginative *Trattato d'architettura* of the fifteenth century reflects numerous oriental influences, and his bronze gates for St. Peter's, which he executed in 1443–5, contain a readable Arab inscription and other oriental references.

Pintoricchio's *Disputation of S. Catherine* (ca. 1500) in the Borgia apartments contains a number of oriental figures.

The grandson of the last emperor, John VII, is portrayed in picturesque dress, and Mohammed II's son, Gshem, is shown astride a large white horse at the right of the composition. Gshem was the object of a bizarre and intricate assassination plot (between Rome and Constantinople) that involved individuals at almost every level of church and state, from the lowest to the highest. The story illustrates the close relation between Rome and Constantinople at the time and the widespread corruption that existed there.

In Benozzo Gozzoli's *Adoration of the Magi* (1459–60) in the chapel of Palazzo Medici Riccardi, Florence, the train of Magi is a most fascinating one with the grandest figures representing John VII (who had traveled to Ferrara in 1438 and then to Florence, where Pisanello made a medal of him). He appears here in the attire of a Magus, and the artist has conceived of him as a picturesque prince of the East, even though he was the Christian emperor.

Mantegna's (workshop) *Adoration of the Magi* (1450s) features oriental figures in Turkish dress who represent Europe, Asia, and Africa. This kind of allegory is similarly found in the Low Countries as in the *Ecce Homo* (11–18, 19; after 1500, by the Master of the Bruges Passion) in the London National Gallery, and cufic inscriptions are also found in the north. Particularly rich examples of this oriental material appear in the works of Memling and Schongauer. Actually, the religious iconography of the time abounds with this oriental vocabulary, both in the north and in the south.

This oriental vogue was reflected in the public life of the period as well, as is illustrated by Jacques Callot's drawings and engravings of scenery for theatrical productions of the seventeenth century (11–20). Also illustrative of this influence are the drawings and etchings of Turkish riders as well as religious compositions by the interesting, if mad, French Mannerist, Jacques Bellànge (11–21). The event that perhaps most spectacularly illustrates the oriental penetration into European manners of the period was the festival affair that Bellànge developed and produced in celebration of the wedding of Henry of Lorrain and Margarite, 19 June 1606, that featured thirty-six gentlemen dressed as Turks.

The most important Dutch painter of the Baroque period, Rembrandt van Rijn, was deeply concerned with oriental dress and customs (11–22, 23), yet his biographer, Jakob Rosenberg,

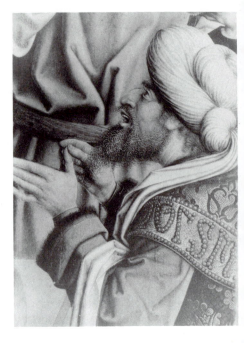

Figure 11-18 (left). Master of the Bruges Passion. *Ecce Homo.* 1500–10. National Gallery, London. *11-19 (right)* Detail of 11-18.

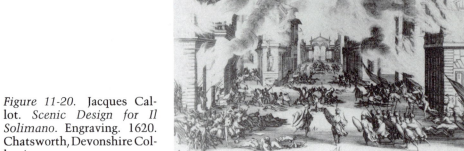

Figure 11-20. Jacques Callot. *Scenic Design for Il Solimano.* Engraving. 1620. Chatsworth, Devonshire Collection.

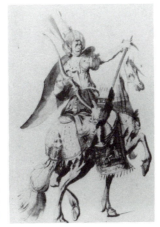
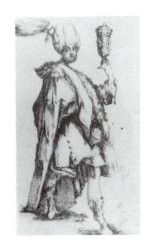

Figure 11-21. Jacques Bel-
lànge. *Oriental rider (left),
Magus (right).* Etching. ca.
1600. Louvre. Reproduced in
Baltrušaitis, *Aberrations.*

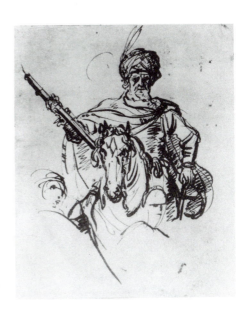

Figure 11-22. Rembrandt van Rijn. *Or
ental on Horseback.* Drawing. 1625–6
British Museum, London.

makes no reference to Rembrandt's interest in Turkish man-
ners. The artist grew up in an ambience in which people were
virtually saturated with Turkish things. For example, he was
obviously aware of the work of Nicoletto's *Turkish Family* (ca.
1500; 11–24), which is particularly puzzling in its juxtaposition
of a woman in a turban next to a sophisticated Turk. This
subject by Nicoletto, an engraver who derived much from Man-

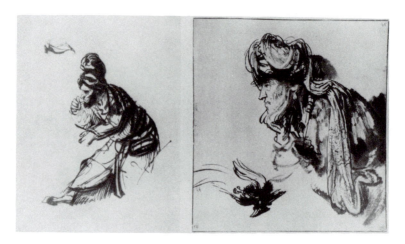

Figure 11-23. Rembrandt van Rijn. *Orientals in Turbans*. Drawing. ca. 1637. British Museum, London.

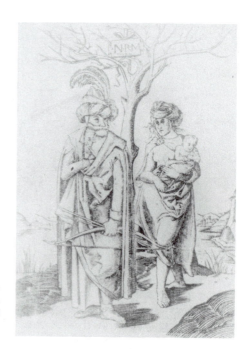

Figure 11-24. Nicoletto. *Turkish Family.* Engraving. ca. 1500. London Collection. Published in Arthur M. Hind, *Early Italian Engraving*. Washington, D.C., 1948.

tegna, is not easy to understand. Is it religious? Equally compelling is Vrancke van der Stoct, who was involved with Hieronymus Bosch, and his subject here (11–25) for which I have found no explanation may have something in common with Bosch's explorations.

Jan Lieven's *Esther Accusing Haman*, with Ahasuerus (ca. 1620–30; 11–26) characterized as a great Eastern potentate, impressed Rembrandt. Indeed, this painting was long attributed to Rembrandt. Pieter Lastman's work was also influential on the great Dutch painter. Lastman's *Massacre of the Innocents* in which the artist depicts people falling in great disarray is a typical Baroque composition, but a striking feature that relates the painting to this discussion is the appearance of figures that are obviously inspired by Turkish manners; for example, Lastman has rendered the messenger on horseback unmistakably as a Turk.

Other sources of Eastern inspiration for Rembrandt came from more immediate material (11–27, 28). The Dutch East India Company, founded in 1602, introduced much material into Holland through its commercial contacts with the Moghul emperors. For example, Rembrandt owned a set of modern Indian miniatures that interested him greatly because of a simple presence he felt they embodied – a spirit that is reflected in much of Rembrandt's work.

In Rembrandt's drawing of the emperor Timur (ca. 1655; 11–29) portrayed enthroned under a baldachin, the artist obviously copied directly from a miniature. In his *Abraham Entertaining Angels* (1656; 11–30), Rembrandt reflects the spirit of a simple, silent presence that he derived from Persian miniatures, but he has transformed that spirit into something quite personal.

His drawing of a Moghul horseman (11–31) in the British Museum in London is directly inspired by Persian miniatures and shows the influence that these miniatures had on his so-called Polish Rider of 1655 in the Frick Collection in New York. This painting dates from a period in which his interest in Moghul miniatures was particularly keen, an influence that has been greatly underestimated by scholars (see, for example, Julius Held, *Art Bulletin*, 1944).

Melchior Lorch, who was in his own time (the sixteenth century) famous, exerted considerable influence on Rembrandt by way of his views of Constantinople. Of Danish and German

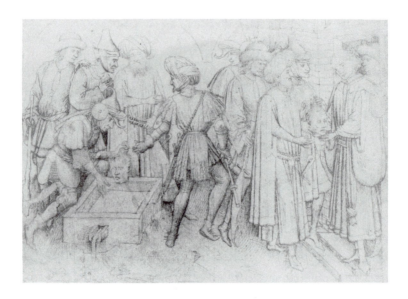

Figure 11-25. Vrancke van der Stoct. Unexplained subject. ca. 1470. Docs. 1471, 1473. Louvre, Paris.

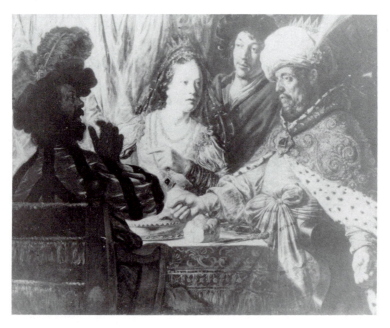

Figure 11-26. Jan Lievens (attributed to Rembrandt). *Esther Accusing Haman.* ca. 1620–30. Museum of Art, Raleigh, North Carolina.

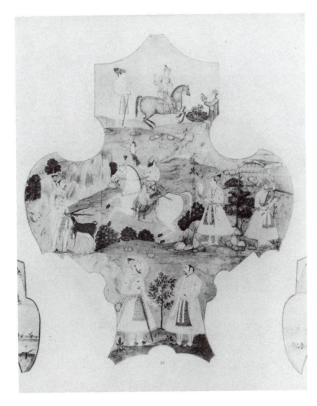

Figure 11-27. Moghul miniature. Schoenbrunn.

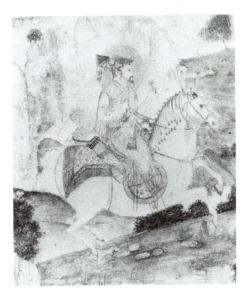

Figure 11-28. Moghul miniature. *Pious Conclave.* Shah Jahan. Seventeenth century.

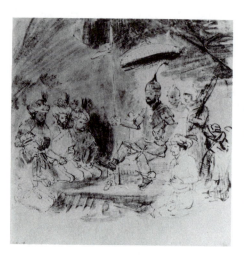

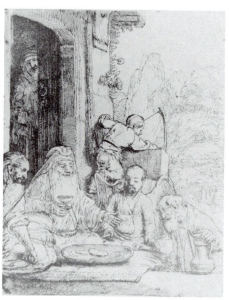

Figure 11-29. Rembrandt van Rijn. Em-
peror Timur. Drawing. ca. 1655. Louvre,
Paris.

Figure 11-30. Rembrandt van Rijn. Abra-
ham Entertaining Angels. Etching. 1656.
Museum of Fine Arts, Boston.

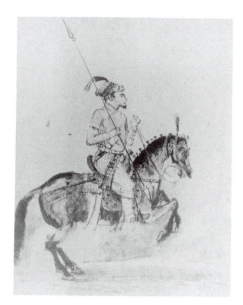

Figure 11-31. Rembrandt van Rijn. In-
dian Horseman. Drawing. British Mu-
seum, London.

descent, Lorch was trained in Germany and, in his twenties, traveled for three years in Italy to Venice, Bologna, Florence, and Rome, supported by the Danish king. He traveled subsequently to Vienna, and then spent four years in Constantinople (1555–9), which served as the inspiration for his book that influenced Rembrandt.

Rembrandt's inventory showed that he owned a book by Lorch that contained an illustration of a Turkish building, which no doubt refers to the book Lorch prepared containing etchings of oriental views and people. Lorch died before the book was finished, but in 1626 the work (which is extremely rare) appeared with 124 woodcuts (republished in 1641, 1646, 1684, and 1688).

Rembrandt's Orientalism, in turn, exerted an influence on Italy, which may be seen in any number of examples, such as his handling of the turban in his *Orientals with Turbans* (11–22) of 1637, or his *Oriental on Horseback* (11–22) of 1625–6. Turbans, as such, were in fashion much earlier, of course. For example, Jan van Eyck's famous portrait, *The Man in Red Turban* (11–32; 1433) in the National Gallery in London, reflects a long tradition in the Low Countries of this kind of thing. Rembrandt, however, developed this tradition further. His influence in this regard may be seen, for example, in Tiepolo's etching of the *Scherzo di Fantasia* (11–33). It should be noted that the influence of Castiglione may be detected here also in Tiepolo's work.

Oriental material continued to play an important role in European painting. In the Romantic period, the interpretation of the Orient placed a distinct emphasis on the exoticism of specific places, as the balance of influence shifted. For example, up to 1830 travelers tended to favor Constantinople and Egypt. However, when Algiers became a French colony in 1830, travel to that area became easier and more attractive.

Théodore Géricault and Eugène Delacroix both painted Algerian scenes as the setting for varied themes ranging from animals fighting for their lives, to historic battles, to harem scenes. Virtually all French Romantic painters of the century contributed to this exploration. Eugène Fromentin's *Falcon Hunt in Algiers* (1863) in the Louvre is typical of the period, and his *Arabs Crossing a Ford* (Metropolitan Museum of Art) painted in 1873 demonstrates that this interest continued late into the century, even when other currents were stronger.

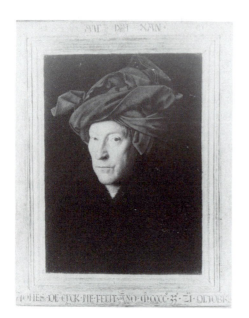

Figure 11-32. Jan van Eyck. *Man in Red Turban.* 1433. National Gallery, London.

Figure 11-33. Tiepolo. *Scherzo di Fantasia.* Etching. See Aldo Rizzi, *The Etchings of the Tiepolos.* London, 1971.

Moreover, J.-A.-D. Ingres's *Odalisque with Slave* (1842) in the Walters Art Gallery in Baltimore and his celebrated tondo of the *Turkish Bath* (1863) in the Louvre remain among the outstanding paintings of the nineteenth century that bear testimony to the character of the oriental influence on French painting of the period.

At the same time, military and political activity afforded the artist stimulating subject matter that was open to different interpretations. Napoleon's painter and David's pupil, Antoine-Jean Gros, for example, portrayed *Napoleon at the Pest House of Jaffa* (or *Napoleon Visiting the Plague-Stricken at Jaffa*; 1804, Louvre) as a Christ figure – he appears to heal the sick by his touch. Furthermore, John Martin, one of England's most spectacular Romantic painters, whose large canvases and popular mezzotints illustrate a wide range of subjects, caused the most excitement with his Biblical themes that reflected oriental in-

fluences, such as in his *Fall of Babylon* (1819) and *Belshazzar's Feast* (1820).

The attraction of the Romantic exoticism of the North African ambience subsided by the 1870s (which coincided with the rising interest in the Japanese print). For example, although Renoir traveled to North Africa and painted Algerian subjects, his paintings convey straightforward views of his subjects there devoid of the Romantic exoticism that characterized the work of earlier painters. It is noteworthy, too, that even though Monet had military service in Algiers, his painting remained unresponsive to what had stimulated previous generations.

Thus, by 1870, Romantic exoticism was outdated, and painters then turned to an anti-Renaissance primitivism that went back to the Nazarenes and the English Pre-Raphaelites. Fundamental to this was a reevaluation of eighteenth- and nineteenth-century values; the most influential figure at the center of this artistic revolution was Gustave Courbet, who turned to naturalism and primitivism for his inspiration. Courbet's quest gave birth to a new naturalism in the 1840s that opened the way for the later contributions of the Impressionists and that laid the foundations ultimately for the achievements of Picasso and the cubist appreciation of form in African art.

Informing the eighteenth and nineteenth centuries with a distinct kind of primitive Romanticism was a constellation of notions and images that crystallized around the idea of the Noble Savage. Captain James Cook's journeys, begun in 1768, served to enrich the idea of the Noble Savage and his habitat and may be seen as being connected with the experience sought by travelers in China (discussed previously) – the discovery of a Golden Age, an earthly paradise, and the like. Cook's explorers were seen as modern-day Homers and the native chieftains they met as something akin to Greek heroes of old. These unsullied people were seen to dwell in Elysian fields that resembled the Garden of Paradise before the Fall of Man when people lived in a natural state. This belief in the nobility and simplicity of nature was reinforced by the images created by such artists as William Hodges, whose renditions enjoyed unquestioned credibility – because he was there, as a member of Cook's expedition (11–34–36). Hodges interpreted Pacific scenes in Claudian terms under the influence of the great English landscape painter and watercolorist Richard Wilson. In

Figure 11-34. William Hodges. *Cape Stephens, New Zealand, with waterspout.* ca. 1776. Admiralty, London.

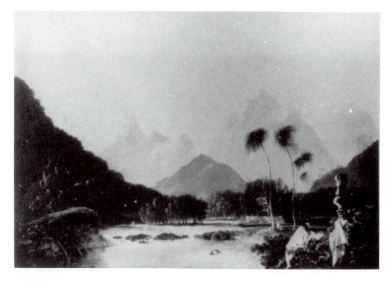

Figure 11-35. William Hodges. *Bay of Oaitepeha, Society Islands.* ca. 1776. Admiralty, London.

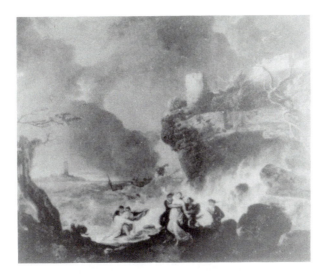

Figure 11-36. Richard Wilson. *Ceyx and Alcyone.* 1768. Private collection. Published in B. W. Smith, *The European Vision and the South Pacific; a Study in the History of Art and Ideas.* Oxford, 1960.

the following decade, the idea of the Noble Savage reached a high point in its development in Sir Joshua Reynolds's portrait of the Noble Omai (1776) in Castle Howard (in a stance strikingly reminiscent of the Apollo Belvedere), which introduced the Noble Savage into the London Salon.

Bibliography
RUDOLF WITTKOWER'S READING LIST, 1969

General

J. Baltrušaitis. *Art sumérien, art roman.* Paris, 1934.

———. *Le Moyen Âge fantastique, Antiquitée et exotismes dans l'art Gothique.* Paris, 1955. This author is always interesting and full of ideas, but he often operates with unfounded assumptions.

R. Bernheimer. *Romanische Tierplastik und die Ursprünge ihrer Motive.* Munich, 1931. This is a most thoughtful work and, to my mind, still the best statement about the impact of the Near East on the Romanesque style.

T. Bowie, ed. *East-West in Art: Patterns of Cultural and Aesthetic Relationships.* Bloomington, Ind., 1966. The book contains a collection of ten papers by various authors. The quality of the contributions is unequal, but, on the whole, new avenues to the problem are opened up.

R. A. Jairazbhoy. *Oriental Influences in Western Art.* New York, 1965. Very learned, but a little diffuse and not quite easy to digest. But the book contains much interesting material.

E. Mâle. *L'art religieux du XIIe siècle en France: Étude sur les origines de l'iconographie du Moyen Age.* Paris, 1922. Basic study.

V. Slomann. *Bicorporates: Studies in Revivals and Migrations of Art Motifs,* 2 vols. Copenhagen, 1967. An exemplary study; rather slow moving though. The plate volume contains 739 illustrations. Starting point of the investigation: the

monster with two bodies and one head. I do not agree with Slomann's conclusions.

B. W. Smith. *European Vision and the South Pacific, 1768–1850: A Study in the History of Art and Ideas.* Oxford, 1960.

Geographical Lore and Discoveries

C. R. Beazley. *The Dawn of Modern Geography: A History of Exploration and Geographical Science,* 3 vols. Oxford, 1897–1906; reprint, New York, 1949. Standard work. Covers period from ca. A.D. 300 to the fifteenth century.

E. H. Bunbury. *A History of Ancient Geography among the Greeks and Romans, from the Earliest Ages till the Fall of the Roman Empire.* London, 1879.

George H. T. Kimble. *Geography in the Middle Ages.* London, 1938. Excellent survey.

John Kirtland Wright. *The Geographical Lore of the Time of the Crusades: A Study in the History of Medieval Science and Tradition in Western Europe.* New York, 1925. An excellent exposition with critical bibliography.

Cartography

T. Gasparrini Leporace. *Mostra "L'Asia nella Cartografia degli Occidentali."* Venice, 1954. With further literature.

Konrad Miller. *Mappaemundi: Die ältesten Weltkarten,* 6 vols. Stuttgart, 1895–8. Reproduction and discussion of all early maps.

Travels

G. F. Hudson. *Europe and China: A Survey of Their Relation from the Earliest Times to 1800.* London, 1931.

Arthur Percival Newton, ed. *Travel and Travellers of the Middle Ages.* London, 1926. A good survey.

L. S. S. O'Malley, ed. *Modern India and the West: A Study of the Interaction of Their Civilizations.* Oxford, 1941.

H. G. Rawlinson. *Intercourse between India and the Western World from the Earliest Times to the Fall of Rome,* 2nd ed. Cambridge, 1926.

Anastasius Van Den Wyngaert and Georgius Mensaert. *Sinica Franciscana,* 5 vols. Florence, 1929–54. Critical editions of Franciscan missions, thirteenth and fourteenth centuries.

E. H. Warmington. *The Commerce between the Roman Empire and India.* Cambridge, 1928.

H. Yule and H. Cordier. *The Book of Ser Marco Polo.* London, 1903; rev. ed., 1920. The classic English edition.

Ancient Near East

H. Frankfort. *The Art and Architecture of the Ancient Orient.* Harmondsworth, 1955.

———. *Cylinder Seals: A Documentary Essay on the Art and Religion*

of the Ancient Near East. London, 1939. Frankfort's two books are the most authoritative in their respective fields.

H. Kantor. *The Aegean and the Orient in the Second Millennium B.C.* Bloomington, Ind., 1947.

W. F. Volbach. "Oriental Influences in the Animal Sculpture of Campania." *Art Bulletin* 24 (1942): 172–80.

Egypt

W. S. Smith. *The Art and Architecture of Ancient Egypt.* Harmondsworth, 1958.

Iran (Persia)

Roman Ghirshman. *Iran, From the Earliest Times to the Islamic Conquest.* Harmondsworth, 1954.

———. *Persian Art: The Parthian and Sassanian Dynasties, 249 B.C.–A.D. 651.* New York, 1962.

A. U. Pope, ed. *A Survey of Persian Art.* 6 vols., Oxford, 1938–58. The area's standard work.

Edith Porada. *The Art of Ancient Iran: Pre-Islamic Cultures.* New York, 1965.

7000 Years of Iranian Art. Circulated by the Smithsonian Institution, 1964–5.

Byzantium

L. Bréhier. *La sculpture et les arts mineurs byzantins.* Paris, 1936.

G. Duthuit and F. Volbach. *Art Byzantin.* Paris, 1933. Both books with brief texts and many good plates.

S. Runciman. *Byzantine Civilization.* London, 1961. An excellent general introduction.

China and Europe

Historical

G. F. Hudson. *Europa and China.* London, 1931. Good introduction, mainly for early period.

Early Travels and Missions to China

C. Dawson. *The Mongol Mission.* New York, 1955. With excellent introduction and translations.

A. Percival Newton, ed. *Travel and Travellers of the Middle Ages.* London, 1930. A good survey.

P. Anastasius Van Den Wyngaert. *Sinica Franciscana.* Florence, 1929. Standard edition of Franciscan missions, thirteenth and fourteenth centuries.

R. Wittkower. "Marco Polo and the Pictorial Tradition of the Marvels of the East." In *Oriente Poliano, studi e conferenze tenute*

all'Is.M.E.O. in occasione del VII centenario della nascita di Marco Polo (1254–1954), pp. 155–72. Rome, 1957.
H. Yule and H. Cordier. *The Book of Ser Marco Polo.* London, 1903; rev. ed., 1920. The classic English edition.

China and the Renaissance
B. Berenson. *Essays in the Study of Sienese Painting.* New York, 1918. Opened the discussion of Chinese influence on Sienese painting.
L. Olschki. "Asiatic Exoticism in Italian Art of the Early Renaissance." *Art Bulletin* 26 (1944): 95–106. Does not admit formative Chinese influence in fourteenth and fifteenth centuries.
I. V. Pouzyna. *La Chine: l'Italie et les débuts de la Renaissance.* Paris, 1935. Advocates formative influence of China, particularly on Sienese art.
G. Soulier. *Les influences orientales dans la peinture toscane.* Paris, 1924. Far Eastern influences play a minor part in this work.
C. Sterling. "Le paysage dans l'art Européen et dans l'art Chinois." *L'Amour de l'Art* 12 (1931): 9ff., 101ff. Important summary of the problems.

Chinoiserie

GENERAL
William W. Appleton. *A Cycle of Cathay.* New York, 1951. Recommended for the literary background.
Henri Cordier. *La Chine en France au XVIIIe siècle.* Paris, 1910.
Jacques Guérin. *La chinoiserie en Europe an XVIIIe siècle.* Paris, 1911.
Hugh Honour. *Chinoiserie: The Vision of Cathay.* London, 1961. From a modern art historical point of view. With rich critical notes.
Sidney Fiske Kimball. *The Creation of the Rococo.* Philadelphia, 1943.
Adolf Reichwein. *China and Europe.* New York, 1925.
Allen B. Sprague. *Tides in English Taste.* Cambridge, Mass., 1937. Recommended for the literary background.

TRAVEL ACCOUNTS
Jean-Baptiste Du Halde. *A Description of the Empire of China...* Paris, 1735; English: London, 1738–41. The most encyclopedic work.
George Louis Le Rouge. *Detail des Nouveaux Jardins à la Mode et Jardins Anglo-Chinois.* Paris, 1773–85.
Jan Nieuhof. *An Embassy from the East-India Company... to the Grand Tartar.* Amsterdam, 1665; English: London, 1669. First important account.
Father Matteo Ripa. *Thirty-six Views of Jehol.* Jehol (China), 1713. A very rare series of engravings of the imperial palaces of Jehol. One set is in the New York Public Library.

TREATISES AND PATTERN BOOKS

William Chambers. *Designs of Chinese Buildings, Furniture, Dresses, Machines, and Utensils.* London, 1757.

———. *A Dissertation on Oriental Gardening.* London, 1772.

———. *Plans, Elevations, Sections and Perspective Views of the Gardens and Buildings at Kew in Surrey.* London, 1763.

J. B. Fischer von Erlach. *Entwurff einer historischen Architectur.* Leipzig, 1721, 1725.

William Halfpenny and John Halfpenny. *Chinese and Gothic Architecture properly ornamented.* London, 1752.

———. *Rural Architecture in the Chinese Taste.* London, 1750, 1752, 1755.

Charles Over. *Ornamental Architecture in the Gothic, Chinese and Modern Taste.* London, 1758.

GARDENS

H. F. Clark. "Eighteenth Century Elysiums." *Journal of the Warburg and Courtauld Institutes* 6 (1943): 165–89. Not specifically concerned with the "Anglo-Chinese" garden, but invaluable as a general background.

E. von Erdberg. *Chinese Influence on European Garden Structures.* Cambridge, Mass., 1936.

S. Lang and N. Pevsner. "Sir William Temple and Sharawadgi." *Architectural Review* 106 (1949): 391–3. An excellent study.

Arthur O. Lovejoy. "The Chinese Origin of a Romanticism." In *Essays in the History of Ideas.* New York, 1955, pp. 99–135. A classic, first published in 1933. I disagree with Lovejoy's main thesis.

Osvald Sirén. *China and the Gardens of Europe in the Eighteenth Century.* New York, 1950. Probably the best and most comprehensive work. The author knew China well. Many splendid illustrations.

Egypt and Europe

General

J. Baltrušaitis. *Essai sur la légende d'un mythe: La Quête d'Isis, Introduction à l'Égyptomanie.* Paris, 1967. Follows up Egyptomania in France and to a lesser extent in other countries. Contains a great deal of new and interesting material, but is difficult to digest.

Karl H. Dannenfeldt. "Egypt and Egyptian Antiquities in the Renaissance." *Studies in the Renaissance* 6 (1959): 7–27. Contains some interesting material, but not an entirely satisfactory paper.

Erik Iversen. *The Myth of Egypt and Its Hieroglyphics in European Tradition.* Copenhagen, 1961. An excellent book. Main theme, as title says: hieroglyphics. But the book contains much other material relevant to this course.

N. Pevsner and S. Lang. "The Egyptian Revival." *Architectural Review* 119 (May 1956): 242–54. An excellent collection of material.

Frank J. Roos. "The Egyptian Style." *Magazine of Art* 30 (1940): 218–23.

Hieroglyphics

George Boas. *The Hieroglyphica of Horapollo*. New York, 1950. Translation of Horapollo's text with excellent introduction.

L. Dieckmann. "Renaissance Hieroglyphics." *Comparative Literature* 9 (1957): 308–21.

Karl Giehlow. "Die Hieroglyphenkunde des Humanismus in der Allegorie der Renaissance." *Jahrbuch der Kunsthistorischen Sammlungen des Allerhöchsten Kaiserhauses* 32 (1915): 1–232.

Erwin Panofsky. *The Iconography of Correggio's Camera di San Paolo*. London, 1961.

Ludwig Volkmann. *Bilderschriften der Renaissance*. Leipzig, 1923. Giehlow's and Volkmann's are the basic studies on which all further research has been based.

India, Islam, and Europe

Cufic Script

A. H. Christi. "The Development of Ornament from Arab Script." *Burlington Magazine* 41 (1922): 34–41.

S. D. T. Spittle. "Cufic Lettering in Christian Art." *The Archaeological Journal* 111 (1955): 138–52. Concerned with cufic script in Medieval art.

India

H. Goetz. "An Indian Element in 17th Century Dutch Art." *Oud Holland* 54 (1937): 222–30.

———. "Oriental Types and Scenes in Renaissance and Baroque Painting." *Burlington Magazine* 73 (1938): 50–62, 105–15.

Julius Held. "Rembrandt's 'Polish' Rider." *The Art Bulletin* 26 (1944): 246–65.

F. Sarre. "Ein neues Blatt von Rembrandts Indischen Minaturen." *Jahrbuch der Königlich Preuszischen Kunstsammlungen* 30 (1909): 283–90.

———. "Rembrandts Zeichungen nach Indisch-Islamischen Miniaturen." Ibid. 25 (1904): 143–58.

H. Schmidt. "Rembrandt, der islamische Orient und die Antike." In *Festschrift für Ernst Kühnel*. Edited by Richard Ettinghausen. Berlin, 1959.

J. Strzygowski. *Die Indischen Miniaturen im Schlosse Schönbrunn*. Vienna, 1923. Contains Rembrandt's Indian exemplars.

Turks

T. Alazard. *L'orient et la peinture francaise au XIXe siècle.* Paris, 1930. The basic work. See also *Gaz. d. beaux arts*, 1894 (Renan, *La peinture orientaliste*), 1899 (Benedite, *Les peintres orientalistes franc.*), 1911 (Vaudoyer, *L'orientalism en Europe au XVIIIe siècle*), 1921 (Escholier, *L'orientalism de Chasseriau*).

J. Ebersolt. *Orient et Occident.* Paris, 1929. Chapters on Turks and fall of Constantinople.

G. Soulier. *Les influences orientales dans la peinture toscane.* Paris, 1924. Fullest survey; contains also section on cufic script.

C. Vecellio. *Habiti antichi e moderni.* 1590. This book was used in the seventeenth and eighteenth centuries as model for costumes of orientals.

Venice

F. Babinger. "Un ritratto ignoto di Maometto II opera di Gentile Bellini." *Arte Veneta* 15 (1961): 25–32. Rich material for Mehmed II.

P. Cellini. "Per una revisione di attribuzione a Tiziano." *Arte antica e moderna* 13–16 (1961): 465. Reattribution of portrait of Sultan in Brass Collection.

F. Gilles de la Tourette. *L'orient et les peintres de Venise.* Paris, 1924. The best book, covering topic from early times to end of sixteenth century; emphasis on Gentile Bellini and Carpaccio.

Silk

Luce Boulnois. *The Silk Road.* Translated by D. Chamberlain. New York, 1966. A lively, somewhat journalistic history of trade between China and the West from antiquity to modern times.

O. von Falke. *Kunstgeschichte der Seidenweberei.* Berlin, 1921. The basic study.

E. J. Grube. "Two Hispano-Islamic Silks." *The Metropolitan Museum Bulletin* n.s. 19 (November 1960): 77–86.

P. Oliver Harper. "The Senmurv." *The Metropolitan Museum Bulletin* n.s. 20 (1961): 95–101.

E. Kitzinger. "The Horse and Lion Tapestry at Dumbarton Oaks: A Study in Coptic and Sassanian Textile Design." *Dumbarton Oaks Papers* 3 (1946): 1–72.

R. S. Lopez. "The Silk Industry in the Byzantine Empire." *Speculum* 20 (1945): 1–42.

F. May. *Silk Textiles of Spain.* New York, 1957.

H. Peirce and R. Tylor. "The Elephant-Tamer Silk, VIIIth Century." *Dumbarton Oaks Papers* 2 (1941): 19–26.

————. "The Prague Rider-Silk and the Persian-Byzantine Problem." *Burlington Magazine* 68 (1936): 213–20.

E. Sabbe. "L'importation des tissus orientaux en Europe occidental aux IXc–Xc siècles." *Revue belge de philologie et d'histoire* 14 (1935): 811–48, 1260–88.

Sakrale Gewaender des Mittelalters: Ausstellung im Bayerischen Nationalmuseum. Munich, 1955. A most instructive catalog.

H. Schmidt. "Persian Silks of the Early Middle Ages." *Burlington Magazine* 57 (1930): 284–94.

D. G. Shepherd. "A Dated Hispano-Islamic Silk." *Ars Orientalis* 2 (1957): 373–82.

J. Strzygowski. "Seidenstoffe aus Äegypten im Kaiser Friedrich-Museum wechselwirkungen zwischen China, Persien und Syrien in spätantiker Zeit." *Jahrbuch der Preussischen Kunstsammlungen* 24 (1903): 147–78. Opened the scholarly discussion of transmissions.

Tiles

E. J. Grube. "Some Lustre Painted Tiles from Kashan of the Thirteenth and Early Fourteenth Centuries." *Oriental Art* 18 (1962): 167–74.

Iconography

A. J. Braham. "L'Eglise du Dome." *Journal of the Warburg and Courtauld Institutes* 23 (1960): 216–24.

C. G. Dempsey. "Poussin and Egypt." *The Art Bulletin* 45 (1963): 109–19.

A. Dessenne. *Le sphinx.* Paris, 1957.

W. Heckscher. "Bernini's Elephant and Obelisk." *The Art Bulletin* 21 (1947): 155–82.

K. Rathe. "Der Richter auf dem Fabeltier." In *Festschrift für Julius Schlosser.* Vienna, 1927, pp. 187–208. Griffin in late Medieval and Renaissance art. A fine paper.

U. Schweitzer. "Löwe und Sphinx im alten Ägypten." *Ägyptologische Forschungen* 15 (1948): 9–76.

J. Shearman. "The Chapel in S. Maria del Popolo." *Journal of the Warburg and Courtauld Institutes* 25 (1961): 129–60.

A. Warburg. "Italienische Kunst und internationale Astrologie im Palazzo Schifanoja zu Ferrará." *L'Italica e l'Arte Straniera. Atti del X Congresso Internazionale di Storia dell'Arte, 1912.* Rome, 1922.

R. Wittkower. "Eagle and Serpent: A Study in the Migration of Symbols." *Journal of the Warburg and Courtauld Institutes* 2 (1938–9): 293–325.

Index

Ackerman, James, 60–1. *See also* Egypt, Rome
Adam, Robert, 137
Addison, 188
Alberti, 72–3, 97
Alciati, Andrea, 110, 111. *See also* Valeriano, 110
Alexander the Great, in Egypt, 37; in Asia, 148; invasion of India, 194. *See also* China
Alexander VII, Pope, 80–2, 114, 116–17. *See also* Bernini
Alexander VI, Pope. *See* Nanni da Viterbo
Alexander VIII, Pope, 80. *See also* Heckscher
Alexandria, 37–8
Alison, 176
Alphonso V. medal of, 100–101
Alton Tower, 191
Amalfi, port of, 19
Andaman Islands, Black population of, 148. *See* Marco Polo
Arabia, sources in Renaissance art, 33; Chinese connections, 145
Arles Museum, sphinxes, 26, 29
Armenia, Venetian trade with, 19
Asia, Mongol conquest of, 146
Asia Minor, art objects from, 1
Assyria, change of Egyptian sphinx in, 53
Athens, 38
Augustus, Silk trade during Age of, 145
Augustus the Strong. *See* Böttger

Babylon, 32; Ishtar Gate, 10
Babylonia, influence of its art on Romanesque animal forms, 22–33
Baghdad, Eastern Caliphate, 19
Baltrušaitis, Romanesque animal forms, 23
Barca, Pietro Antonio, 70
Bastian, Adolf, 6

Battista, Doge. *See* Genoa
Beatus, commentaries, 42, 44,
 49. *See also* Spain
Bellànge, Jacques, 207
Bellini, Gentile, 203, 204, 206
Berenson, B., 205
Bernheimer, 22
Bernini, Gianlorenzo, 75, 76,
 77, 79, 80, 87, 114, 116. *See
 also* Alexander VII, Ercole
 Ferrata, Fontana, Kircher
Bibiena, Baroque scenogra-
 phers, 129
Blondel, Nicolas François, 117
Bocchi, Achillis, 113, 114
Borromini, Francesco, 76
Bracciolini, Poggio, 96
Braham, A. J., 118
Bramante, Donato, 63, 64
Brown, Capability, 191
Böttger, Johann Friedrich, 162
Boullée, Étienne-Louis, 138,
 139
Burke, Edmund, 176. *See also*
 Piranesi
Burlington, Lord, 91–3, 176–9,
 184–5, 189. *See also* Kent
Byzantium. Silk trade, 20, 21,
 145; Chinese material
 reaches West via Byzantium,
 147–7. *See also* China

Caesar, Julius, obelisk as Cae-
 sar's tomb, 43, 44
Caligula, Temple of Isis, 40
Callot, Jacques, 207, 208
Cambi, Giovanni Battista, 70–1.
Canopus, 40
Canova, Antonio, 55, 57
Caracalla, Temple to Isis, 40
Carpaccio, 206
Carpino, John del Piano di, 146
Castagno, Andrea del, 200
Castell, Robert, 186
Caylus, Count de, 125
Cellini, 205
Chambers, Sir William, 175,
 180, 191
Charlemagne, 18

Chateauneuf-sur-Charente, 26,
 30
China, Chinoiserie and Ro-
 coco, 165; Dura-Europos,
 145; design assimilation into
 Giotto and Renaissance art,
 154–157; European contacts,
 6, 145, 146, 150, 161; *I-
 Ching*, 160; influence on Ro-
 coco, 162–3; influence on
 Western arts, 148, 150–1,
 153–5, 157–9, 161; Jesuit
 missionaries, 159, 160; Scy-
 thian trade, 145; silkworm,
 20; Tartar Dynasty replaced
 by Ming Dynasty, 146–7;
 trade/routes and silk/trade,
 20, 145; Western conception
 of China, 148. *See also* Addi-
 son, Alexander the Great,
 Alison, Andrew of Perugia,
 Asia, Augustus, Augustus
 the Strong, Böttger, Brown,
 Burke, Burlington, Byzan-
 tium, Chambers, Confucius,
 Dresden, Dura-Europos, Eng-
 land, Erlach, Florence, Fred-
 erick II, Genoa, Hudson,
 John the Fearless, Kahn, Kal-
 muck, Kames, Kent, Kim-
 ball, Leibniz, Le Vau, John
 of Magrignola, Manderville,
 Marco Polo, John of Monte
 Corvino, Mme. de Montes-
 ban, Naples, Nieuhof, Od-
 eric, Olschki, Pegolotti,
 Persia, Pisanello, Ripa, Rus-
 sia, Scythia, Shaftesbury, Si-
 lesia, Sterling, Thomson,
 Trismegistus, Vasco da
 Gama, Venice, Voltaire,
 Walpole.
Christina of Austria, Arch-
 duchess, 55, 57
Christophorus, 96. *See also*
 Niccolò Niccoli, Poggio
 Braccialini
Cimabue, 200

Clement XI, Pope, 83
Clement XIV, Pope, 75
Cockerell, Samuel Pepys, 196
Cockerell, Sir Charles, 196
Colonna, Francesco, 98–99
Courbet, Gustave, 217
Constantine, arch of, 11, 15
Confucius, 159–60
Constantinople, Alexander Sarcophagus, 10, 12; conquest of 1453, 200; Mesopotamian designs, 20; pontifical robes, 26, 28; Venetian trade, 19
Cook, James, 217
Cremona, Cathedral of, 70–71. *See also* Sfondrato, Cambi, Dattaro
Cumano, Belloto, 102

Damascus, 19
Daniell, Thomas, 199
Dattaro, Francesco, 70–1. *See also* Cambi
Delacroix, Eugène, 215
Delft, 162
Dempsey, C.,
Denon, 121
Diocletian, 11
Dresden, porcelain production of, 167. *See also* Böttger
Duccio, 200–1
Dürer, Albrecht, 130; Indian influences, 200
Dura-Europos, Chinese influences in Syrian designs, 145, 147; Temple of Baal fresco. *See also* China
Dutton, Ralph, 11, 13, 194

Eagle and snake symbolism, *Warburg Journal*, 4, 5
Egypt, 36–50, 53, 54, 67, 88. *See also* Ackerman, Alberti, Alciati, Alexander VIII, Alexander the Great, Assyria, Bernini, Blondel, Bramante, Cambi, Canopus, Canova, Capitoline, Ciriaco, Dattaro, Filarete, Fontaine

and Percier, C. Fontana, Fontana, Ficino, Goujon, Grimani, Hallerstein, Henry II, Herodotus, *Hypnerotomachia Polifili*, Innocent X, Kircher, London, Lukas, Maderno, Mantegna, Michelangelo, Mirandola, Moses, Napoleon, New York, Nicholas V, Nile landscape, Norden, Padua, Panofsky, Pasti, Pisanello, Piranesi, Pliny, Plotinus, Plutarch, Pococke, Poussin, Primaticcio, Raphael, Rome, Rossi, Sangallo, Sanmicheli, Sansovino, Serlio, Sfondrato, Tempesta, Trismegistus, Valeriano, Vedder, Venice, Vignola, Warburton
England, 22, 87–93, 140, 176, 191, 194. *See also* Burlington, Hawksmoor, Kent, Mantegna, Palladio, Parentino, Vanbrugh
Etruria, 10–14
Euphrates Valley, 22
Evans, E. P.., 42
Eyck, Jan van, 2–3, 215–6

Fabriano, Gentile da, 200
Ferrara, Costanza da, 204. *See also* Pisanello
Ferrara, 32, 33
Ferrata, Ercole, 79, 80, 81
Ficino, Marsilio, Egyptian wisdom, 95; influence on Valeriano's *Hieroglyphica*, 110; Plato's teachings, 94
Filarete, Antonio, 97–8, 206
Fischer von Erlach, Johann, 127, 167, 176. *See also* Piranesi
Florence, 150, 153–4, 207. *See also* Michelangelo
Fontaine, Pierre, 138
Fontana, Carlo, 82, 83
Fontana, Domenico, 44, 73–4.

Fontana, Dominico (*cont.*)
 See also Maderna; Rome;
 Sixtus V
France, Animal forms, 21–2;
 Egyptian painting influence
 on French manuscripts, 44.
 See also Napoleon
Frankfort, 9, 10
Frederick II, Emperor, 152
Freemasons, Egyptian influ-
 ence on, 126; momentum in
 seventeenth century, 144
Fromentin, Eugène, 215

Gallerani, Cecilia, *See*
 Leonardo
Garrick, David, 199
Genova, Battista Elia de, 103,
 104
Géricault, Théodore, 215
Genoa, Mongol slaves, 150;
 Oriental trade, 19
Germany, 26, 28; animal forms
 in, 22–3; influence of Sca-
 mozzi, 87
Gibralter, Persian artisans in,
 19
Giehlow, Karl. *See*
 Pirckheimer
Giorgio, Francesco di, 103, 104
Goujon, Jean, 115. *See also*
 Henry II, Paris
Gozzalli, Benozzo, 207
Gray, Thomas, 189–91
Greece, 20, 36–7, 94; celestial
 sphere, 32, 33; Greek art
Grimani, Marco, 67
Gros, Antoine-Jean, 216
Grube, E., 199–200
Gundestrup (Denmark), 16–17

Halicarnassus, Mausoleum.
 See Hawksmoor (St.
 George's Bloomsbury)
Hallerstein, H. von, 140, 142–3
Hawksmoor, 89–93
Heckscher, William S., 80, 114
Henry II, 114, 116
Herodotus, in Egypt, 36; hiero-

glyphics, 95; on India, 193;
 Physiologus, 103
Herrera, Juan de, 68, 70
Hodges, William, 196, 217, 218
Horace, 189
Horapollo Hieroglyphica, 96–7,
 108, 110
Hudson, G. F., 145
Hume, David, 176
Hypnerotomachia Poliphili,
 116–8

Il Moro, Ludovico. *See*
 Leonardo
India, 124, 193–4. *See also*
 Alexander the Great, Bel-
 lànge, Bellini, Berenson, Ber-
 tholdo, Callot, Castagno,
 Carpaccio, Cimabue, Cock-
 erell, Constantinople, Dan-
 iell, Delacroix, Duccio,
 Dutton, Fabriano, Ferrara,
 Filarete, Fromentin, Géri-
 cault, Gozzalli, Gros, Grube,
 Herodotus, Hodges, Ingres,
 Kresias, Lastman, Lequeu,
 Lievens, Lorch, Masaccio,
 Medici, Megasthenes, Mem-
 ling, Nash, Perugino, Pinto-
 ricchio, Pisanello, Raphael,
 Rembrandt, Schongauer, Se-
 leucus, Sicily, Signorelli, Ti-
 tian, Zoffany
Ingres, J. A. D., 216
Innocent IV, Pope, 146
Innocent X, Pope. *See* Kircher
Iran, 20, 30. *See also* Persia
Ireland, 17
Isis, identified with the Virgin
 Mary, 121
Islam, 19, 32
Italy, animal forms, 21, 23, 26;
 cults of Isis and Serapis, 40;
 obelisks, 61–2, 204; villas in
 north, 87

John III, 204
John the Fearless, 148
Justinian, Emperor, 145. *See
 also* Byzantium; China

Kalmuck. *See* Pisanello
Kames, Lord, 176
Kent, William, 91–3, 179, 184–5, 189. *See also* Ripa
Khan, Jenghis, 146. *See also* Carpino, Persia, Russia, Silesia
Kimball, Fiske, 162
Kircher, Athanasius, 113, 114, 116. *See also* Warburton
Ktesias, 193

Lastman, Pieter, 207–15
Leibnitz, 160
Leo, X, Pope. *See* Valeriano
Leonardo, 102, 104, 200
Lequeu, J. J., 196, 199
LeVau, Louis, 165
Lievens, Jan, 211–12
London, obelisks, 88
Lonigo, Villa Pisani, 87
Lorch, Melchior, 122
Lorenzetti, Ambrogio, 150–1
Lorrain, Claude. Influence on English landscape garden, p. 115
Louis XIV, 165. *See also* Confucius
Lovejoy, 191. *See also* Chambers
Lucca, 153
Lukas, Paul, 121. *See also* Fischer von Erlach

Maderno, Carlo, 74
Mâle, Emile, 23
Mandeville, John, 148
Mansard, J. H., 118–19
Mantegna, 98–9, 108, 206–7
Marignola, John of, 146
Marseilles, 19
Martin, John, 216–17
Masaccio, 200–2
Master of the Bruges Passion, 203, 207–8
Mattei, Ciriaco, 75
Maximillian, 103, 108–9
Medici, 162, 204–5
Megasthenes, 193–4
Memling, 207

Mesopotamia, 9, 20–1
Metella, Cecilia, monument of, 76
Michelangelo, 58
Milan. *See* Barca, Seregni, Vignola
Mirandola, Pico della, 94, 112
Monet, Claude, 217
Monte Corvino, John of, 146
Montespan, Madame de, 165
Monfaucon, B., 123
Moses, 94
Mozac, 3, 23
Munich, 140–1
Muscardo, Count Ludwig, 122

Nanni da Viterbo, Fra Giovanni, 103
Naples, 19, 150
Napoleon, 88, 126, 138, 144
Nash, John, 194
Netherlands, 87–8
New York, 88, 90
Niccoli, Niccolò, 96–7
Nicholas V, Pope, 72
Nicoletto, 209–10
Nieuhof, Jan, 167, 172–3
Noah. *See* Maximillian
Nomad art, of Scythians 5, 7; of Celts, 7, 8
Norden, Ludwig, 121–3

Oderic, Friar, 146, 148
Olschki, Leonard, 150–2, 156. *See also* Pisanello

Padua, 51–3. *See also* Parentino
Palestrina, 41
Palladio, Andrea, 93
Panofsky, Erwin, 18, 110
Parentino, Bernardo, 110
Paris, Place de la Concorde obelisk, 89. *See also* Henry II Monument, Napolean, Serlio
Peraga, 87–8
Pasquale, Fra., 44, 48
Pasti, Matteo de, 100–1
Paul V., Pope, 87
Pegolotti, Francesco Balducci, 146

Percier, Charles, 138
Persepolis. Doorway of Tripy-
lon, p. 8
Persia, 27, 30, 32, 41, 145. *See
also* China
Perugia, Andrew of, 146
Perugino, 200
Peruzzi, Baldassare, 87
Physiologus, 42–3, 103
Picasso, 2, 5
Pindar, 189
Pintoricchio, 206–7
Piranesi, Giovanni Battista,
129–30, 132–8
Pirckheimer, Willibald, 97–8,
103, 105
Pisanello, 100–2, 150–2, 204
Plato, 94
Pliny, 95, 102–3
Plotinus, 94–7
Plutarch, 95
Pococke, 67, 121
Polo, Maffeo, 146
Polo, Marco, 146–8
Polo, Nicolo, 146
Pompeii, 41
Poitiers, 26, 29
Ponzio, Flaminio, 87
Poussin, Gaspard, 189
Poussin, Nicolas, 118–9
Primaticcio, 53

Raphael, 47, 50–2, 54, 64, 200
Ravenna, 14, 17
Rembrandt, 207–9, 211, 213–
14
Regent, Prince, 196
Renoir, Pierre Auguste, 217
Repton, Humphrey, 196
Ripa, Fr. Matteo, 189. *See also*
Burlington, Kent
Robinson, P. F., 140, 142
Romano, Giuliano, 98–100
Rome, 1, 38–41, 43, 53–4, 60,
63–8, 73–5, 83–5, 98–9, 114–
6. *See also* Ackerman, Alex-
ander VII, Augustus, Bernini,
Bramante, Clement XI,
Clement XIV, Ferrata, Fon-
taine, Fontana, Hawksmoor,
Hudson, Maderno, Man-
tegna, Nicholas V, Paul V,
Percier, Peruzzi, Piranesi,
Ponzio, Raphael, Romano,
Rossi, Scythians, Serlio,
Sfondrato, Sixtus V, Tem-
pesta, Urban VIII, Vignola
Rosa, Salvator, 189–90
Rosicrucians, 126, 144
Rossi, Vincenzo de' 4. *See also*
Rome
Rubruck, William, 146
Runciman, 14
Russia, Mongol Conquest, 146

Salerno, 19
Samarkand, Persian artisans in,
19
Sangallo, Antonio da. 60–2.
See also Vignola
Sangallo, Antonio da (younger),
61
Sanmicheli, 50–2
Sansovino, Jacopo, 63
Saracen, 19. *See also* Sicily
Sassanids Eagle symbolism, 42;
metal work, 11, 13; silk
trade, 20, 145; transmission
of motifs, 22–3. *See also*
China
Scamozzi, Vincenzo, 86–8. *See
also* Sansovino
Schongauer, 130
Scythians, animal style, 14;
mongolian gold, 145. *See
also* China
Seleucus. *See* Megasthenes
Serapis, 120–1
Seregni, Vincenzo, 70
Serlio, Sebastiano, *L'Architet-
tura*, 64, 87; in Paris, 64;
central-plan design, 65, 67
Sfondrato, 70–1, 114
Shaftesbury, 179
Shearman, John, 47–8
Shrewsbury, Earl of. *See* Alton
Tower
Siberia, Marco Polo's accounts
of, 150, 151
Sicily, in Arab hands, 19; cen-

Sicily (*cont.*)
 ter of Saracen cultures, 19;
 cufic script in Europe, 200;
 Persian and Arab craftsmen
 in, 20; silk trade, 20
Siena. Cathedral (see Trisme-
 gistus), S. Francesco of Siena
 (see Lorenzetti, A.) (IX–7, 9)
Signorelli, 200
Silesia, Mongol conquest, 146
Sixtus V., Pope, 72, 75, 83, 87
Sorrento, 23, 25
Spain, 1, 22, 23, 26–7, 32–3.
 See also Herrera
Spannocchi, Antonio. *See* di
 Giorgio
Staffordshire, 119
Sterling, Charles, 156
Stoct, Vrancke van der, 211,
 212
Suger, Abbot, 30
Sumer, 22
Susa, 11, 12
Swedish tombs, Persian and
 Chinese objects in, 1
Syria, 20, 145

Tempesta, Plan of Rome, 74
Temple, Sir William, 188
Thomson, James, 186
Tivoli, 40
Titian, 55, 57, 205
Trismegistus, Hermes, 95–6,
 160

Urban VIII, 80
Uruk, 7, 9

Valeriano, Pierio, 94–6, 110,
 112
Vanbrugh, 89
Vasari, Giorgio. *See* Valeriano
Vasco da Gama, 158–9
Vassaletto, 43, 46
Vedder, Elihu, 143
Venice, 19, 43, 45, 63, 150,
 153. *See also* Egypt, *Hora-
 pollo, Hypnerotomachia Po-
 liphili,* Serlio
Verona, 150, 152
Versailles, 165
Vicenza, Cathedral by Sanmi-
 chele, 50; Villa Foscarini
 87–8
Vienna. Library—*see*
 Pirckheimer
Vignola, Giacomo da, 68, 70
Virgil, expressed in landscapes
 of Claude and Poussin, 189
Voltaire, 160

Warburg, Aby, 33
Warburton, William, 125. *See
 also* Norden
Walpole, Horace, 190
Wilson, Richard, 196, 217

Zoffany, Johann, 199
Zoroaster, 160